Temples of Nara
and Their Art

Volume 7
THE HEIBONSHA SURVEY OF JAPANESE ART

For a list of the entire series see end of book

CONSULTING EDITORS

Katsuichiro Kamei, *art critic*
Seiichiro Takahashi, *Chairman, Japan Art Academy*
Ichimatsu Tanaka, *Chairman, Cultural Properties Protection Commission*

Temples of Nara and Their Art

by MINORU OOKA

translated by Dennis Lishka

New York · WEATHERHILL/HEIBONSHA · Tokyo

This book was originally published in Japanese by Heibonsha under the title *Nara no Tera* in the Nihon no Bijutsu series. For the English-language edition, the author has made a number of revisions and corrections.

A full glossary-index covering the entire series will be published when the series is complete.

First English Edition, 1973

Jointly published by John Weatherhill, Inc., 149 Madison Avenue, New York, New York 10016, with editorial offices at 7-6-13 Roppongi, Minato-ku, Tokyo 106, and Heibonsha, Tokyo. Copyright © 1965, 1973, by Heibonsha; all rights reserved. Printed in Japan.

Library of Congress Cataloging in Publication Data: Ooka Minoru, 1900– / Temples of Nara and their art. / (The Heibonsha survey of Japanese art) / Translation of Nara no tera. / 1. Temples—Japan—Nara (City) 2. Temples, Buddhist—Japan—Nara (City). / I. Title. II. Series. / NA6057. N305513 726'.1'43095218 72–78601 ISBN 0–8348–1010–7

Contents

Temples of Nara
and Their Art

CHAPTER ONE

The Dawn of
Japan's Buddhist Culture

A TURNING POINT IN THE ANCIENT WORLD Buddhism was born in northern India around 500 B.C. Its originator, known as Sakyamuni (563?–483? B.C.), had achieved enlightenment through sitting in meditation and had become the Buddha, the Enlightened One. Soon his disciples spread his teachings to neighboring villages and towns and then to bordering countries. The two major currents of Buddhism were Mahayana (literally, "the Greater Vehicle"), which advanced mainly in eastern Asia, and Hinayana (literally, "the Lesser Vehicle"), which influenced southeast Asia west of Vietnam. It was Mahayana, sometimes called Northern Buddhism, that ultimately reached Japan via China and Korea in the sixth century of the Christian Era.

Buddhism had spread throughout India by the third century B.C., was the dominant religion in China from the mid-fourth to the late eighth century, and had reached the Korean kingdom of Koguryo (37 B.C.–A.D. 668) in 372. Japan, as an island country relatively isolated from the Asian continent, remained uninfluenced by Buddhism for a long time. Around the third century A.D., when Japan arose as the Yamato state, the country consisted of a large number of clanlike units, each semi-independent and self-contained. The members of each such tribe considered themselves to be of common origin and worshiped their own deity, identified with a legendary progenitor. Society was simple, and the political system was primitive, although the hereditary-emperor system seems already to have been in existence. By the fifth and sixth centuries, however, society became complicated, and the need of a suitable administrative structure more centralized and organized than just a loose federation of semiautonomous tribes was felt. The greatest weakness of the Yamato rulers was the lack of any firm ideology that would unite the tribes more strongly and thereby help to create a centralized government.

It was not until 552, during the reign of Emperor Kimmei (509–71), that Buddhism crossed the Sea of Japan. In this year the Korean kingdom of Paekche (18 B.C.–A.D. 663) presented Japan with a gilt-bronze Buddhist image and volumes of sutras, at the same time recommending the adoption of the Indian religion. This offer was an attempt by Paekche to win Japanese support against Silla (57 B.C.–A.D. 935), a third kingdom of Korea, which was to conquer both Koguryo and Paekche in the mid-seventh century. Of the three greatest court families of Yamato, the Nakatomi family of Shinto ritualists and the Mononobe family of warriors opposed Buddhism, but the Soga family supported

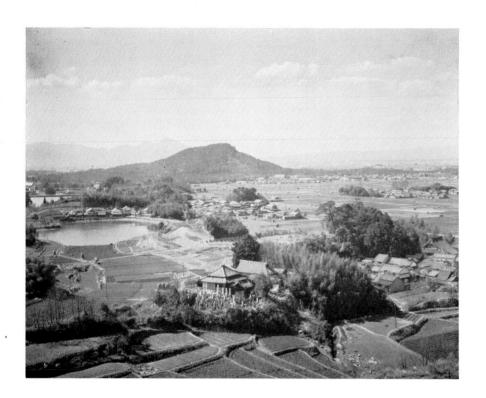

it, advocating a sterner policy against Silla. The conflict among the rival court families over the admission of the alien religion aggravated the mutual antagonism of the Soga and the Mononobe, and a violent dispute ensued. But the quarrel ended in favor of the Soga when Emperor Yomei (540–87) became a Buddhist just before his death. The victory of the Soga made it possible to insure that the imperial throne be occupied by persons born of Soga mothers. But it was the penetrating insight of Prince Shotoku (574–622), related to the Soga by blood and acting as regent for his aunt the empress Suiko (554–628), that helped to orient the nation toward the full adoption of Buddhist culture. In order to organize the nation into a powerful and cultured one, it seemed to him imperative to import Buddhism, which had encouraged two of the world's oldest civilizations. About a century and a half after his time, a cultural growth and a consolidation of the state would be apparent in what was to be called Heijo-kyo, the capital city later to be known as Nara.

EARLY TEMPLE CONSTRUCTION As can easily be imagined, the Buddhist temples and institutions of that time were created as instruments of social leadership. In other words, a national Buddhism had been established. The state itself built many temples, and their construction enterprises were operated by the government. For example, when the building of the Yakushi-ji monastery in Nara was undertaken in accordance with the wishes of Emperor Temmu (622–86), the Yakushi-ji Construction Agency was set up. This agency, established within the government bureaucratic system, was comparable to the organization established within the Imperial Household Agency for the construction of the present Imperial Palace in Tokyo. Another example of the government's undertaking of a mon-

2. Image of a Buddha excavated at ruins of Golden Hall, Yamada-dera, Yamada, Nara Prefecture. Terra-cotta wall relief; height, 17.5 cm. Second half of seventh century. Tokyo National Museum.

astery-construction project was the Kofuku-ji Construction Agency, set up in 720 for the purpose of building an octagonal hall within the Kofuku-ji temple compound in memory of Fujiwara Fuhito* (659–720). This octagonal hall is now called the North Round Hall. The Kofuku-ji monastery was the family temple of the Fujiwara clan—that is, a private temple—but the fact that a government agency was created for the construction of its buildings clearly indicates the treatment of the Kofuku-ji as a state temple.

Little is known about the early legendary temples like the North Pagoda at Onogaoka or the seminary at Sakurai, which are said to have been built during the Soga-Mononobe dispute, but they could not have been large-scale constructions even

* The names of all premodern Japanese in this book are given, as in this case, in Japanese style (surname first); those of all modern (post-1868) Japanese are given in Western style (surname last).

if they existed at all. It appears that the first temples fully equipped with halls and pagodas and having a clear history were products of the Asuka period (552–646): Prince Shotoku's Shitenno-ji, built in Osaka (then called Naniwa) after the overthrow of the Mononobe family; the Soga family's Hoko-ji (also pronounced Hokko-ji); and the Horyu-ji, which the severely ill Emperor Yomei commanded Empress Suiko and Prince Shotoku to build in 587. Of these three early temples, the construction date of the Hoko-ji is verified by the *Nihon Shoki* (Chronicles of Japan), the oldest officially written history of Japan, compiled in 720. According to this record, in 592 a Buddha hall, in which the chief Buddha statue was kept, and corridors were built, and the entire temple was finished in 596. The Shitenno-ji is claimed to have been completed in 592, the first year of Empress Suiko's reign. It was also during her reign that the Horyu-ji was built. These facts seem to suggest that

3. East Golden Hall (left) and Five-storied Pagoda, Kofuku-ji, Nara. East Golden Hall: frontage 23.5 m.; fifth reconstruction, dated 1415. Five-storied Pagoda: height, 50.1 m.; fifth reconstruction, dated 1426.

4. Aerial view of West Precinct, Horyu-ji, Ikaruga, ▷ Nara Prefecture, from southeast. Late seventh century.

the construction of temples in Japan gradually began to be carried out during the reign of this empress. As for the state of progress after that, we find in the *Nihon Shoki* a record to the effect that in the year 624 some first- and second-rank monks were appointed, while a later survey on the number of Buddhist monasteries, monks, and nuns revealed that there were 46 monasteries, 816 monks, and 569 nuns, the record states. The fact that by this time Buddhism enjoyed such a prosperous condition, involving 1,385 clerical persons altogether, is indeed surprising.

A large-scale temple-construction project of the pre-Heijo-kyo era was that of the Kudara Dai-ji, once a small cloister at Kumagori (in Nara Prefecture) but converted into a fully equipped temple at the end of the Asuka period according to the wishes of Prince Shotoku. The *Nihon Shoki* states that in 639 the people living east of the Kudara River were ordered to build the temple and those living west of the river to construct palace buildings. During the reign of Emperor Tenji (626–71; reigned from 668), which was, properly speaking, already in the Nara period (646–794), the construction of the Tsukushi Kanzeon-ji in Kyushu was ordered, and the Kawara-dera was built in the Asuka district of Nara Prefecture. In the reign of Emperor Temmu, which lasted from 673 to 686, the Kudara Dai-ji was moved to Asuka Village in Takaichi County (Nara Prefecture) and renamed the Takechi Dai-ji (later to be called the Daikan Dai-ji and, more recently, the Daian-ji). In 680, Emperor Temmu ordered the erection of the Yakushi-ji (later to be called the Moto Yakushi-ji —literally, "the original Yakushi-ji"), enshrining an image of Yakushi (in Sanskrit, Bhaisajyaguru),

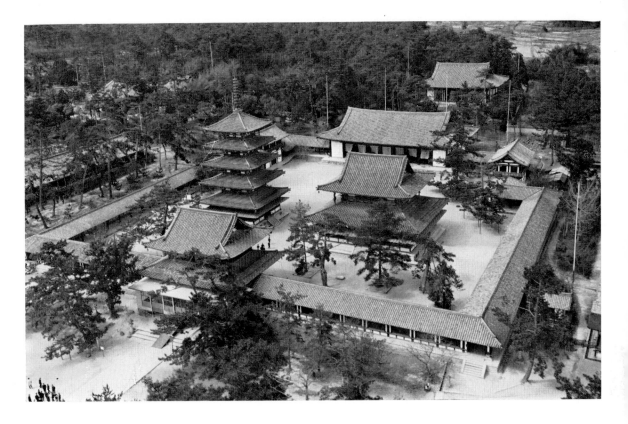

the Buddha of Healing. This temple, which occupied a site in present-day Kidono, Kashihara City, Nara Prefecture, was built in supplication for the cure of an eye disease of Temmu's consort, who later became Empress Jito (645–702; reigned 690–97).

In addition to these state temples, there were private temples built by powerful families. The Yamada-dera, built by Soga no Kurayamada no Ishikawamaro at Yamada, Sakurai City, was one example, and its foundation stones are still extant. Its construction was discontinued at Ishikawa-maro's political downfall, but we are told in the *Jogu Shotoku Ho-o Teisetsu*, a biography of Prince Shotoku, that its principal Buddha image was cast in 678. The head of this image, which is the only surviving portion, is now kept by the Kofuku-ji, and it clearly attests to the excellent achievement

in sculpture during the Hakuho, or early Nara, period (646–710)—full-bodied sculpture far above the Asuka style. Moreover, the head is important as one of the rare figures whose dates have been established.

Only six architectural remnants survive from this period: the Horyu-ji Golden Hall, Five-storied Pagoda, Inner Gate, and corridor; the Three-storied Pagoda of the Hokki-ji; and the East Pagoda of the Yakushi-ji, a different temple from the Moto Yakushi-ji mentioned above. (See Chapter 2.) The distinctive stylistic features of the Horyu-ji and the Hokki-ji are the strong entasis of the pillars —reminiscent of the Doric order in classical Greek architecture—and the use of cloud-shaped bracket arms, which, resting on the pillars, support the eaves. Clearly, however, the Horyu-ji temple compound as we see it today is not the original one. It

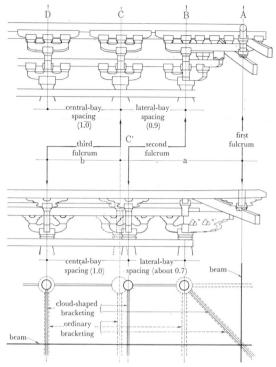

5. Relation of bracketing to ground plan.

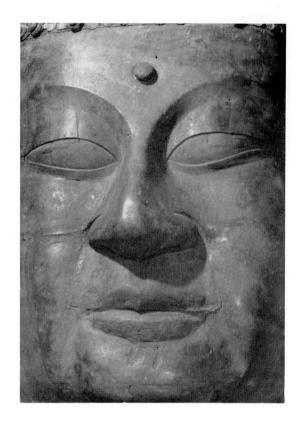

is commonly believed, on the basis of observations made during recent repairs, that the present temple compound was built after 670, the year of the "great fire" recorded in the *Nihon Shoki*. Many claim that the architectural style common at the end of the seventh century was the one we see today in the Three-storied Pagoda of the Hokki-ji, since an inscription from the year 706 was found on the "dew basin," or finial base, atop the pagoda. But since the construction of the pagoda began as early as 685 and since the Golden Hall—the main hall of the temple compound, in which the chief object of worship was enshrined—had been built still earlier, the plan of the entire temple must, at the latest, date back to immediately after the Taika Reforms of 645: the "great change" (*taika*) of government following a coup d'état against the Soga by the progenitor of the Fujiwara family. There is a great possibility that the rebuilding of the Horyu-ji after the "great fire" was carried out in a restorative way, in which case its style can be traced as far back as the end of the Asuka period. Even though there is no evidence extant from this period that can stand as actual proof, it is my own theory that the architectural style seen in the Horyu-ji and the Hokki-ji materialized around the time of the construction of the Kudara Dai-ji.

TEMPLE ARCHITECTURE OF THE ASUKA PERIOD

It has been noted above that the style seen in the Horyu-ji and the Hokki-ji, using cloud-shaped bracket arms, dates back to the Asuka period, but this style was certainly not the one prevalent in the early Asuka period. One reason for this claim is the fact that the plan of the Hokki-ji dates back to, but

6. *Face of seated Sakyamuni (Shaka), Ango-in (also called Asuka-dera), Asuka, Nara Prefecture. Also called the Asuka Great Buddha and originally the chief image of the Hoko-ji. Gilt bronze; height of entire statue, 275.7 cm. Early seventh century.*

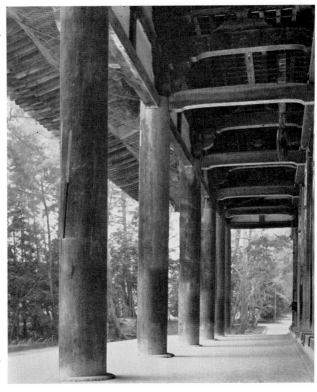

7. *Portico of Golden Hall, Toshodai-ji, Nara. Second half of eighth century.*

only to, the mid-seventh century. Even in the case of the Horyu-ji, granted that the rebuilding of it faithfully restored the stylistic features of the temple compound before its destruction in the "great fire" of 670, the present temple compound still cannot be regarded as stylistically identical with the original—the so-called Wakakusa layout—built at the wish of Emperor Yomei. The first reason for this contention is the discrepancy in the position of the two temple compounds. The second is that the designs used in the roof tiles are different. In the Wakakusa layout the convex (or cylindrical) tiles used for its halls were designed with lotus flowers with a single layer of petals and the concave (or flat) tiles with ginkgo leaves. In the present halls and pagoda of the Horyu-ji, however, designs of lotus flowers with multilayered petals and of anthemia are used in the convex and the concave

tiles respectively. Therefore, because of this difference, it is too difficult, if not impossible, to ascribe the cloud-shaped bracketing method to the early Asuka-period architectural style.

What, then, was the style of the early Asuka-period architecture? The question cannot be answered without some degree of difficulty, but it is quite probable that the use of three-block bracketing—that is, the bracket complex composed of three small bearing blocks above and one base bearing block below the bracket arm—together with inverted-Y posts placed alternately between the bracket complexes (Fig. 61) characterized the early Asuka style. In fact, we can find examples of the use of three-block bracketing and inverted-Y posts reflected in the relief carvings of stone-cave temples in China, obviously the source country of Japanese temple architecture, although there are

THE ASUKA PERIOD · 15

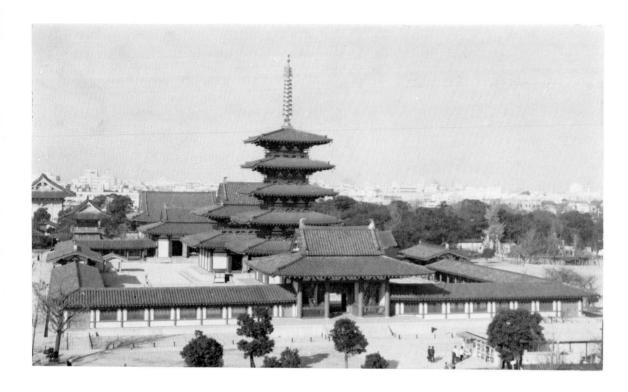

no remains of wooden structures from the same period in present-day China. In the Horyu-ji the cloud-shaped bracket arms soon catch the eye, but the three-block brackets can also be found in the interior of the Golden Hall and of the Inner Gate, and the balustrade of the Golden Hall illustrates the use of both three-block brackets and inverted-Y posts. Therefore it seems quite reasonable to conclude that the style of this combination was imported directly from China in the early Asuka period (Fig. 61). This thesis is indirectly supported by the fact that, judging from its ground plan, the Asuka-dera (later to be called the Hoko-ji) did not have cloud-shaped bracketing. Since the cloud-shaped bracket extends only in the direction of 45 degrees (Fig. 5), the end bay (interpillar span) would have to be exceedingly narrow—that is, the second fulcrum would have to be moved toward the corner pillar—in order to maintain the structural balance. In the ordinary bracket system (Fig. 5, top) the bracket arms extend in the direction

of 90 degrees as well as that of 45 degrees at the corner, but in the cloud-shaped bracketing (Fig. 5, middle) the bracket arm protrudes only in the direction of 45 degrees. If in the cloud-shaped bracketing a pillar is located at point C, as in the case of ordinary bracketing, the distance a between the first and the second fulcrum would be so much longer than the distance b between the second and the third fulcrum that it would destroy the aesthetic as well as the structural balance (Fig. 5, bottom: overhead view). Consequently, in a structure using cloud-shaped bracketing, the second fulcrum is always moved toward the corner pillar to point C', and the space of the lateral bay is reduced to obtain stability. In the Golden Hall and the Inner Gate of the Asuka-dera, however, the corner bays were not narrowed at all.

A word should be added here as to the temple-compound layout of this period. The temple-compound layout is the arrangement of the positions of essential halls and pagodas of a temple

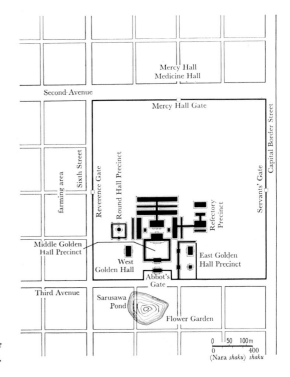

8. *Present compound of Shitenno-ji, Osaka. Originally constructed in late sixth century; restoration completed in 1958.*

9. *Plan of original temple grounds, Kofuku-ji, Nara.*

(see Foldout 1). This subject was first given study around the end of the nineteenth century, during the period when the foundations of Japanese architectural history were laid, but there was little systematic or concrete research done until the mid-1920s. The standard theory on Asuka-period temple-compound layouts until recent years was that the lecture hall, the golden hall, the pagoda, and the inner gate were placed either on a straight north-south line in this order, with the golden hall and the pagoda surrounded by the corridor, as at the Shitenno-ji in Osaka (Fig. 8), or the surrounding corridor enclosing the golden hall and the pagoda laid out on an east-west line (in either order), as at the Horyu-ji (Fig. 4). It has been generally believed that the Shitenno-ji style was handed down from the Asian mainland, since it was identical with the layout style of such Korean temples as the deserted one at Kunsuri (in Japanese, Gunshuri Haiji) of Paekche and the Hwang-ryong-sa (in Japanese, Koryu-ji) of Silla, and that

the Horyu-ji style was an original creation in Japan because there was no corresponding style to be found on the continent. But the excavations conducted at the remains of the Asuka-dera a few years ago were rewarded with a new discovery and introduced a breath of fresh air among the scholars in this field. It was found out that the Asuka-dera had golden-hall triplets (although it is still debatable whether all three of them were actually golden halls) surrounding a pagoda on its east, west, and north, all enclosed by the corridor—an arrangement unimagined before. And since exactly the same temple-compound layout was found at the deserted temple of Ch'ongamri (in Japanese, Seiganri Haiji) of the Korean kingdom of Koguryo, although the pagoda was octagonal, this style was proved to have been an exact copy from the mainland, as it was a natural tendency in early times. Thus two styles have been established for the Asuka-period temple-compound layouts: the Asuka-dera style and the Shitenno-ji style.

CHAPTER TWO

---•-•---

The Temples of Ancient Nara

THE CONSTRUCTION OF THE HEIJO CAPITAL In very ancient times, each emperor changed the site of the imperial palace upon his accession to the throne, and no capital continued for more than one era. As contacts with the Asian mainland became more frequent, there was a rapid increase in the number of visits to Japan by foreign envoys. Matters of prestige therefore became rather important, and especially after the Taika Reforms, when the administrative system of the government was substantially restructured to create a number of new bureaus, the need of new buildings became pressing. Now it was apparent that the construction of a capital on a permanent basis was an urgent requirement.

The plan for such a capital was first embodied at Naniwa, or the modern city of Osaka, the construction of which began immediately after the Taika Reforms. But this site was abandoned for Otsu (in the modern Shiga Prefecture), where Emperor Tenji established his capital. Again, in 691, a site in the Asuka district surrounded by the so-called Three Hills of Yamato—Kagu, Miminashi, and Unebi—was chosen for a new capital. It was called the Fujiwara capital after the name of the then powerful clan. The division of the city into wards was already seen here, and it was well organized and equipped. But the geographical conditions were not quite ideal, and it became necessary to transfer the capital to the northern part of the Yamato Plain, a broad region surrounded by mountains and hills on the north, east, and west. In 710, Empress Gemmei (or Gemmyo) moved her palace to this highly systematized and well-equipped Heijo-kyo (or Heizei-kyo)—that is, the Heijo capital. Today it is the city of Nara, and it will be less confusing to call it by that name, which is also the name given to the period (646–794) during whose latter half it flourished.

The construction of Nara had been ordered by an imperial decree of 708 stipulating that it be "properly instituted, so that nothing shall be added hereafter." In other words, the capital must be constructed in such a perfect manner that no more modifications would be possible. The decree was indeed a declaration by the empress of her idealist aspirations. Only in such a capital would it be possible to embody the centuries-old yearning to see the Asian continental civilization flourish in Japan through the painstaking efforts to introduce Buddhist culture since the mid-sixth century. The main part of the capital of Nara was divided into square sectors and these, in turn, into blocks, the divisions being made by boulevards and narrow streets or alleys. It extended 32 blocks (approximately 4.2 kilometers) from east to west and 36 blocks (approximately 4.7 kilometers) from north to south.

During the seventh and eighth centuries it was a trend among emerging Asian nations to pattern their capitals after the great capital city Ch'angan of T'ang-dynasty China, then one of the centers of world civilization. Kyongju of the Korean kingdom

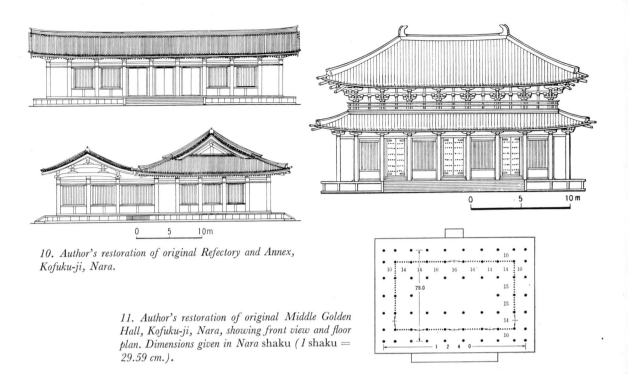

10. *Author's restoration of original Refectory and Annex, Kofuku-ji, Nara.*

11. *Author's restoration of original Middle Golden Hall, Kofuku-ji, Nara, showing front view and floor plan. Dimensions given in Nara* shaku *(1* shaku = *29.59 cm.).*

of Silla and Tungching-cheng of P'ohai (713–926), a Tungusic tributary state under the T'ang dynasty, were two examples of this copying. Nara was no exception to the rule and, in fact, had a more efficiently organized system of administration than that of Ch'angan. Its method of expressing directions and locations was very well worked out. It was not as large a capital as Ch'angan, but it was an imposing one nonetheless and was in no way shabby-looking. In fact, the cities of ancient times were in general quite small, as exemplified even by mighty Rome, whose actual center was only about four kilometers long and three kilometers wide, not to speak of other settlements and colonies of smaller scope. In this sense, Nara was one of the most significant capitals of the ancient world. Residential land was allocated according to the ranks and classes of the people, the allotment of the highest nobleman being four blocks or about 57,600 square meters. (One side of a block was about 120 meters long). Buddhist temples of high social standing

placed here and there within the capital contributed much to its overall beauty. The rationality and integrity of the Nara-period culture strike us in its high achievements, and at the same time we are astonished at the sensuous beauty expressed in its surviving fine arts and literature—most notably in the *Man'yoshu,* an anthology of some 4,500 poems completed during the closing years of the period.

THE FUJIWARA CLAN TEMPLE: KOFUKU-JI It was only natural that the powerful temples of the Asuka district should compete with one another in making plans for expansion into the new capital of Nara. The earliest of the Nara temples was the Kofuku-ji (also called the Kobuku-ji), which was built there sometime after 710 under the patronage of the influential statesman Fujiwara Fuhito, who had also proposed the construction of the new capital. It is not known whether plans for the Kofuku-ji had

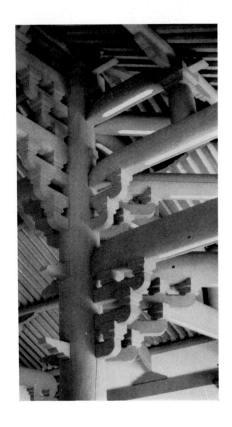

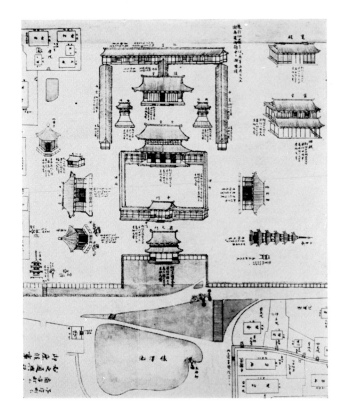

been included in the original building of the capital or whether it was constructed after Empress Gemmei had moved there, but it is believed that the temple had originally been built as the Yamashina-dera by Fujiwara Kamatari (614–69), the nobleman who played a great role in the Taika Reforms, and that during the reign of Emperor Temmu it was moved to the vicinity of the Kiyomihara Palace in Asuka, where it was called the Umaya-saka-dera. Although the exact earlier locations and other circumstances are not clear, we know that the Kofuku-ji was ranked among the first-class temples of Nara. Situated in the northeastern part of the city, in the area known as the Outer Capital, it stood on a plateau, an extension of the south-western ridge of Mount Wakakusa, and commanded an unobstructed view of the entire capital. This choice of the foremost scenic area in

Nara for his temple was evidence of Fuhito's strength of will.

Since the Kofuku-ji temple compound, among all those surviving from Nara times, represents the best restoration to original condition and scale (Fig. 9, Foldout 1), let us look at its principal structures to acquire some familiarity with the characteristics of the Nara-period temple-monastery. The Golden Hall, in which the main Buddhist image was enshrined, was the heart of the temple complex. The Lecture Hall served as a place for lectures and discussions on the subject of Buddhist doctrine and practice. The Refectory was the dining hall, attached to which were a kitchen, a pantry, and an annex perhaps used by monks for preparation before entering the Refectory itself. The Monks' Quarters, in addition to serving as a residential area for the clerical personnel, were a

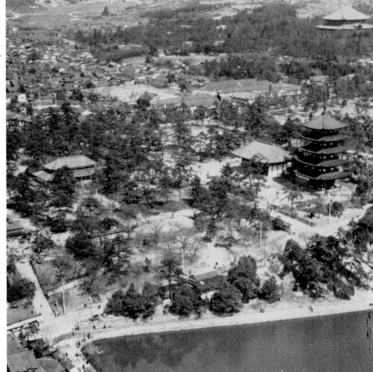

◁ 12 (opposite page, left). Brackets in Great Buddha style, Pure Land Hall, Jodo-ji, Hyogo Prefecture. Dated 1192.

◁ 13 (opposite page, right). Old drawing of temple compound, Kofuku-ji, Nara, showing its fifteenth-century reconstruction. India ink on paper. Dated 1760.

14. Aerial view of Kofuku-ji, Nara, from southwest. At left, Middle Golden Hall; at right, East Golden Hall and Five-storied Pagoda; in foreground, Sarusawa Pond; in background at extreme upper right, Great Buddha Hall, Todai-ji.

place for study, comparable to modern university seminars, where groups of ten or more monks shared their study and daily life under the guidance of a leader monk, each group occupying, in the case of a large temple, an area of some 165 square meters. In the Sutra Repository, which played the role of a library, were stored such volumes of religious literature as sutras and commentaries: the basic sources of Buddhist learning. The Belfry housed the great bronze bell that served to announce the time. The Pagoda was a reliquary in which were enshrined legendary fragments of the ashes of Sakyamuni, usually inside the foundation stone under the central pillar but sometimes inside the "sacred jewel" of the finial atop the structure. In temples employing the twin-pagoda style, the ashes were enshrined in only one of the pagodas. The South Main Gate was the principal gate, opening to the south of the temple precinct, and the Inner Gate played the role of central gate, belonging to the surrounding corridor, which enclosed the courtyard in front of the Golden Hall.

As is clear from the simple definitions of these structures, the temple monastery of this period was tantamount to a university or research center of Buddhism composed of many seminar rooms where students attended lectures, devoted their time to self-study, or discussed the results of their religious endeavor under strict and rigorous guidance. The temple-monastery not only served as a seat of learning but also contributed to the artistic and cultural enrichment of the community through the creation of a large number of Buddhist statues and paintings that were themselves superb examples of art, solidly based on the doctrines and disciplines of Buddhism. Nor was the monastery merely an

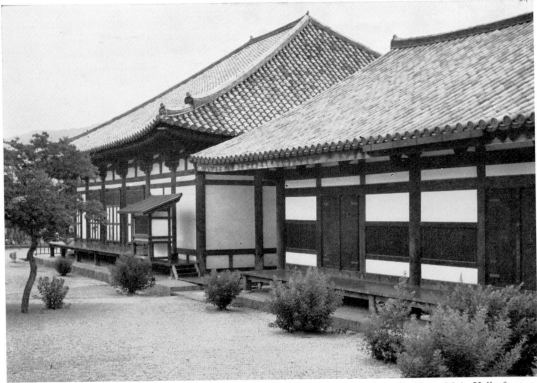

15. *North side of Main Hall (left) and Meditation Room (right), Gokuraku-bo, Gango-ji, Nara. Main Hall: frontage, 17.1 m.; depth, 17.7 m. Dated 1244. Meditation Room: length, 26.65 m.; width, 12.85 m. Eighth century; greatly remodeled in early thirteenth century.*

ivory tower confining itself to academic fields. A closer look at the facilities established within the temple grounds will reveal aspects of social activity as well.

Figure 9 is a reproduction of the Kofuku-ji ground plan taken from old documents. On the site of the present Sarusawa Pond (to the south in the drawing), just outside the southern roofed earthen wall marking off the temple's main precinct, was the Flower Garden, four blocks long and one block wide, used by the people of the capital for relaxation and enjoyment. To the north were the Mercy Hall, corresponding to a modern orphanage or old people's home, and the Medicine Hall, a center for free medical examination and treatment. The Bathhouse was open to all people

and fulfilled a preventive medical function. To the west was a farming area that supplied the temple with fruit, vegetables, flowers, and the like, thereby enabling it to maintain a self-sufficient economy. In short, the temple performed the service of public facilities and played an important role in social welfare. That is to say, the government of the period provided the social services of scholarship, education, public welfare, and social management through various temple-monasteries in the community. Naturally, for the temples to be active in these areas, adequate knowledge and comparative skill in each of the areas were an absolute necessity, and, needless to say, such disciplines were all conveyed to Japan through the exchange with China of scholarly monks. The significant and

16. Detail of eaves, East Pagoda, Yakushi-ji, Nara. Dated 730.

17. Detail of water-flame ornament on finial, East Pagoda, Yakushi-ji, Nara. Gilt bronze; total height, 190 cm. About 730.

multifarious social role played by the Nara temples is indeed evidence that there was no other way for Japan to develop as a cultured nation except through the introduction of Buddhism and its culture.

As the power of the Fujiwara clan increased through the retention by its members of long-term influential positions within the imperial court, the Kofuku-ji developed into the most powerful of all the Nara temples. But its prosperity was often reversed by great fires. To single out the chief conflagrations during the Heian period (794–1185), the monastery burned down in 1046, 1060, and 1096, although each time it was immediately rebuilt. During the civil war between the Taira and the Minamoto at the close of the Heian period, the

entire temple complex was burned to the ground, and next to nothing was left standing. In the medieval period, too, great conflagrations occurred in 1277, 1327, 1356, and 1411, and finally, in 1717, the Golden Hall area caught fire. Before the Meiji Restoration of 1868 only a temporary Golden Hall stood in the old one's place, and the glory of the prosperous Kofuku-ji in ancient times seemed to survive only in recollection. To make matters worse, the separation of the previously amalgamated Shintoism and Buddhism resulted in the detachment of Buddhism from state patronage, and sentiment favoring the rejection of the religion soon culminated in fierce conflicts that involved the smashing of Buddhist statues and the destruction of sutras—a kind of iconoclastic movement

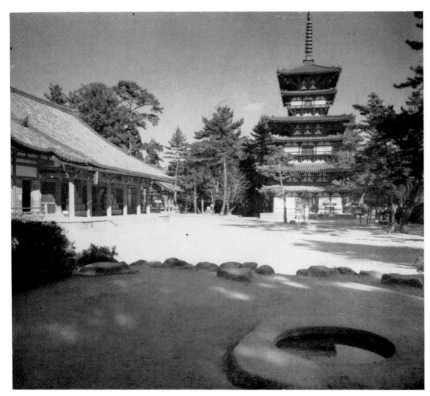

18. *Central area of temple compound, Yakushi-ji, Nara. At left, Golden Hall (second reconstruction); at right, East Pagoda; in foreground, central-pillar foundation of West Pagoda. The temple was moved to its present site in the early eighth century.*

19. *The Buddha Birushana (Vairocana), Golden Hall, Toshodai-ji, Nara. Gold on dry lacquer; height, 303 cm. Second half of eighth century.* ▷

that expressed itself most violently at the Kofuku-ji. The deeply regrettable tragedy of tossing Buddhist images into bonfires became a daily routine. Nevertheless, valuable statues from the Tempyo, or late Nara, period (710–94), such as those of Sakyamuni's Ten Great Disciples and the Eight Guardian Gods, which have fortunately survived to the present day, bring us a clear intimation of the marvelous intensity of the artists' spirit and at the same time display their realistic technique, even though there are certain deformations in the final outcome of their efforts.

TEMPLES MOVED FROM ASUKA: GANGO-JI, DAIAN-JI, YAKUSHI-JI After the Kofuku-ji had been constructed in Nara, three of the highly respected Four Great Temples of the Asuka region were

moved to the capital. These were the Gango-ji, the Daian-ji, and the Yakushi-ji. The fourth of these temples, the Kawara-dera (later to be called the Gufuku-ji), was not moved, and we do not know the reason why. The earliest transfer of a temple to Nara recorded in the *Shoku Nihongi* (Chronicles of Japan Continued), compiled in 791, is that of the Gango-ji in 716. The center of the Gango-ji compound, however, has regrettably been so encroached upon by the modern city that there are no traces of what it looked like in the Nara age. Even its pagoda, which once stood in rivalry with that of the Kofuku-ji, was lost in a fire in 1855. Since this disaster took place not much more than a century ago, the foundation stones of the pagoda have survived fairly intact, and some altar fittings were discovered during recent excavations (Fig. 53). The present Gango-ji precinct includes only

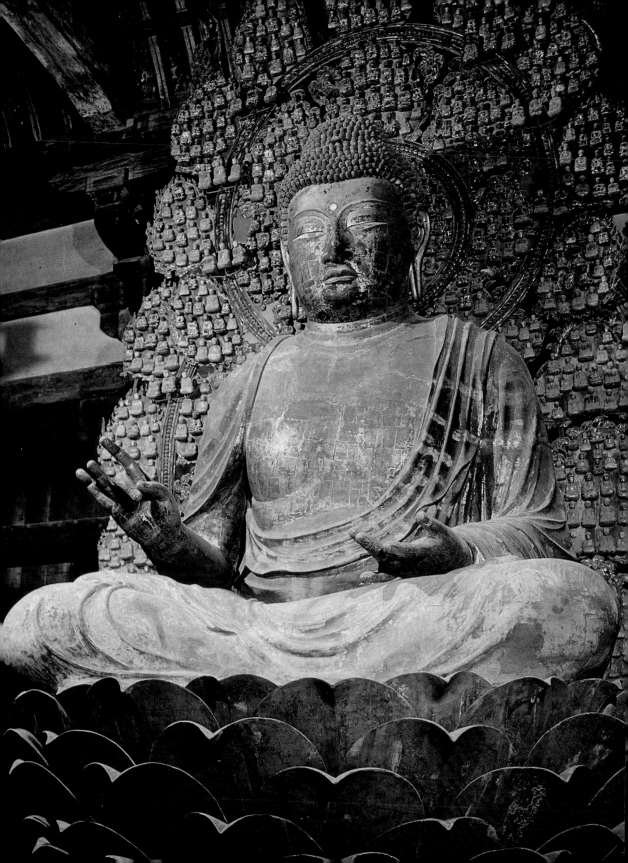

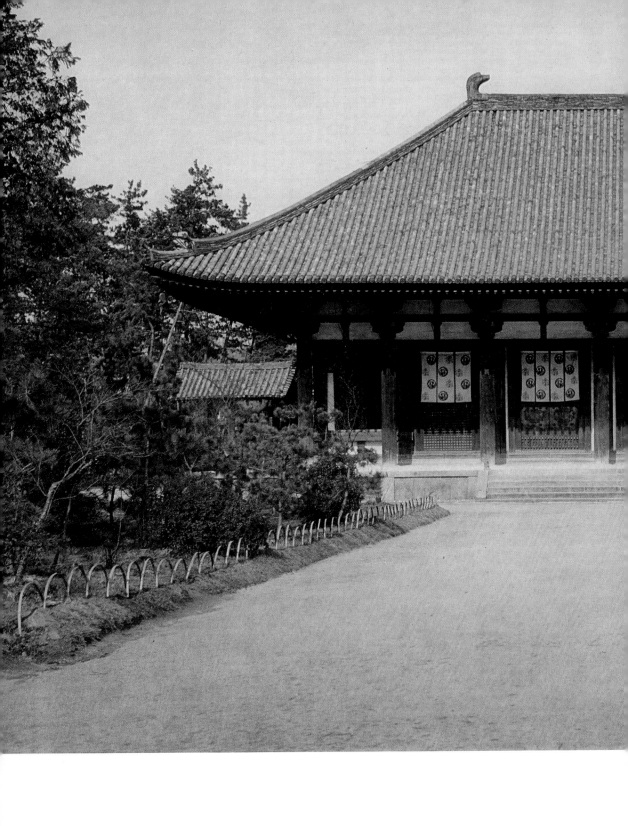

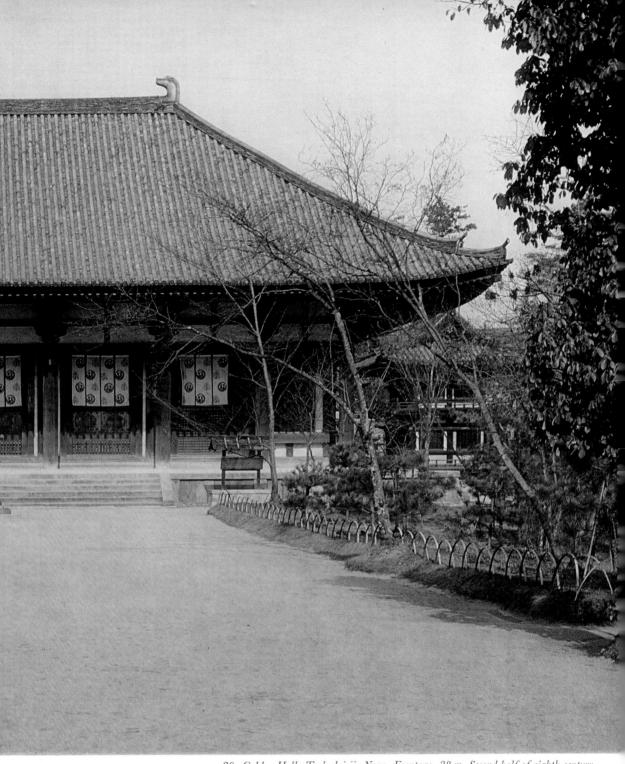

20. *Golden Hall, Toshodai-ji, Nara. Frontage, 28 m. Second half of eighth century.*

21. *Ashura (Asura), one of the Eight Supernatural Guardians of Sakyamuni, Kofuku-ji, Nara. Colors on dry lacquer; height of entire statue, 152.8 cm. About 734.*

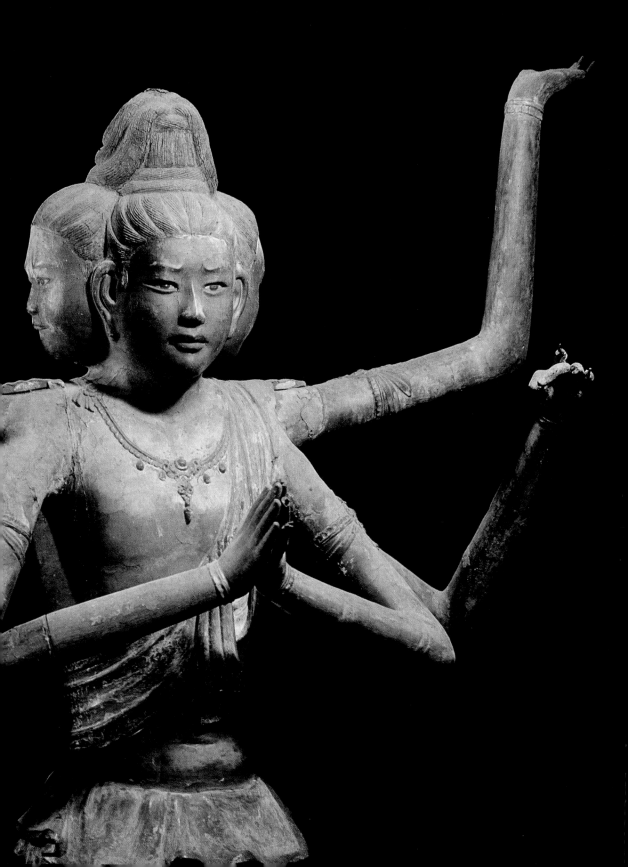

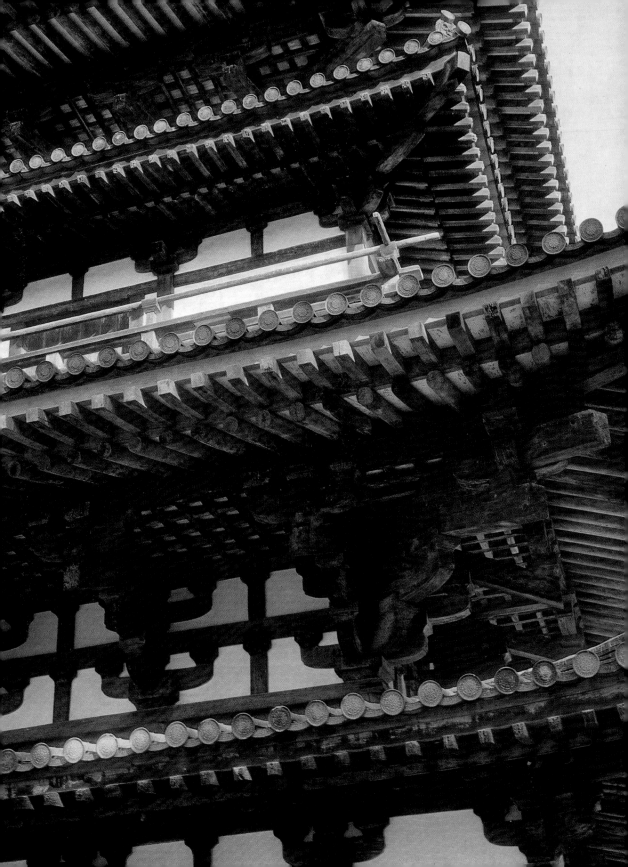

23. *Detail of ceiling, inner sanctuary, Lotus Hall, Todai-ji, Nara. First half of eighth century.*

◁ 22. *Detail of East Pagoda, Yakushi-ji, Nara. Dated 730.*

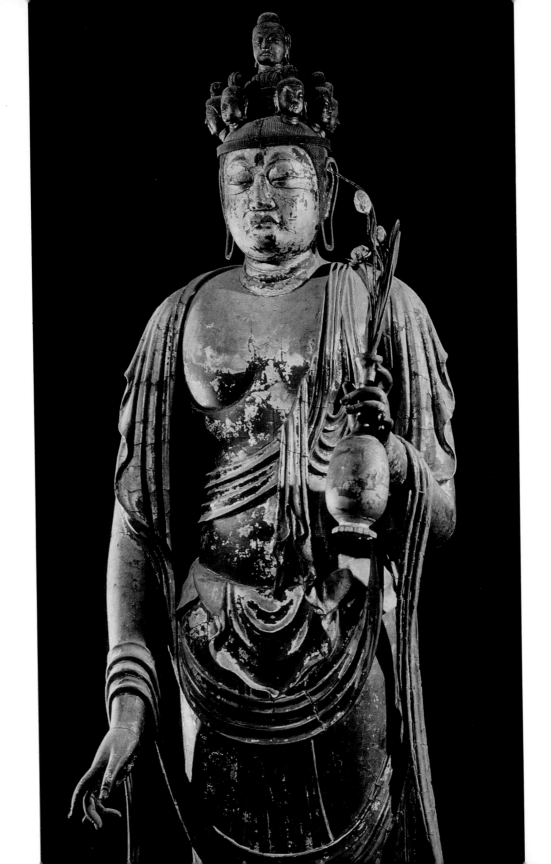

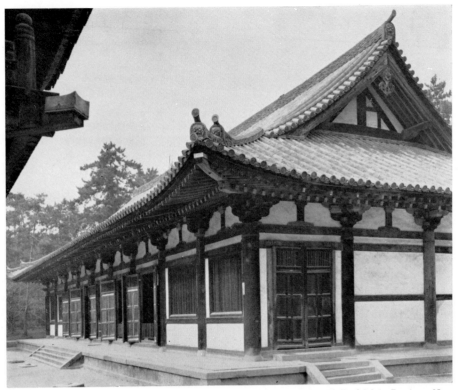

25. *Lecture Hall, Toshodai-ji, Nara. Originally East Public Assembly Hall of Main Precinct, Nara Imperial Palace—the only extant structure from the palace. Frontage, 33.8 m.; depth, 13.5 m. About 748; moved to present site to be remodeled about 760; further remodeling in 1275 and 1675.*

the narrow section in the vicinity of the pagoda ruins, but a recently conducted survey has confirmed that the present Gokuraku-bo (Paradise Hall), composed of a main hall and a meditation room, was situated north of the ruins of the pagoda.

The previously mentioned Kudara Dai-ji, built according to the wishes of Prince Shotoku, was first moved to Takaichi County in Nara Prefecture during the reign of Emperor Temmu and was there renamed the Takechi Dai-ji. Later the name was changed to Daikan Dai-ji and then to Daian-ji. The year of the temple's transfer to Nara is generally believed to have been 717. But, taking the transfer of the Gango-ji into consideration, I suspect that the legend that the monk Doji

(?–744) repaired the temple in 729 actually refers to its original construction. In any case, it is neither convenient nor necessary to go into a detailed explanation here.

Currently the Daian-ji is in a pitiful state. The earthen podiums of the East Pagoda and the West Pagoda now stand in the midst of vegetable fields, and the present precinct covers only the narrow section around the ruins of the South Main Gate and the Inner Gate. The ruins of the Golden Hall are on private property, and those of the Lecture Hall have become the site for a grade school. Excavations in recent years, however, have demonstrated the probability that other artifacts survive in reasonably well-preserved condition, and it is

◁ 24. *Eleven-headed Kannon (Ekadasamukha), Shorin-ji, Sakurai, Nara Prefecture. Gold on dry lacquer; height, 209 cm. Second half of eighth century.*

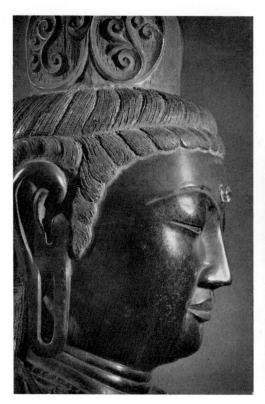

26. *Head of Sho Kannon (Aryavalokitesvara), East Precinct Hall, Yakushi-ji, Nara. Gilt bronze; height of entire statue, 188.5 cm. Late seventh to early eighth century.*

27. *Stone carved with footprints of the Buddha, Buddha's Footprint Hall, Yakushi-ji, Nara. Surface breadth, 112 cm. Dated 752.*

indeed regrettable that they lie neglected underground. The principal remains include nine wooden Buddhist statues known to represent a deviant style in Nara-period sculpture (Fig. 29), but we no longer have the excellent statue of the historical Buddha Sakyamuni (in Japanese, Shaka) —the statue that inspired Oe no Chikamichi (?- 1151), in his *Shichidaiji Junrei Shiki* (Personal Record of Pilgrimages to the Seven Great Temples) of 1140, to designate it as the most superior work of art to be found in the capital city of Nara. The demon-face ridge-end tile ornament unearthed within the present temple precinct (Fig. 28) appears to be in one of the standard styles of the Nara period and is among the finest of tile ornaments of its kind. Some time ago a green-glazed decorative tile for use at the end of a rafter was excavated on the temple site. Even such a small

discovery helps us to realize the beauty and grandeur of the magnificent temples sponsored and supported by the Nara imperial government.

The construction of the Yakushi-ji in the Fujiwara capital at the request of Emperor Temmu was not completed before the emperor's death. In fact, the actual construction took place during the reign of Empress Jito, and the installation ceremony for enshrining the chief Buddhist statue was held in 697. The whole temple compound was finished around 698, when, according to a record of the times, "a number of monks were ordered by imperial edict to live in the Yakushi-ji monastery, since construction of the temple was almost completed." But it was only ten years later that the capital was moved to Nara, and reluctance to leave the finely designed Yakushi-ji in the old capital inspired a plan to move it to the new one. Accord-

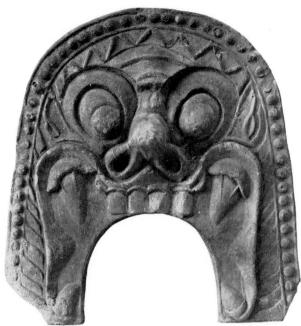

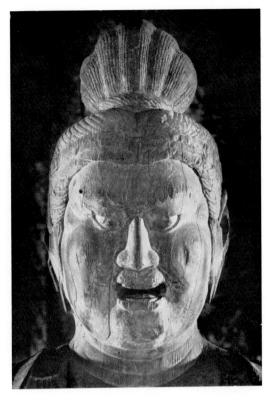

28. *Demon-face tile unearthed at Daian-ji, Nara. Height, 41 cm. First half of eighth century.*

29. *Head of Yoryu Kannon (a manifestation of Avalokitesvara), Daian-ji, Nara. Wood; height of entire statue, 171.5 cm. Second half of eighth century.*

ing to the *Yakushi-ji Engi* (History of the Yakushi-ji) and other sources, the temple was moved in 718, and the East Pagoda was built in 730. The temple precinct occupied a site in the western half of the capital. Extant within the temple compound today are the East Pagoda, the complete arrangement of foundation stones for the Golden Hall, and the central-pillar stone of the West Pagoda. Portions of the South Main Gate, the Inner Gate, the Lecture Hall, the corridor, and the Monks' Quarters have already been excavated, and it is now quite possible to get an accurate picture of the original layout.

Of the extant structures at the Yakushi-ji, the East Pagoda is the most important. Although it is a three-storied pagoda, it is the same size as an ordinary five-storied pagoda because of its unique design of furnishing a secondary roof under the regular roof of each of its three stories (Figs. 22, 39). This ingeniously conceived shape displays a sense of reassurance and harmony and at the same time expresses heavy accents in accord with its overall feeling of tranquility. It is decidedly a highly sophisticated and thoroughly refined design. Together with the Five-storied Pagoda of the Horyu-ji, which also imparts a feeling of composure and dignity, it certainly represents the epitome of pagoda architecture in Japan. The water-flame ornament near the top of the finial is also so elaborate and brilliant that one cannot find a parallel in other structures (Fig. 17). In the interior we can still observe a decorative design used extensively from the Nara period onward: that of the *hosoge,* an imaginary flower resembling the peony (Fig. 40).

That the two-storied Golden Hall of the Yakushi-

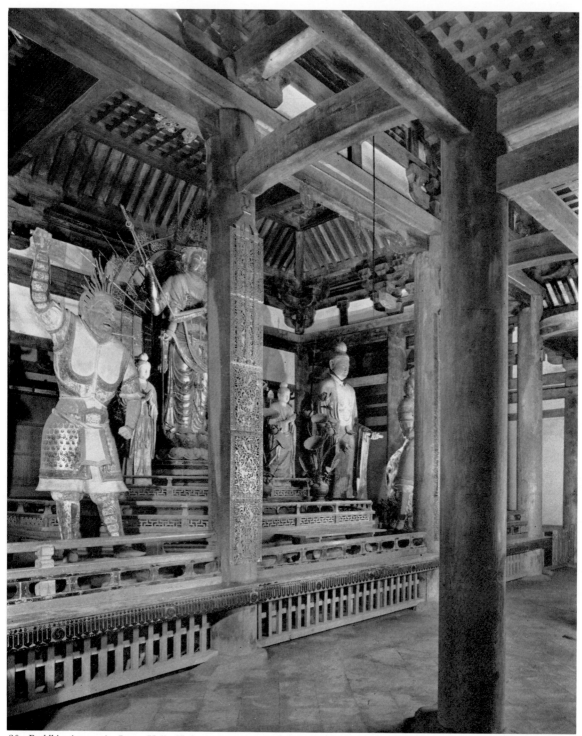

30. Buddhist images in Lotus Hall, Todai-ji, Nara, with Fukukenjaku Kannon (Amoghapasa) at center of group. Height of Fukukenjaku Kannon, 360.6 cm. About mid-eighth century.

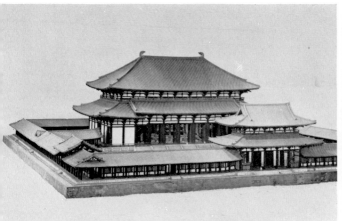

31. Restoration model of original Great Buddha Hall (Golden Hall), Todai-ji, Nara. Dimensions of actual hall (dated 751): frontage, 88 m.; height, 48.5 m.

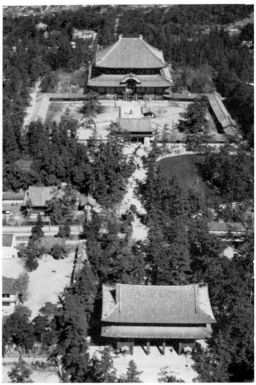

32. Aerial view of temple compound, Todai-ji, Nara, from south. Foreground: reconstruction of South Main Gate; background: second reconstruction of Great Buddha Hall (Golden Hall). Originally constructed in mid-eighth century.

ji was also furnished with secondary roofs is known from a description by Oe no Chikamichi in the above-noted account of his pilgrimages: "[The inner sanctuary of] the Golden Hall is five bays long and is surrounded by the outer sanctuary on its four sides, and the tiled roof of each story is accompanied by another roof—that is, the whole structure appears as if it were four-storied." The Lecture Hall was only of one story, but it too had a secondary roof. In effect, the design of the East Pagoda was reflected in all other structures in the temple compound, and the appearance of a whole temple complex designed in the same style throughout must have been of an elegance almost beyond conjecture when all of the buildings were still standing.

Now, which stylistic period does the Yakushi-ji temple-monastery represent? Previous theories on this question may be summarized into two posi-

tions: first, that it must represent the Hakuho era of the Nara period because the pagodas had been transferred from the Moto Yakushi-ji in the Fujiwara capital; second, that it must represent the Tempyo era because the Yakushi-ji pagodas were newly erected in the Nara capital. But investigations seem to call for a third possibility, which I believe was actually the case—namely, that the pagodas were newly constructed at the present site of the Yakushi-ji but followed the style of the original ones. There are three items of evidence that support this proposal. First, if we may judge from the above-mentioned *History of the Yakushi-ji*, it would appear that the pagodas of the Moto Yakushi-ji were never transferred from the Fujiwara capital. Second, whereas the compound layout of all the other great temples in Nara is in the new (that is, Tempyo) style, the Yakushi-ji alone preserves the old (Hakuho) style, the reason

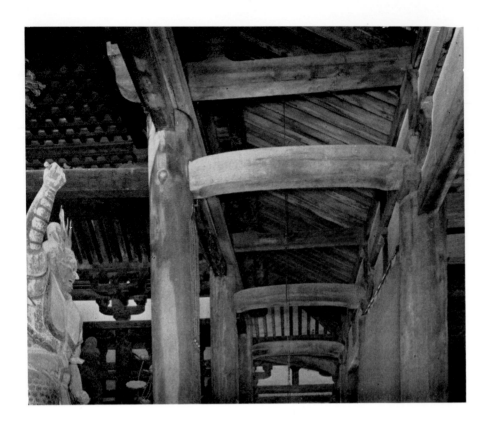

being that the superior style of the Moto Yakushi-ji was so highly regarded that it had to be inherited somewhere when the capital was moved. Third, and related to the second reason above, it is most logical to assume that the halls and pagodas of the Moto Yakushi-ji had secondary roofs just like those of the Yakushi-ji in the city of Nara.

The last point requires a bit of explanation. Since the foundation stones marking the extent of the secondary roofs of the Moto Yakushi-ji pagodas are not extant, it has been claimed that the pagodas were not in the style that employed secondary roofs. But the pillar spacing of the core structure of the pagodas—that is, disregarding the eaves extending beyond the edge of the core structure—supplies an indirect proof that they were. At both the Moto Yakushi-ji and the Nara Yaku-shi-ji each of the three bays (interpillar spans) of

the main structure of the pagoda measures 8 *shaku*, or about 2.4 meters, but in an artistically well-designed pagoda it was customary to make the central bay one *shaku* (29.59 centimeters) longer than the other two in order to give a sense of stability, as was the case in the pagodas of all the other temples of Nara. In a splendid work of art like the Moto Yakushi-ji, however, it is almost unimaginable that the plan should have permitted the erection of a pagoda employing the three-equal-bays method. Nevertheless, if we assume the installation of secondary roofs, the case is quite the contrary, for this would require an additional bay on either side of the three bays, and these lateral bays were designed to be narrower than the middle ones in order not to create a visual imbalance (Fig. 39). In short, without secondary roofs it was impossible to have three equal bays,

◁ *33. Detail of interior, Lotus Hall, Todai-ji, Nara, showing coved-and-latticed ceiling of inner sanctuary and open-timbered ceiling of outer sanctuary. About 747.*

34. Top: restorations of tricolored rafter-end tiles of East Pagoda and West Pagoda, Saidai-ji, Nara. Diameter of round tile, 13.6 cm. Bottom: map showing original positions of pagodas together with present temple compound (shadowed). Late eighth century.

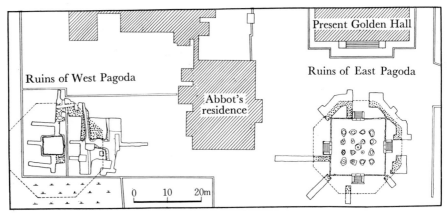

Ruins of West Pagoda

Abbot's residence

Present Golden Hall

Ruins of East Pagoda

0 10 20m

but with secondary roofs it was perfectly in accord with the overall structure. Therefore it is natural to assume that the temple-compound layout as well as the ground plans of the halls and pagodas of the Nara Yakushi-ji were in complete harmony with those of the Moto Yakushi-ji.

Another important feature of the Yakushi-ji besides its architecture is that it is a treasure house of Buddhist sculpture. To quote again from Oe no Chikamichi's record of his pilgrimages, "The Buddhist images and decorations of the Yakushi-ji are exceedingly superior to those of other temples, next only to the statue of Sakyamuni at the Daian-ji." This record, written in a period when the chief Buddhist statues of the contemporary temples were in existence, is an invaluable one through which we can discover the stature of Nara-period sculpture, for, as previously noted, many of the sculp-

tural works, including the Daian-ji Sakyamuni, have not survived to this day.

The Yakushi (Bhaisajyaguru) Triad (Yakushi Sanzon) in the Golden Hall, consisting of the seated Yakushi in the center attended by the solar Bodhisattva Nikko (Suryaprabha) and the lunar Bodhisattva Gakko (Candraprabha), is considered to be one of the crowning achievements of Nara-period sculpture (Fig. 37). It is equaled in excellence by the Sho Kannon (Alryavalokitesvara: a manifestation of Avalokitesvara) stored in the East Precinct Hall (Fig. 26). The chief Buddhist statue in the Lecture Hall is a work of the early Nara period.

In a small hall in the southeast corner of the temple compound are two stone monuments, one carved with footprints of the historical Buddha on its upper surface and with an inscription in literary

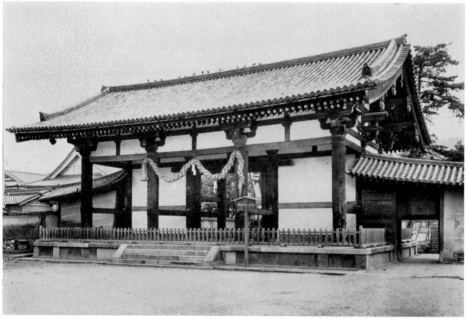

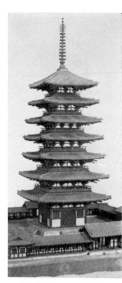

35. *Tegai Gate, Todai-ji, Nara. Front-age, 16.6 m. About mid-eighth century.*

36. *Restoration model of original Seven-storied Pagoda, Todai-ji, Nara. Height of actual pagoda (late eighth century), 96 m.*

37. *Yakushi Triad, with the Buddha Yakushi (Bhaisajyaguru) at center, the Bodhisattva Nikko* ▷ *(Suryaprabha) at right, and the Bodhisattva Gakko (Candraprabha) at left, Golden Hall, Yakushi-ji, Nara. Gilt bronze; height of Yakushi, 254.7 cm. Late seventh or early eighth century.*

Chinese on its four sides (Fig. 27) and the other inscribed with verses in Japanese (using Chinese characters phonetically to render Japanese syllables) praising the footprints. These monuments were made in 752 by Fumiya no Mahito Chinu in memory of his deceased wife, Mamuta, following the ancient Indian tradition of worshiping the Buddha's footprints carved in stone: a religious rite observed before the ancient Greek civilization influenced the Indians into worshiping anthropomorphic figures such as an image of Sakyamuni. The Chinese text on the one monument expounds the virtue of creating footprints of the Buddha in stone in commemoration of the actual footprints he left in distant India, while the Japanese verses on the other monument were sung during the religious practice of walking around it. These Chinese and Japanese texts are unique examples among extant Buddhist literary art, for the origin of both is clearly known. Whether the two monuments actually originated at their present location is somewhat questionable, but since there is no doubt as to their authenticity, they decidedly evoke the pleasurable feeling of appreciating the atmosphere of prosperous Nara during this period.

GRAND NATIONAL TEMPLES: TODAI-JI, SAIDAI-JI In order to strengthen the character of Buddhism as a state religion, Emperor Temmu, in 685, issued a decree advocating that each family in every province have a Buddhist altar to house Buddhist statues and sutra scrolls and that memorial services be held on various occasions. An even more thor-

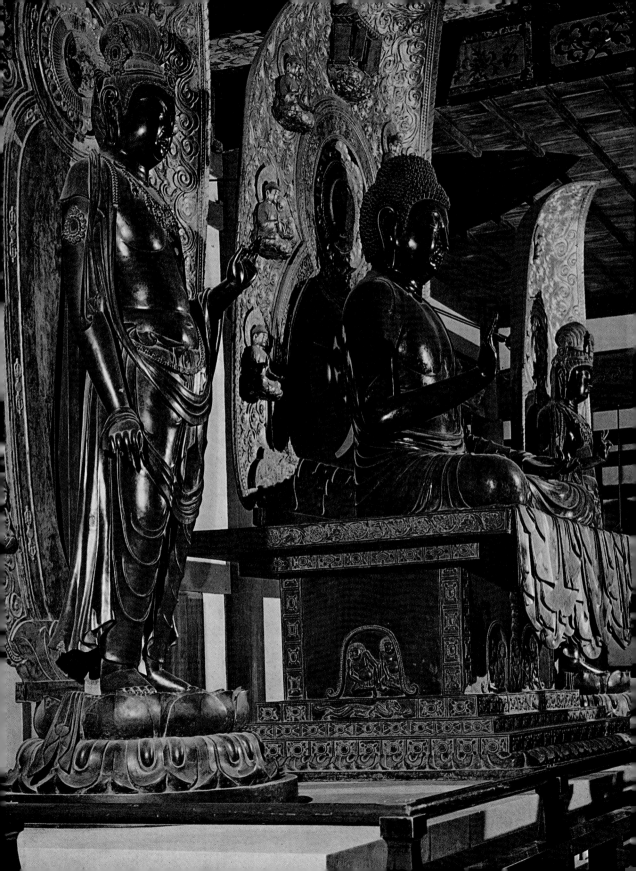

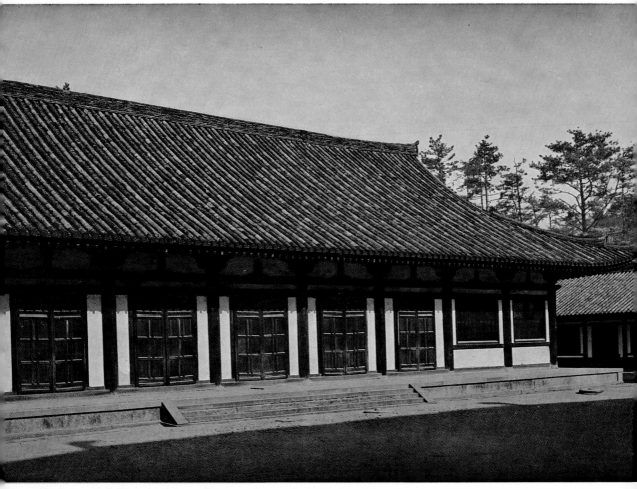

38. Lecture Hall, Toshodai-ji, Nara. Frontage, 33.8 m. About 747. Moved from Nara Imperial Palace to be remodeled about 760; further remodeling in 1275 and about 1675.

39. East Pagoda, Yakushi-ji, Nara. Height, 34.14 m.; ▷ dimensions of first story, 10.52 m. by 10.52 m. Dated 730.

40 (overleaf left). Detail of first-story ceiling, showing ▷ hosoge floral designs, East Pagoda, Yakushi-ji, Nara. Dated 730.

41 (overleaf right). Detail of ceiling, showing hosoge ▷ floral designs, Golden Hall, Toshodai-ji, Nara. Second half of eighth century.

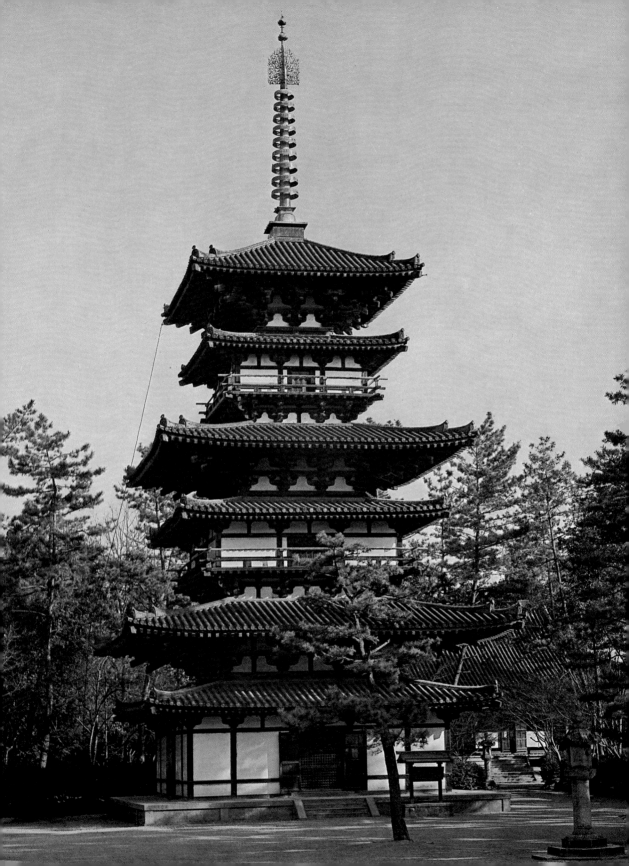

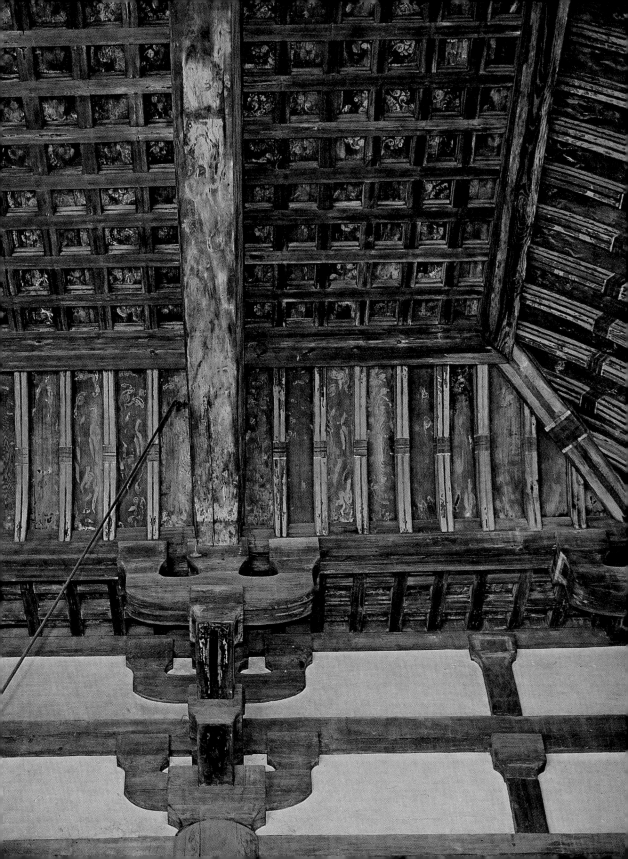

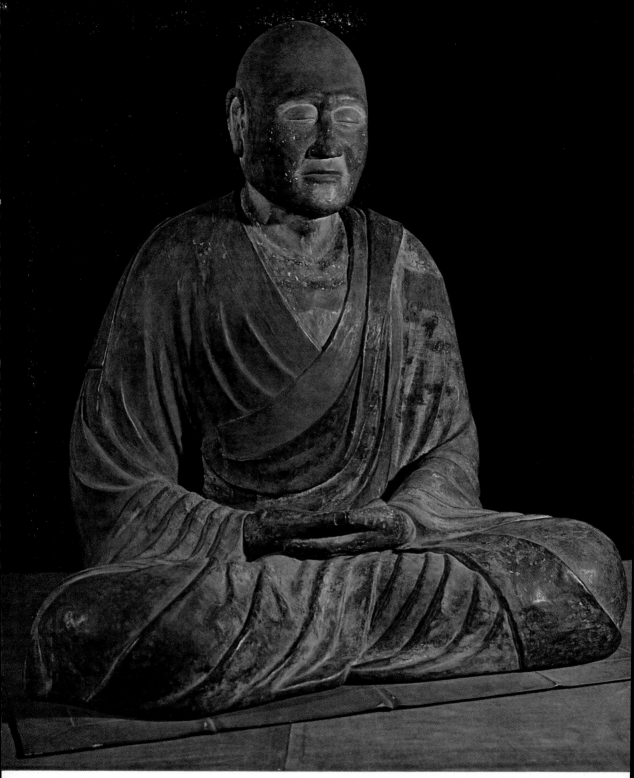

42. *Ganjin (Chien Chen), founder of the Ritsu sect, Portrait Hall, Toshodai-ji, Nara. Colors on dry lacquer; height, 80.5 cm. About 763.*

43. *Interior of Golden Hall, Toshodai-ji, Nara. Seated at* ▷ *center is the Buddha Birushana (Vairocana), with the Thousand-armed Kannon (Sahasrabhuja) on his right and the Buddha Yakushi (Bhaisajyaguru) on his left. Second half of eighth century.*

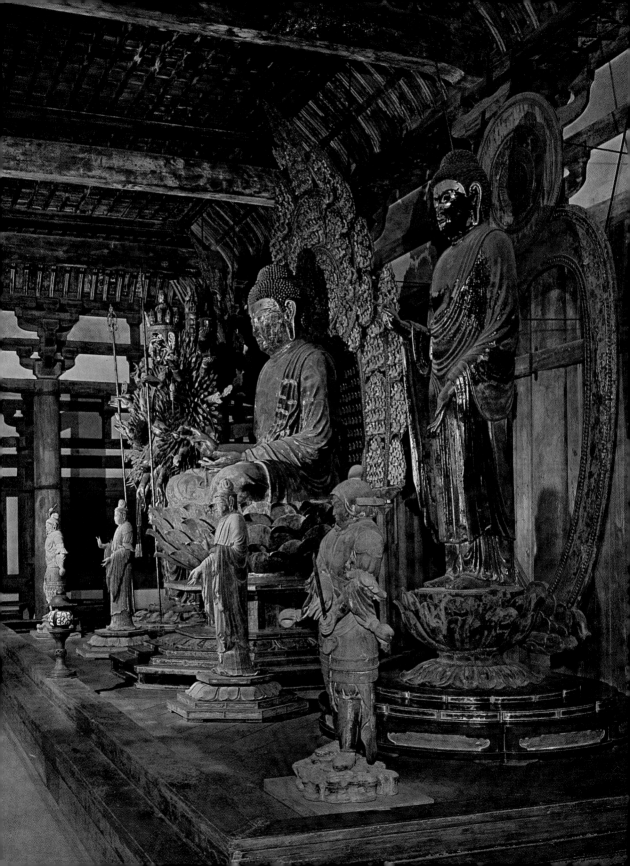

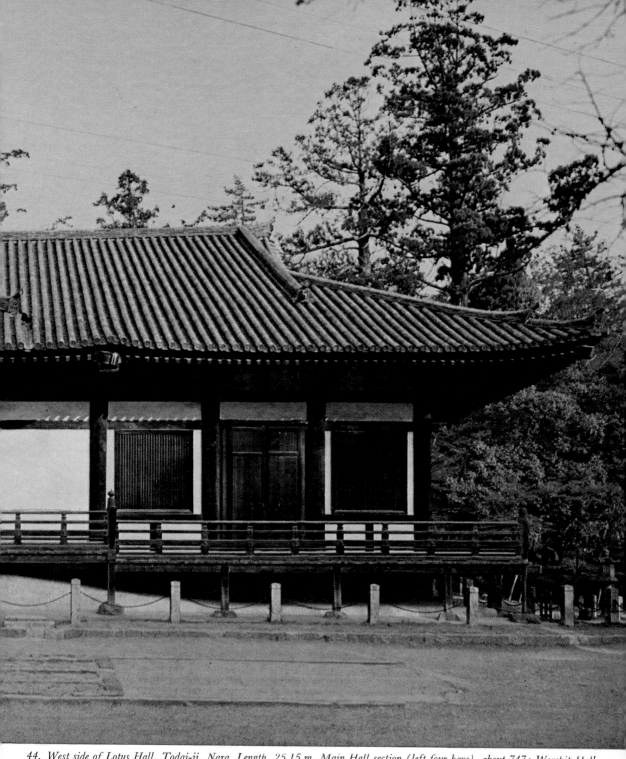

44. *West side of Lotus Hall, Todai-ji, Nara. Length, 25.15 m. Main Hall section (left four bays), about 747; Worship Hall section (remainder of building) greatly remodeled in 1199.*

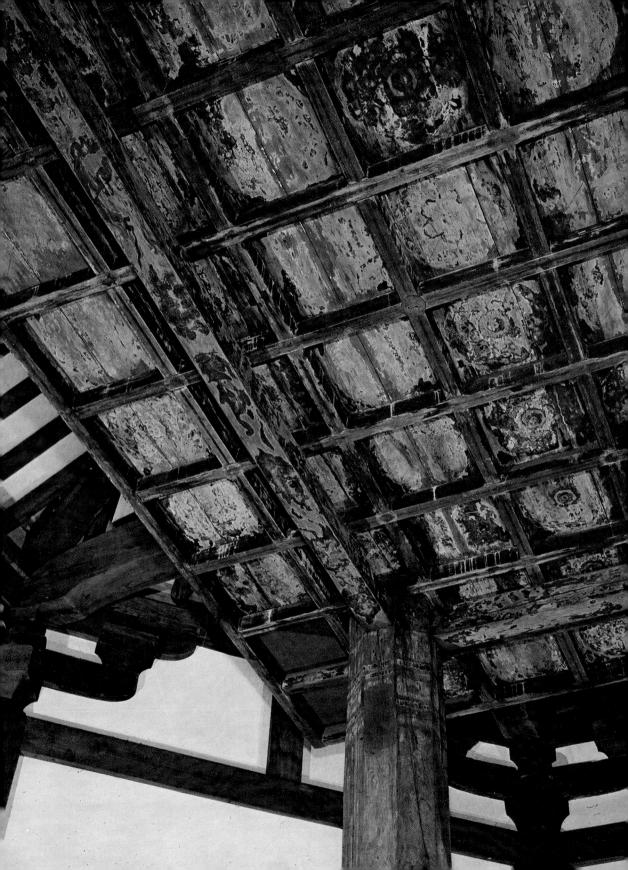

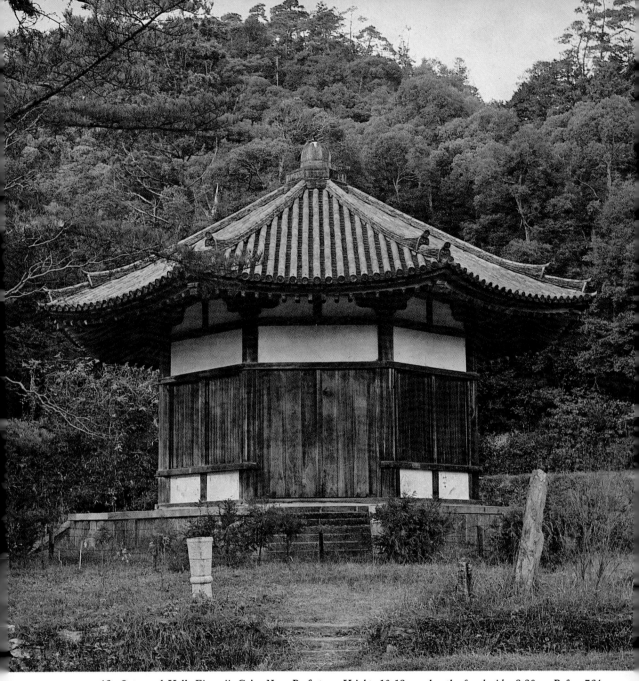

46. *Octagonal Hall, Eizan-ji, Gojo, Nara Prefecture. Height, 10.13 m.; length of each side, 3.28 m. Before 764.*

◁ 45. *Detail of interior, Octagonal Hall, Ei-
zan-ji, Gojo, Nara Prefecture. Before 764.*

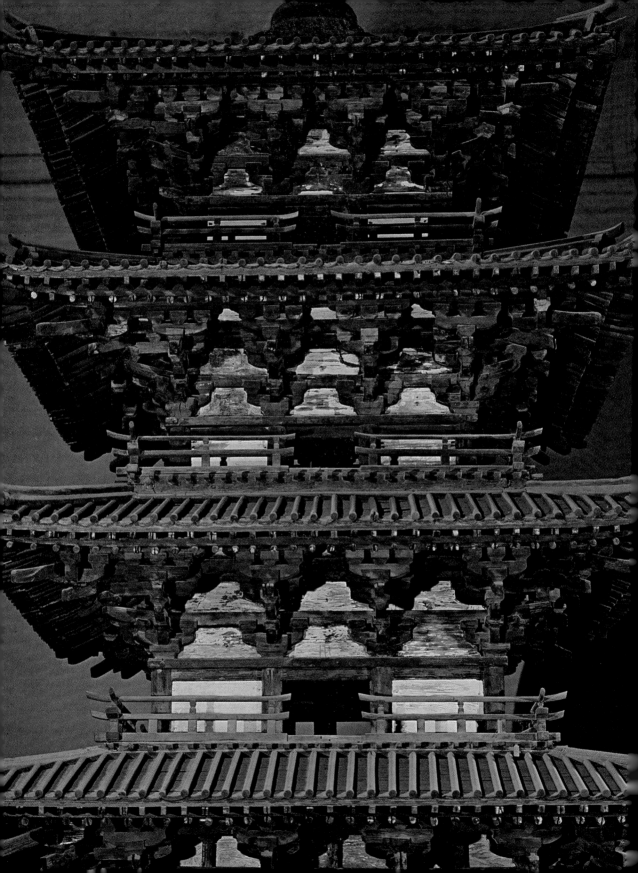

47. *Five-storied Model Pagoda, Go-kuraku-bo, Gango-ji, Nara. Height, 561 cm.; dimensions of first story, 116 cm. by 116 cm. Eighth century.*

48. *Five-storied Model Pagoda, Kai-ryuo-ji, Nara. Height, 401 cm.; dimensions of first story, 79 cm. by 79 cm. Late seventh or early eighth century.*

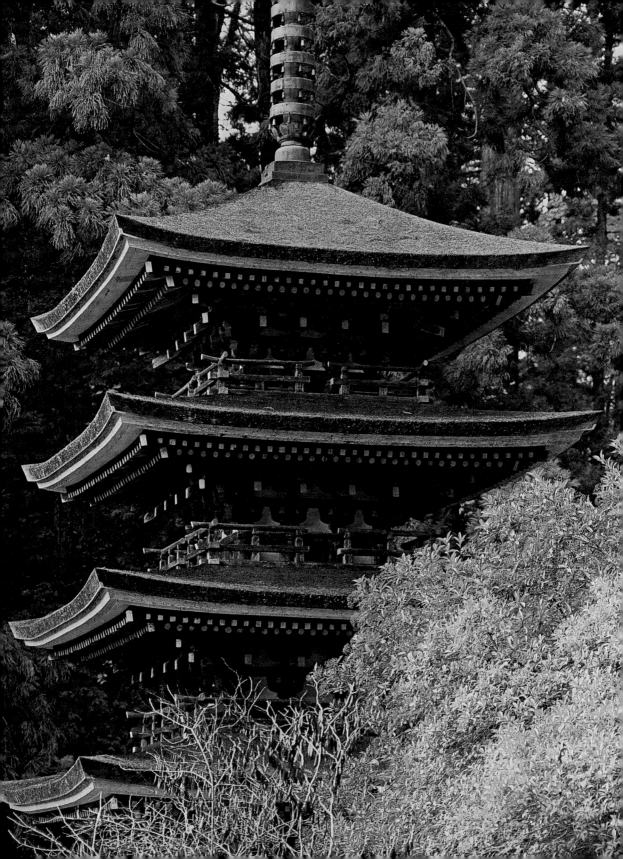

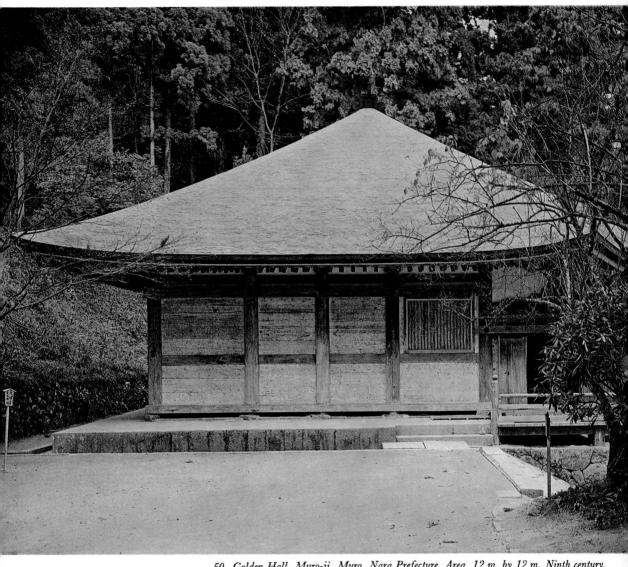

50. Golden Hall, Muro-ji, Muro, Nara Prefecture. Area, 12 m. by 12 m. Ninth century.

◁ *49. Five-storied Pagoda, Muro-ji, Muro, Nara Prefecture. Height, 16.2 m.; dimensions of first story, 2.45 m. by 2.45 m. Early ninth century.*

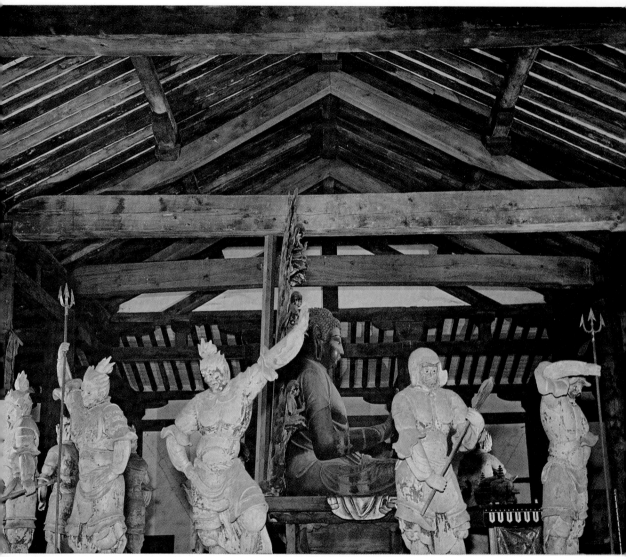

51. *Interior of Main Hall, Shin Yakushi-ji, Nara. Frontage, 22.7 m. Second half of eighth century.*

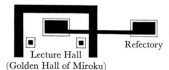
Lecture Hall
(Golden Hall of Miroku)

Refectory

52. Original temple-compound layout of Saidai-ji, Nara. Based on pagoda ruins and the Record of the Saidai-ji Temple Property. *Second half of eighth century.*

Golden Hall
(Golden Hall of Yakushi)

Inner Gate

West Pagoda East Pagoda

South Main Gate

53. Altar furnishings unearthed at ruins of Five-storied Pagoda, Gango-ji, Nara. Length of comma-shaped agate jewels, 3 to 4 cm. First half of eighth century.

ough attempt at religious institutionalization followed in 741, when Emperor Shomu (701–56) decreed that a national branch temple be built in each province, and in 743, when he decreed that a grand-scale temple be built as a headquarters to supervise all the provincial temples. The result of this latter imperial desire was the erection of the Todai-ji, or Great East Temple, the construction of which was begun at a site in the modern Koga County in Shiga Prefecture. In the following year, however, the location was changed to Nara. The Golden Hall, or Great Buddha Hall, as it is popularly known, was begun in 747 and almost completed by 751. The casting of the colossal bronze statue of Vairocana (in Japanese, Birushana), the Buddha of Universal Sunlight, was roughly finished in 749, except for the gilding, which was completed in 771, and a magnificent enshrinement ceremony took place in 752. This is the statue more commonly known as the Great Buddha of Nara.

Since it was built to house the gigantic image of Vairocana, over 16 meters in height, the Great Buddha Hall was an enormous structure with a frontage of 88 meters, a depth of 51.5 meters, and a height of 48.5 meters. Certainly there had been no time in history when the construction of buildings and the making of statues had attained such high excellence. But this achievement, even though it was the sign of a prosperous age, also marked the first step in the deterioration of Nara culture. The tremendous construction expenses of the Todai-ji became a major cause for the extreme exhaustion of the nation's economy, and the participation of priests and monks—most notably Gembo (?–746) —in governmental affairs accelerated the corruption of the clergy. Prince Shotoku's lofty ideal of adopting the spiritually surpassing aspect of Buddhism and placing it at the heart of the governmental code to guide society was now beset by great evils resulting from such excessively venturous

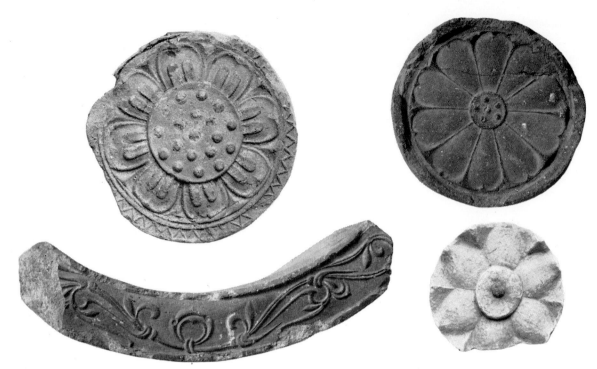

54. *Unearthed eaves tiles of Horyu-ji, Ikaruga, Nara Prefecture. Diameter of circular tile, 18.6 cm. Second half of seventh century.*

55. *Unearthed tiles of Hoko-ji (Asuka-dera), Asuka, Nara Prefecture. Top: eaves tile; diameter, 16.4 cm. Bottom: rafter-end tile; diameter, 11.4 cm. Late sixth century.*

enterprises as the building of the Todai-ji and the casting of the Great Buddha. The last days of Nara culture had already begun, even though, as we have seen in the example of the Kofuku-ji, the temples of this period were centers of learning and cultural growth. Their contribution to Japanese society was remarkable, for the prosperity of the powerful ones among them elevated the nation in one bound from the level of a culturally backward country to that of a highly developed one. In this sense it would be a mistake to underestimate the results of the prosperity of Buddhism in Nara-period Japan.

The Todai-ji, constructed at the high point of the flourishing Buddhist culture, was not immune to damage. As in the case of the Kofuku-ji, the greater part of the temple complex was destroyed

in the civil war between the Taira and the Minamoto toward the close of the twelfth century. A similar disaster occurred in 1567. The original structures that can be seen today include only the Tegai Gate, built at the east end of First South Avenue in the old city of Nara (Fig. 35); the Lotus Hall (also called the Third-Month Hall), thought to have been a hall belonging to the Kinsho-ji, the prototype of the Todai-ji (Fig. 44); four storehouses of the log-cabin type: the Sutra Repository of the Fund-raising Office, the Lotus Hall Sutra Repository, the Tamukeyama Shrine Treasury, and the Main Precinct Sutra Repository; and the Shoso-in repositories of the log-cabin type, which formerly belonged to the Todai-ji and are now imperial properties. The original Great Buddha Hall and the statue of Vairocana were destroyed during the

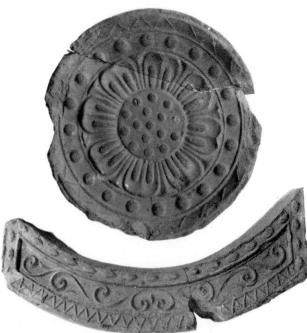

56. Cover tile for hip rafter, unearthed at Shindo deserted temple, Tondabayashi, Osaka. Length, 19.6 cm. Mid-seventh century.

57. Unearthed eaves tiles of Kofuku-ji, Nara. Diameter of circular tile, 20 cm. First half of eighth century.

two wars mentioned above, but the lotus-petal base of the statue, engraved around 757 with an iconographic rendering of the Lotus Treasure World, exists today, even though it is partly burned. (The present hall and the statue are of course restorations.) The bronze lantern standing in front of the Great Buddha Hall has been partially repaired, but it still displays the fine achievements of Nara-period metalwork in its finial and other details.

Fortunately, a large number of Nara-period sculptural works have survived the centuries in the Lotus Hall. Among the excellent examples of Tempyo sculpture to be seen there are the statues of the Fukukenjaku Kannon (Amoghapasa: one form of Avalokitesvara, the Bodhisattva of Salvation); the Bodhisattvas Nikko and Gakko; the Four Guardian Kings; Bon Ten (Brahma), the god who

created the universe and transcended all sexual desire; Taishaku Ten (Indra), the tutelary deity of the east quarter; Kissho Ten (Sridevi or Srimaha-devi), goddess of happiness and virtue; and the Kongo Rikishi (Vajrapani), a pair of guardian kings who carry the *vajra* (an ancient Indian weapon) as a symbol of their Herculean strength. (A group of these statues appears in Figure 30.) The superb painted-clay statue of the guardian deity Shukongojin, concealed within the altar at the back of the inner sanctuary and shown to the public only on rare occasions, still maintains the beauty of its colorful ornamentation after more than twelve hundred years.

In the Ordination Hall of the Kaidan-in Precinct, where initiation ceremonies are held, there are statues of the Four Guardian Kings, Sakyamuni,

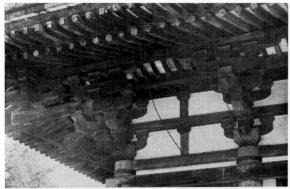

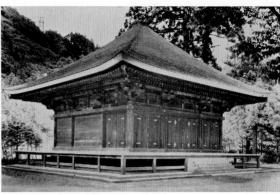

59 (above right). Shiramizu Amida Hall, Ganjo-ji, Fukushima Prefecture. Area, 9.39 m. by 9.39 m. Dated 1160.

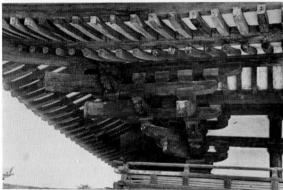

58. Comparison of eaves and bracketing. Top: Golden Hall, Toshodai-ji, Nara; second half of eighth century. Bottom: Phoenix Hall, Byodo-in, Uji, Kyoto Prefecture; dated 1053.

and Taho (Prabhutaratna), the Buddha who appeared before Sakyamuni and praised him for his expounding of the first ten chapters of a sutra. The image of Sakyamuni at birth stored in the Main Precinct Sutra Repository is also a splendid piece of sculpture. Of all the extant works mentioned here, the Nikko and Gakko of the Lotus Hall and the Four Guardian Kings of the Ordination Hall have always been included among the most distinguished works in the history of Japanese sculpture. There also survive at the Todai-ji a number of masks once used in the ancient but now vanished form of musical and theatrical entertainment called Gigaku. These reveal yet another aspect of Tempyo art.

The Shoso-in repositories also deserve special mention. Both the buildings and their contents—possessions of the Emperor Shomu and objects used

in the enshrinement ceremony for the Great Buddha—have been completely preserved. Though these extant relics are only a part of those dating from the time when the Todai-ji was established, they most decidedly convey a clear idea of how majestic a temple it was.

The most damaging instance of the involvement of the clergy in the national government was that of the priest Dokyo (?–772) during the closing years of the Nara period. Despite the financial exhaustion that followed the building of the Todai-ji, the energy to build temples and make statues reasserted itself in a plan to build the Saidai-ji, or Great West Temple. In all probability this plan originated with the second accession to the throne by Empress Shotoku (718–70) and resulted from her strong attachment to Dokyo. Even though the Saidai-ji was obviously built out of antagonism against the

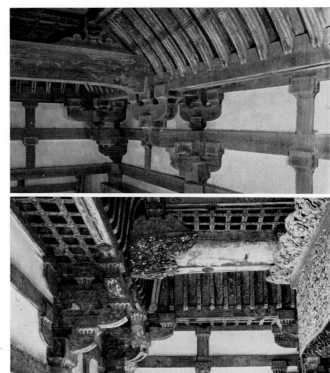

60. *Comparison of inner-sanctuary support structures.*
Top: Golden Hall, Toshodai-ji, Nara; second half
of eighth century. Bottom: Phoenix Hall, Byodo-in,
Uji, Kyoto Prefecture; dated 1053.

Todai-ji, it was nothing to compare with the Todai-ji when it was completed. In 764, when the empress ordered the construction of the Saidai-ji, gilt-bronze statues of the Four Guardian Kings, each two meters in height, were also requested. After having been cast in the following year, these statues had to undergo many mishaps by fire, and eventually all but the demon figures on which they stood were lost. In 767 a mural painting of the Pure Land (the paradise of Amida Buddha) with icons of the Bodhisattva Miroku (Maitreya) was produced for the temple.

It is extremely difficult to investigate the scale of the original Saidai-ji compound because the locations of most of the structures, including the Golden Hall, have been turned into residential lots. But a recent excavation authenticated the ruins of the West Pagoda in addition to the present remains of the East Pagoda. As a result of the excavation it was discovered that the twin pagodas stood approximately 100 meters apart from each other and that each of them had an octagonal base of approximately 27-meter diameter. This discovery proved the truth of the legend that the square five-storied pagodas had originally been planned as octagonal seven-storied pagodas (Fig. 34).

The measurements of the Golden Hall are not precisely known, but the descriptions in the *Saidai-ji Shizai Ruki-cho* (Record of the Saidai-ji Temple Property) of 780 offer some hints as to its size (Figs. 52, 71). The Hall of the Four Guardian Kings and the Hall of the Eleven-headed Kannon (Juichimen Kannon, or Ekadasamukha) were also important structures of the temple, but it is the Golden Hall that commands the most attention. According to the property record, its roof decorations included

61. *Three-block brackets and inverted-Y posts. Top: Yunkang cave temples (tenth cave), Tat'ung, Shansi Province, China; about 470 (Northern Wei dynasty). Bottom: Golden Hall, Horyu-ji, Ikaruga, Nara Prefecture; late seventh century.*

flame ornaments, two lions on top of cloud-shaped ornaments, and two Chinese phoenixes holding bronze bells in their bills. The main ridge had ornamental end tiles called "owl tails," while the ends of the subordinate ridges were decorated with flower-shaped ornaments. The roof was covered with copper, and the eaves were decorated with thirty-six flame ornaments. In short, the Golden Hall was an unusually extravagant structure. It is true, of course, that in China there were buildings with similarly extravagant roof decorations, sculptured podiums, and so on, but such intricate ornamentation, except in the case of color patterns, did not take hold in Japan in ancient and medieval times. It was only from the Momoyama period (1568–1603) that Japan came to make use of exuberant sculptural decorations. The fact that the extravagance displayed in the Saidai-ji Golden Hall was an exceptional case seems to be ascribable to the unique and innovative artistic sense of the ancient Japanese people. It has long been my

opinion that despite strong influences from China the Japanese were able to select only what they wished from the successive waves of Chinese culture that reached Japan, for Japanese art has been characterized by a sense of elegant simplicity and a distaste for intricacy. Cultural choices were not always made simply because of economic motivations.

Because the Saidai-ji suffered a rapid decline, there are only a few Nara-period remains there. Besides the previously mentioned four demons, which used to be trampled under the feet of the Four Guardian Kings, there are four Buddha images that were enshrined in the Five-storied Pagoda: Amitabha (in Japanese, Amida), the Buddha of Infinite Light; Sakyamuni (Shaka); Aksobhya (Ashuku), the Immovable Buddha; and Ratnasambhava (Hosho), the Buddha of Equality. Since this set of the Four Buddhas is the only one surviving from the Tempyo era, it is regarded as a work of considerable importance.

CHAPTER THREE

—•—

Temple Architecture of the Nara Period

TEMPLE GROUNDS As we have already noted, the city of Nara was divided by boulevards and alleys into square sectors and, within the sectors, into blocks. Since the temples were built within the capital, their boundaries were in principle marked off by such boulevards and alleys, and it is quite reasonable to assume that they were allocated different-sized areas of land according to their rank. To begin with the smallest, there were one-block temples—that is, temples whose sites measured approximately 120 meters on each side. Among these were the Ki-dera, the Saeki-in, the Katsuragi-dera, and the Hotsumi-dera. The Kairyuo-ji seems not to have fit the crisscross grid pattern, but it still measured about one block on each side. This was the standard area for the lowest-ranking temples (Fig. 65). The next usable unit of measurement was the four-block area—that is, two blocks to a side. The Toshodai-ji and the Sairyu-ji occupied areas of this size. In the case of the Kiko-ji, part of the temple occupies an extra block, but its basic site may be considered to be the four-block type.

The next group comprises the national temples, but they do not appear to have been of uniform size. The Yakushi-ji seems to fit the nine-block (that is, three blocks on a side) area, as does the Gango-ji if the Flower Garden is ignored. The obvious exceptions are the Kofuku-ji, the Daian-ji, and the Saidai-ji. It is not known why the Kofuku-ji was built on a four-by-four-block piece of land, but a likely reason seems to have been the ostentatious ideas of the powerful nobleman Fujiwara Fuhito. The Daian-ji had a three-block frontage and a five-block depth. Since this temple followed the tradition of building exceptionally large pagodas, these structures had to be located outside the South Main Gate. The temple area, other than that occupied by the pagodas, measures the proper nine blocks. The Saidai-ji was a purely special case because it was built at the end of the Nara period. To summarize, the smallest of the Nara temples were allotted one block; the next size, four blocks; and the national temples, nine or more blocks.

Among the national temples, the Yakushi-ji, the Gango-ji, and the Daian-ji had their lecture halls, golden halls, and south main gates aligned on the central north-south axis of the temple compound, which coincided with the alley one block east of the western end of the temple grounds. National temples with wider frontages, such as the Kofuku-ji and the Saidai-ji, placed their central axes one block and a half east of the western edge of the temple grounds. In both cases there remained a one-block-wide band of land in the eastern part of the temple grounds to be used for other facilities.

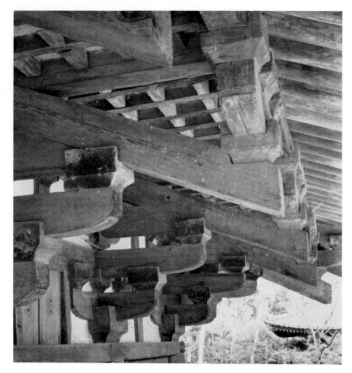

62. *Detail of East Pagoda, showing three-handed* (mitesaki) *bracket system, Yakushi-ji, Nara. Dated 730.*

Temples located in outlying towns also followed the same method of land allocation if the towns had crisscross streets and avenues.

TEMPLE-COMPOUND LAYOUT As noted in the first chapter, the Asuka-dera and the Shitenno-ji represented two of the temple-compound layouts of the Asuka period. The Horyu-ji layout has also been considered to be among the Asuka-period layout styles, but many theories attribute it to as late as the early Nara period because of similar examples dating from that period. It is my opinion, nevertheless, that the style of the Horyu-ji was established around the time of the construction of the Kudara Dai-ji. New evidence has recently been offered by the excavations at the site of the Kawara-dera, where a pagoda and a golden hall stood opposite each other on an east-west line running through the corridor. Opposite the inner

gate there was another golden hall connected by the northern wings of the corridor on both sides. A lecture hall was placed beyond this golden hall, outside the corridor. A similar style is found at the Tsukushi Kanzeon-ji, except that a lecture hall instead of a golden hall stands opposite the inner gate. Both of these two variants are thought to be in the style of around 670—that is, during the reign of Emperor Tenji.

As for the Daikan Dai-ji, there has been no investigation concerning the direction in which its golden hall faced, but both the pagoda and the golden hall were enclosed within the corridor, and the hall opposite the inner gate was a lecture hall. Some researchers in the Nara National Cultural Assets Research Institute seem to regard the layout style of the Kawara-dera as the result of the omission of one of the golden halls from the Asuka-dera style and that of the Horyu-ji as a development of the Tsukushi Kanzeon-ji style (with a change in

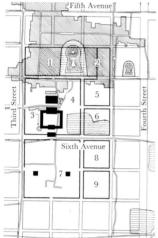

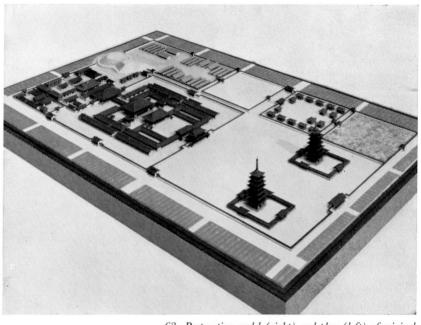

63. *Restoration model (right) and plan (left) of original Daian-ji, Nara. First half of eighth century.*

the exact site of the golden hall). I surmise that the Kawara-dera style and the Horyu-ji style could have coexisted because, as far as we know now, the Horyu-ji had its lecture hall beyond the surrounding corridor. At any rate, the complexity of the situation calls for more ruins to be excavated before a definite conclusion can be drawn.

Another style of temple-compound layout developed during the early Nara period: that of the Yakushi-ji. Enclosed by the surrounding corridor were a golden hall and, this time, two pagodas facing each other in front of it. Since these twin pagodas were basically a derivation from the pagoda of the Shitenno-ji style, there can be no objection to concluding that the Yakushi-ji layout developed from this style. And this same style can be seen in such temples as the Korean Sach'onwang-sa (in Japanese, Shitenno-ji) and Mangdok-sa (in Japanese, Botoku-ji), built under United Silla's rule (668–935).

To summarize the above discussion, two lineages have been found in the layout styles for the time span from the Asuka period through the early Nara period. One is the Koguryo lineage, under which, despite some minor problems, fall the Asuka-dera, the Kawara-dera, the Kanzeon-ji, and the Daikan Dai-ji, since the Asuka-dera style is found at Koguryo's deserted temple Ch'ongamri Taesa. The other is the Paekche-Silla lineage, which includes the Shitenno-ji style found at Paekche's deserted temple Kunsunri Taesa and at Silla's Hwangryong-sa and the Yakushi-ji style found at United Silla's Sach'onwang-sa and Mangdok-sa. It should be noted that although the pagoda, as a reliquary for Sakyamuni's ashes, had been considered an important object of worship, in the Yakushi-ji layout there was a heavier emphasis on its position with respect to the overall spectacle of the temple compound.

As more and more temples were constructed in

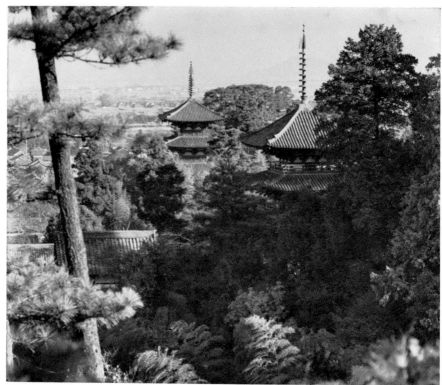

64. *West Pagoda (right) and East Pagoda (left) of Taima-dera, Taima, Nara Prefecture. Heights: East Pagoda, 23.2 m.; West Pagoda, 24.8 m. Eighth to ninth century.*

the capital city of Nara, the Yakushi-ji layout evolved into a new style in which the pagodas stood outside the corridor. Now it became the standard practice to start the corridor wings from both sides of the inner gate and to elongate them only to meet at the front edges of the golden hall, thus forming a square forecourt for the golden hall. At the Kofuku-ji and the Gango-ji, only the East Pagoda was erected, the reason being that the other pagoda, although plans for it existed, somehow never came to be built. This was in no way an alteration of the layout style, for the twin-pagoda style was the standard, as exemplified by the Todai-ji, the Daian-ji, the Saidai-ji, and the Taima-dera. At present, however, the Taima-dera is the only temple where both the East Pagoda and the West

Pagoda survive (Fig. 64). The East Golden Hall and the West Golden Hall of the Kofuku-ji probably descended from the triple-golden-hall style of the Asuka-dera.

One of the exceptions among the layouts of the temples of Nara was that of the Gango-ji. The pagodas stood outside the corridor, but the corridor itself, after starting from the inner gate, went around and enclosed the golden hall while meeting behind it with the lecture hall. The reason for this choice of plan has not been fully investigated. Perhaps it was an effort, with great respect for the long tradition of the Gango-ji, to preserve the older style of having the golden hall stand alone within the corridor.

Another exception was the Daian-ji, where the

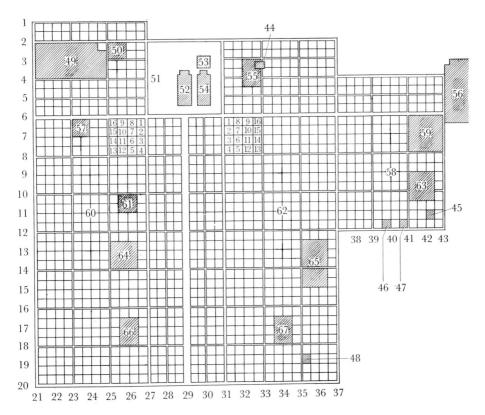

KEY TO THE PLAN

1. Northern limit. 2. First North Ave. 3. First Row. 4. First South Ave. 5. Second Row. 6. Second Ave. 7. Third Row. 8. Third Ave. 9. Fourth Row. 10. Fourth Ave. 11. Fifth Row. 12. Fifth Ave. 13. Sixth Row. 14. Sixth Ave. 15. Seventh Row. 16. Seventh Ave. 17. Eighth Row. 18. Eighth Ave. 19. Ninth Row. 20. Ninth Ave. 21. Fourth St. 22. Fourth Column. 23. Third St. 24. Third Column. 25. Second St. 26. Second Column. 27. First St. 28. First Column. 29. Red Sparrow St. 30. First Column. 31. First St. 32. Second Column. 33. Second St. 34. Third Column. 35. Third St. 36. Fourth Column. 37. Fourth St. 38. Fifth Column. 39. Fifth St. 40. Sixth Column. 41. Sixth St. 42. Seventh Column. 43. Seventh St. 44. Kairyuo-ji. 45. Ki-dera. 46. Katsuragi-dera. 47. Saeki-in. 48. Hozumi-dera. 49. Saidai-ji. 50. Sairyu-ji. 51. Imperial Palace compound. 52. First Public Assembly Hall area. 53. Inner Palace. 54. Second Public Assembly Hall area. 55. Hokke-ji. 56. Todai-ji. 57. Kiko-ji. 58. Outer Capital area. 59. Kofuku-ji. 60. Right Capital area. 61. Toshodai-ji. 62. Left Capital area. 63. Gango-ji. 64. Yakushi-ji. 65. Daian-ji. 66. West Market. 67. East Market.

65. Restoration map of the Heijo capital (Nara) as it existed in the eighth century.

First-class Temples Second-class Temples Third-class Temples

66. Schematic representation of temple land area allotted according to rank. The white squares correspond to those in Figure 65, while the square section within the shaded area indicates where the main temple compound was placed.

67. *Foundation for central pillar of pagoda, site of Hoko-ji (Asuka-dera), Asuka, Nara Prefecture. Late sixth century; excavated in 1957.*

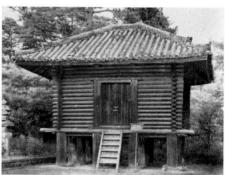

68. *Sutra Repository, Toshodai-ji, Nara. A single-unit storehouse. Eighth century.*

pagodas were constructed facing each other outside the south main gate, much farther south than at the Kofuku-ji. One point of view concerning this layout is to consider it as a development from the Kofuku-ji style, but if that is the case, why were the Todai-ji and the Saidai-ji, both built later than the Daian-ji, not laid out in this style? I should think it more reasonable to call it a case of special circumstances. As we have noted, temples of the Kudara Dai-ji lineage had large pagodas. The Kudara Dai-ji pagodas were nine-story structures, and after the temple was moved to a new site and given the name Daikan Dai-ji, they were extremely large, having a base dimension of about 54 *shaku* (roughly 16 meters) to a side. In Nara also, where the temple was later moved and re-christened the Daian-ji, the pagodas were large, for they had seven stories. In fact, none of the other temples in Nara had seven-storied pagodas except the Todai-ji. To build such enormous structures within the limited area north of the south main gate of the Daian-ji would have resulted in a great aesthetic imbalance, and for this reason additional temple land, with a three-block frontage and a two-block depth, was provided especially for the construction of the pagodas.

So much for the layout of principal halls and pagodas. Let us now turn to other buildings, for the temple-monastery of this period was not complete without the auxiliary structures that, together with the main ones, formed the complement of facilities. The auxiliary buildings were in principle separated from the basic site for the essential halls and pagodas and were built on an L-shaped site of one-block width forming a right angle on the north and the east of the basic site. There is but little

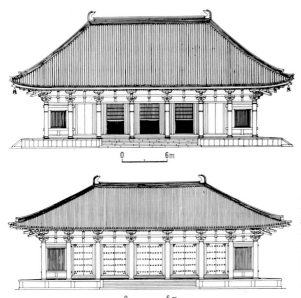

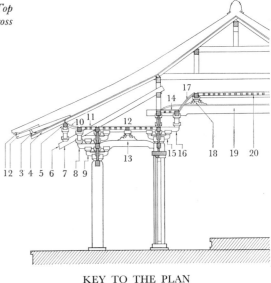

69. *Architectural drawings of Golden Hall, Toshodai-ji, Nara. Top left: present structure; bottom left, restoration of original; right, cross section of original.*

0 6m

0 6 m

KEY TO THE PLAN

1. Eaves support. 2. Flying rafter. 3. Flying-rafter support. 4. Base rafter. 5. Eaves purlin. 6. Tail rafter. 7. Third hand of bracket. 8. Second hand of bracket. 9. First hand of bracket. 10. Slanting strut. 11. Lesser ceiling. 12. Latticed ceiling. 13. Rainbow tie beam. 14. Lesser ceiling. 15. First hand of bracket. 16. Second hand of bracket. 17. Slanting strut. 18. Frog-crotch strut. 19. Greater rainbow beam. 20. Latticed ceiling.

information about the layout of these facilities in general, but the descriptions in the *Daian-ji Garan Engi Ruki Shizai-cho* (History of the Daian-ji and Record of Its Property) of 747 offer some idea of the layout style, which is reproduced in a more readily comprehensible form in Figure 63. The names given to these facilities, although they varied from temple to temple, help to give us a complete picture of the typical temple-monastery of the time: the refectory and general monks' quarters (a complex that included a dining hall, a kitchen, a pantry, storehouses, and other buildings for daily use); the treasury precinct for housing works of art and other valuable property); the servants' quarters; the park; the farm fields; and the temple offices, which served for the handling of business matters and were usually included in the general monks' quarters, as was also the bathhouse.

THE GOLDEN HALL To examine the aspects of the golden halls of Nara-period temples, it is best to begin with the Golden Hall of the Toshodai-ji (Fig. 20), for it is the only one that has survived the centuries since Nara times. This temple was built by the T'ang-dynasty Chinese missionary priest Chien Chen (688–763), who is known to the Japanese as Ganjin. Ganjin had come to Japan to teach the doctrines of the Ritsu (in Sanskrit, Vinaya) sect of Buddhism and had been granted land for a temple by the imperial court. Concerning this land, the *Toshodai-ji Engi* (History of the Toshodai-ji) states that it had been the site of the former residence of Prince Niitabe (?–735). Actually, however, it was the land confiscated by the court in punishment for the misconduct of Niitabe's son Prince Shioyaki. The temple was planned in 759, but the construction

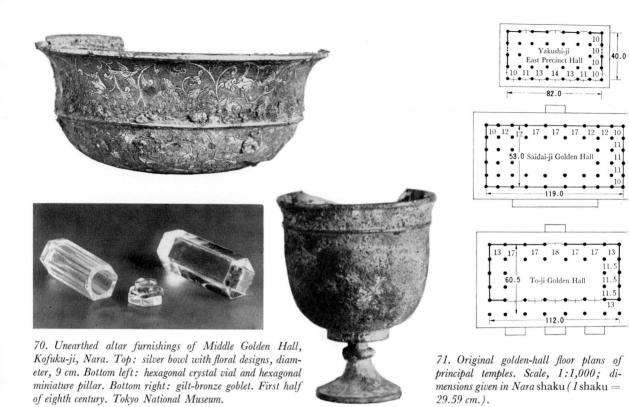

70. *Unearthed altar furnishings of Middle Golden Hall, Kofuku-ji, Nara. Top: silver bowl with floral designs, diameter, 9 cm. Bottom left: hexagonal crystal vial and hexagonal miniature pillar. Bottom right: gilt-bronze goblet. First half of eighth century. Tokyo National Museum.*

71. *Original golden-hall floor plans of principal temples. Scale, 1:1,000; dimensions given in Nara shaku (1 shaku = 29.59 cm.).*

of its halls and pagodas was delayed. In addition to the Golden Hall, the Lecture Hall and the two log-cabin-type treasuries are survivals from the Nara period. The East Wing (or Monks' Quarters), although it underwent large-scale repairs during the Kamakura period (1185–1336), still displays its original dimensions, since much of the old material remains. For these reasons the Toshodai-ji is considered the most important model for the study of Nara-period temple architecture. By examining its Golden Hall we may arrive at an understanding of the characteristics of the golden halls of other temples that have unfortunately been lost.

The Toshodai-ji Golden Hall is seven bays (interpillar spans) in length—that is, approximately 28 meters. As shown in Figure 71, the central bay measures 16 *shaku* (one Nara-period *shaku* equaled

about 29.59 centimeters); the bays on either side of it, 15 *shaku;* the next bays, 13 *shaku;* and the end bays, 11 *shaku.* In depth, the building runs to four bays or 48 *shaku* (approximately 14.2 meters), the two central bays measuring 13 *shaku* and the end bays 11 *shaku.* A distinctive feature of the building is its front side, where the door leaves and windows are set one bay back and the deep overhang of the eaves is supported on eight pillars to create a portico (Fig. 7). In the interior the stone dais for the Buddhist images occupies the three central bays (Fig. 43). The main object of worship is the Buddha Birushana (Vairocana), whose statue stands at the center of the group of deities. To his right is the Bodhisattva known as the Senju (Thousand-armed) Kannon (Sahasrabhuja); to his left, the Buddha Yakushi. In front of him stand smaller statues of Bon Ten and Taishaku Ten, and statues of the

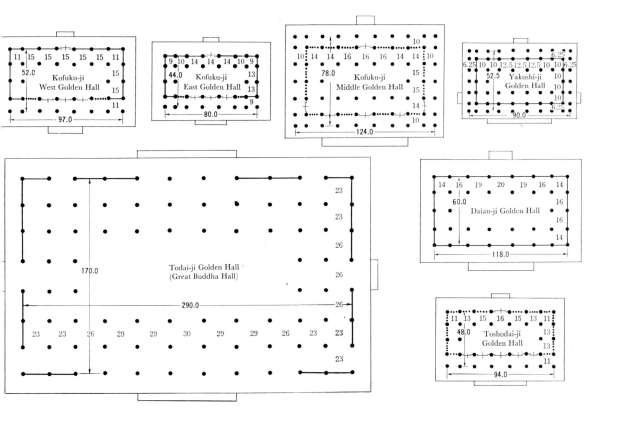

Four Guardian Kings are placed at the four corners of the dais. These are all highly perfected examples of late-eighth-century sculpture. It is truly fortunate that the Golden Hall can be seen today in almost the same form that it had at the time of its original construction in the Nara period, even though it has been repaired on several occasions, the only major change having been the steepening of the roof slope at the end of the seventeenth century (Fig. 69).

The bracket system (the interlocking woodwork complex resting on top of the pillars to support the eaves) used in the Toshodai-ji Golden Hall is of the three-handed (*mitesaki*) type, which is composed of three tiers of bracket arms, the higher ones being longer and therefore projecting farther outward than the lower, each with two or three bearing blocks on it. The use of slanting struts between one of the purlins and a lower beam (Figs. 58, 74) indicates a more mature architectural technique— a step ahead of the technique used in the Yakushi-ji East Pagoda (Figs. 16, 62). This new technique of combining three-handed bracketing and slanting struts was thereafter long employed in many important examples of Nara architecture and heralded the establishment of the Wa-yo (Japanese style), as it was called in later periods.

The Golden Hall has a hip roof whose main ridge is ornamented at the ends with the tiles known as "owl tails" (Fig. 20). Such decorative end tiles had been in use for important buildings since the Asuka period, as records and artifacts make clear, but this hall is the only instance in which an original owl tail (the one at the western end of the ridge) remains intact in the structure. The one at the eastern end of the ridge, however, is a

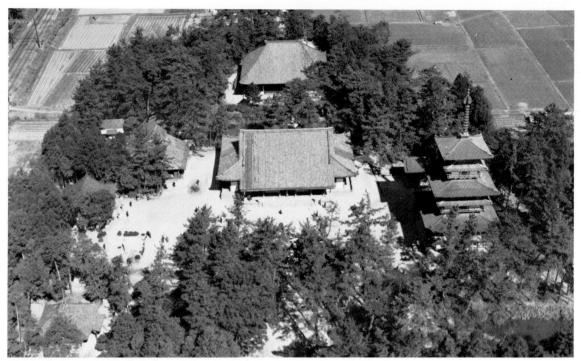

72. *Aerial view of Yakushi-ji temple compound, Nara. Left to right: ruins of West Pagoda; Golden Hall and, behind it, Lecture Hall; East Pagoda. Moved to present site in early eighth century.*

replacement dating from the Kamakura period.

The central raised part of the interior is called the inner sanctuary. Its ceiling is of the type known as a coved ceiling, in which the slanting struts near the wall form a cove. The main area of the ceiling is composed of crisscross lengths of wood, 6 to 10 centimeters square in section, joined together to form a kind of checkerboard pattern. This type of ceiling is known as a latticed ceiling. (If the rectangles of the checkerboard pattern are of larger size than they are here, the ceiling is called a coffered ceiling.)

The periphery of the ceiling is supported by "frog-crotch board struts"—that is, ornamental struts cut from a board and shaped like the crotch of a frog. These, in turn, rest upon "greater rainbow beams." (A tie beam that swells upward at the center is called a rainbow beam, and such a beam, if laid in a long span between pillars, is then called a greater rainbow beam.) These beams are supported by the bracket complexes, which sit on top of the pillars of the inner sanctuary (Figs. 69, 73). The low one-bay-wide area around the inner sanctuary is the outer sanctuary. This narrow space is spanned above by rainbow beams and, over them, a latticed ceiling. Since no slanting struts are used here, it is not a coved ceiling (Fig. 7).

The importance of the composition of the interior lies in the use of the coved-and-latticed ceiling. Its gradual decrease in height from center to periphery creates the superb effect of making it resemble a dome. This effect is further enhanced by the ingeniously curved rainbow beams and the bracket details, and the whole achieves a sense of

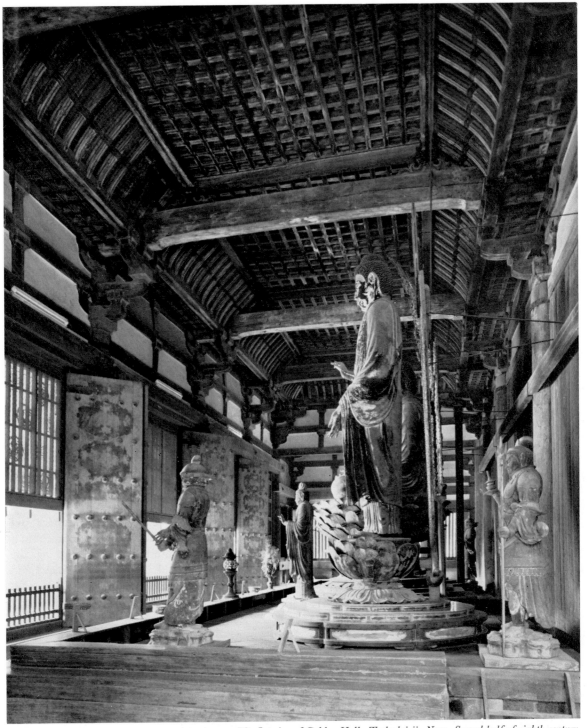

73. Interior of Golden Hall, Toshodai-ji, Nara. Second half of eighth century.

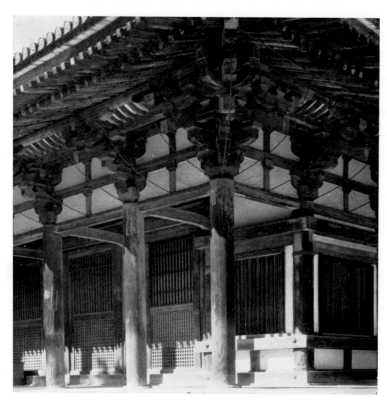

harmony through the successful use of space (Fig. 73).

It is usual for a temple structure to have extremely broad eaves in order that the entire roof may impart a kind of solemnity. Accordingly, the Toshodai-ji Golden Hall has a magnificent roof duly proportioned to the main body of the building so as to create a feeling of stability. The tremendous weight of the roof exerts the greatest pressure at the corners, and for this reason narrower bays are constructed in these areas to gain greater strength of support. The bracket complexes must also strongly support the eaves, but with a feeling of relaxation and composure. Truly, the accomplishment of these difficult tasks in the Golden Hall impresses us with the dignity of the artistic achievements of this period. Before the end of the seventeenth century, when the slope of the roof was less

steep, the lighter roof must have been in better balance with the rest of the building and must, at the same time, have conveyed an even deeper sense of stability.

In the façade of the building the doors and windows, as we have noted, are set back behind a single row of free-standing pillars, leaving the portico exposed to wind and rain. The pillars stand clearly outlined against the shady background, creating the feeling of depth on which the beauty of the building depends. The entablature above the pillars is of the post-and-lintel construction, composed of a horizontal fillet (or taenia) running through the bracket complexes and of vertical props (called block-on-strut posts) placed between the brackets to support it. These props, together with the fillet, form crosses dividing each section of the entablature into four parts. The horizontal

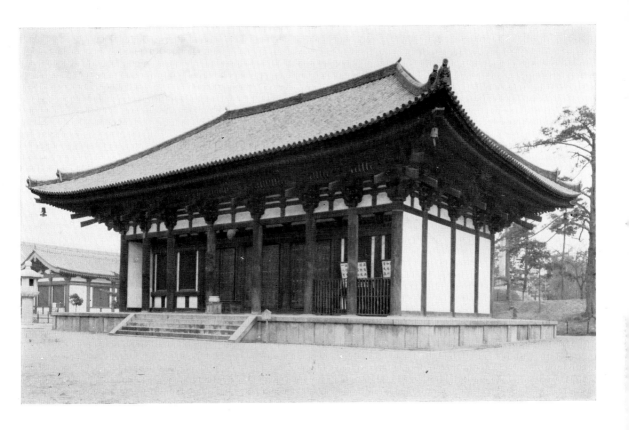

line of cross-shaped units, forming a wide belt, reinforces the harmony of the entablature with the pillars and thereby enriches the overall composition of the building (Figs. 20, 74).

The remains of fine patterns of the imaginary flowers called *hosoge* are found here and there in the interior (Fig. 41). As a result of recent repair work, it was discovered that the exterior of the Golden Hall was also originally painted. In fact, it appears that the entire building was adorned with patterns in the most brilliant of colors.

The scale and the style of the Toshodai-ji Golden Hall, the only extant golden hall of the Nara period, will be clear from the above description. But the question remains as to whether this building was of a universal type or whether it was a special case. Restorations of the golden halls of other temples seem to lead to the conclusion that a

one-story golden hall with a seven-bay frontage and a four-bay depth (hereinafter designated as a seven-by-four-bay hall), like that of the Toshodai-ji, was the standard style for second-class golden halls. Let us therefore make a detailed examination of first-class, second-class, and third-class golden halls in this order.

Since none of the original Nara-period golden halls except that of Toshodai-ji survive, we can make an investigation of first-class golden halls only through restorations. Relying on various sources, let us consider the golden halls of the Kofuku-ji, the Gango-ji, the Daian-ji, the Yakushi-ji, the Todai-ji, and the Saidai-ji.

The present Middle Golden Hall of the Kofuku-ji was built as a temporary hall after the fire of 1717 and offers no clues concerning its predecessor, but fortunately the foundation stones of the original

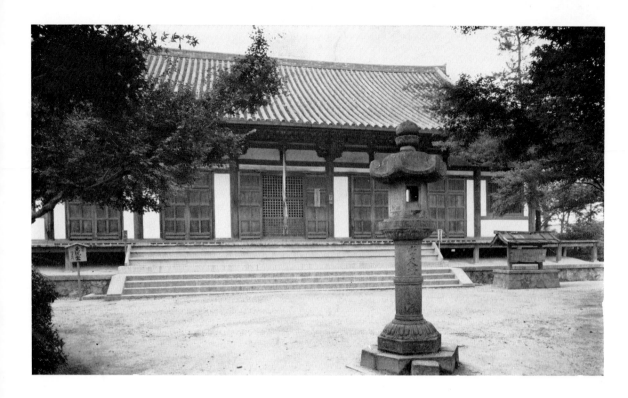

hall remain in good shape. The span of the pillar spacings was evidently determined on the basis of the Nara-period *shaku,* which equaled approximately 29.59 centimeters (the Asuka-period *shaku* equaled about 35.6 centimeters), and the plan of the foundation, as we see it today, coincides fairly well with the dimensions quoted in the *Kofuku-ji Ruki,* a collection of records dealing with the Kofuku-ji. Although there are slight discrepancies, there is no problem involved in regarding these recorded dimensions as representing the size of the original structure (Fig. 71). There is also a drawing of the early-fifteenth-century reconstruction of the Middle Golden Hall (Fig. 13), and since the successive reconstructions of the Kofuku-ji temple compound were always done in a strictly restorative manner, this drawing is a valuable source for establishing the front view of the original, which is shown restored in Figure 11. As shown in the old drawing and the restorative drawing of the original, the building was basically a seven-by-four-bay hall with a secondary roof of one-bay width attached to the core structure. This is verified by Oe no Chikamichi's record of his pilgrimages, in which he remarks: "[The inner sanctuary of] the Golden Hall, facing south, is five bays long and is surrounded by the outer sanctuary on its four sides. The roof is tiled and is of the double type. The hall has three front doors, each of one-bay width, and a surrounding balcony."

Oe no Chikamichi measured the size of the inner sanctuary only and regarded the outer sanctuary more or less as a penthouse, as did all his Heian-period contemporaries, but this does not alter the fact that the building was a seven-by-four-bay hall. Moreover, the record is evidence that the Golden Hall was furnished with a secondary roof. Since this roof was merely a circumferential variant of a pentroof, the building consisted of only one story, even though in external appearance it resembled

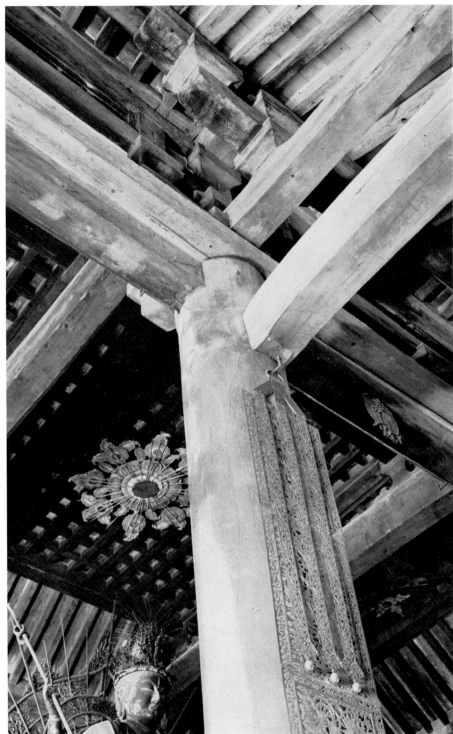

76. *East Precinct Hall Yakushi-ji, Nara. Frontage, 24.25 m. Reconstructed in 1285.*

77. *Detail of interior, Lotus Hall, Todai-ji, Nara. About 747.*

78. *Ceiling of inner sanctuary, Lotus Hall, Todai-ji, Nara. About 747.*

a two-story hall. Such a hall must be structurally distinguished from a two-story building with two regular roofs and two floors. This Golden Hall, then, consisted of a seven-by-four-bay core structure (just like a second-class golden hall) whose ground plan was enlarged (78 by 124 *shaku*) by the addition of a secondary roof and whose prospect was made more majestic through the double-roof technique of the exterior. Like his other descriptions, Chikamichi's statement that the hall had "three front doors, each of one-bay width," is in agreement with the information offered by the old drawing and the extant foundation stones, and the old drawing is thus proved to be an invaluable authentic source. Except for the decorations mentioned in the Kofuku-ji records, there are no sources available for discovering the structural

details of the hall, but a reasonable guess is that the bracketing was of the three-handed type. The roof, as is shown in the drawing, was hipped.

The exact measurements of the Gango-ji Golden Hall cannot be determined because the late-Nara *Gango-ji Ruki Shizai-cho* (Record of the Gango-ji Temple Property) has been lost, and it is nearly impossible to conduct a survey because private residences have been built where the Golden Hall once stood. Nevertheless, three sources are available for discovering the rough scale of the hall at the time of its construction. The *Ken Sonjiki-cho* (Record of the Inspection of Damage), a document belonging to the Todai-ji and written in 1035, offers some evidence that the building had a hipped-and-gabled roof. The second source is Oe no Chikamichi's record, which notes, as in the case of the

Class	Hall	Double-roofed or single-roofed	Number of bays ridge-wise	Number of bays beam-wise	Dimensions in Nara *shaku*	Proportion of length to width
Extra First	Todai-ji Golden Hall including pentroof: main structure only:	double	11 9	7 5	290 × 170 244 × 124	1.71 1.97
First	Kofuku-ji Middle Golden Hall including pentroofs: main structure only:	double	9 7	6 4	124 × 78 104 × 58	1.59 1.79
	Gango-ji Golden Hall including pentroofs: main structure only:	double	9 7	6 4	? ?	? ?
	Yakushi-ji Golden Hall including pentroofs: main structure only:	double	9 7	6 4	90.5 × 53 77.5 × 40	1.17 1.59
	Daian-ji Golden Hall	single	7?	4?	118 × 60	1.97
	Saidai-ji Yakushi Golden Hall	single	9?	5?	119 × 53	2.25
Second	Kofuku-ji East Golden Hall	single	7	4	80 × 44	1.82
	Kofuku-ji West Golden Hall	single	7	4	97 × 52	1.87
	Toshodai-ji Golden Hall	single	7	4	94 × 48	1.96
Third	Todai-ji Lotus Hall	single	5	4	62 × 44	1.41

79. *Data for golden halls of principal temples. Dimensions are given in Nara* shaku *(1* shaku = *29.59 cm.).*

Kofuku-ji Middle Golden Hall, that "[the inner sanctuary of the Gango-ji] Golden Hall, facing south, is five bays long and is surrounded by the outer sanctuary on its four sides" and that "it has a double roof and a surrounding balcony." Since the method of description employed here is the same as that for the Kofuku-ji Middle Golden Hall, it follows that the Gango-ji Golden Hall was a seven-by-four-bay hall with a hipped-and-gabled roof and a secondary roof. The third source is Chikamichi's *Shichidaiji Nikki* (Diary Concerning the Seven Great Temples), which he wrote in 1106. Here he tells us that "the construction of the Golden Hall is excellent. The bracket arms and bearing blocks are all decoratively carved. Although the origin of such ornamentation is not known, it is exceedingly beautiful." A similar

comment is found in his record of pilgrimages, but no details are given, although it suggests that the building was somewhat different from other golden halls of the Nara period.

Next to be considered is the Daian-ji Golden Hall. From what little information is available, we can surmise that it was an exceptional case. The site of the Golden Hall is now occupied by private residences, but a possibility for further research was indicated by the recent discovery of some stones believed to have been used in the podium, although no large-scale excavations have been carried out so far. According to the late-Nara-period *Daian-ji Ruki Shizai-cho* (Record of the Daian-ji Temple Property) of 747, the Golden Hall was 118 *shaku* (approximately 35 meters) long and 60 *shaku* (approximately 18 meters) deep. Oe no Chikamichi's

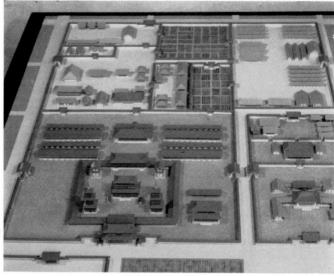

80. Right: restoration model of original compound of Yakushi-ji, Nara. Left: author's restoration of original Golden Hall, Yakushi-ji, Nara. Frontage, 24.3 m. Early eighth century.

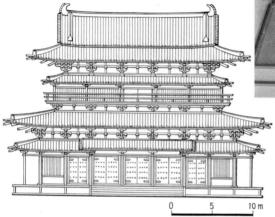

0 5 10 m

81. Bracket complexes of South Main Gate, Todai-ji, Nara. Reconstructed in 1199. ▷

record of his pilgrimages reads: "[The inner sanctuary of] the Golden Hall is five bays long and is surrounded by the outer sanctuary on its four sides, and it has a tiled roof and a surrounding balcony." Since there is no mention of a "double roof" this time, which is what makes it an exceptional case, it seems correct to assume that it was a one-story seven-by-four-bay hall without a secondary roof. From the above-noted dimensions, one might get the impression that each bay of the hall was too large if indeed it was a seven-by-four-bay hall, but this inclination to larger size also applies to the bays of the Inner Gate and the South Main Gate (the remains of both gates have been excavated) and can be recognized as a general tendency inherent in this temple. In short, the Golden Hall was a slightly enlarged version of the Toshodai-ji Golden Hall. The reason why it was

built on a scale larger than usual is not known. There are some who offer the reason that it was modeled after the T'ang-dynasty Hsiming-ssu temple in China.

The dimensions of the Yakushi-ji Golden Hall as given in the historical section of the temple's records are somewhat confused and therefore cannot be completely relied upon, but since the complete podium and the foundation stones, including the dais and the paving stones, fortunately remain, the ground plan is easily restorable. The character of the restored plan suggests that the building was a seven-by-four-bay hall with secondary roofs. This conclusion is supported by the history of the Yakushi-ji included in the records of the temple and by Oe no Chikamichi's record of his temple pilgrimages. The latter, for example, using the Heian-period method of description,

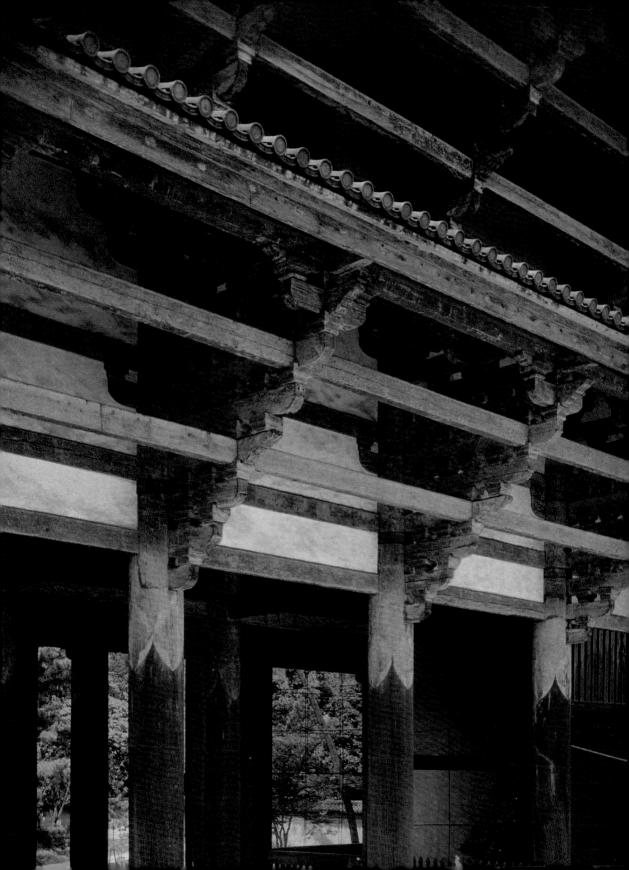

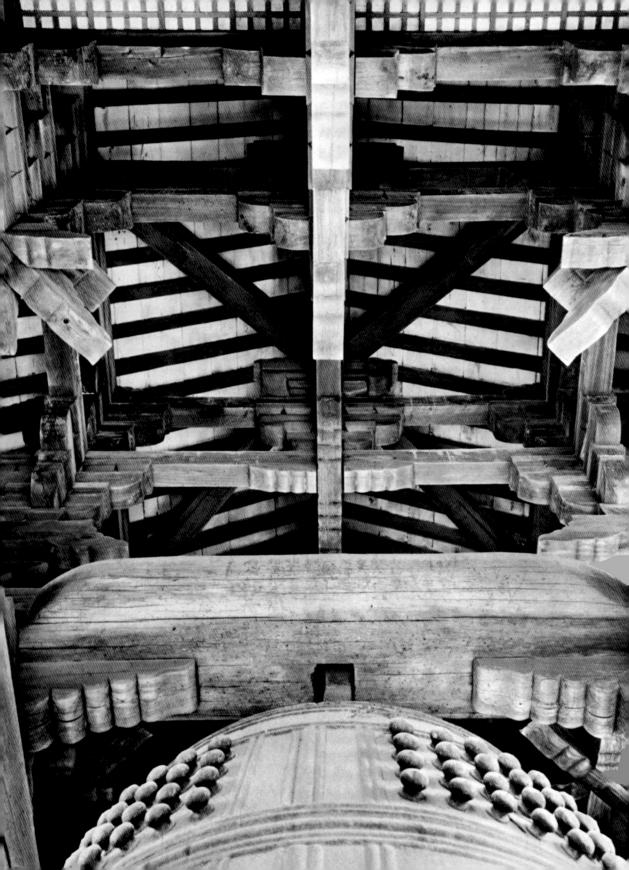

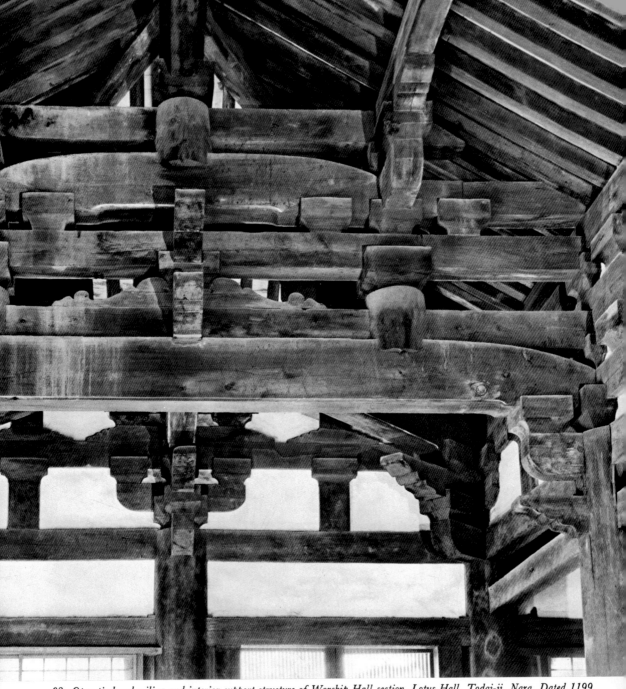

83. Open-timbered ceiling and interior support structure of Worship Hall section, Lotus Hall, Todai-ji, Nara. Dated 1199.

◁ 82. Interior structure of Belfry,
Todai-ji, Nara. Dated 1207–10.

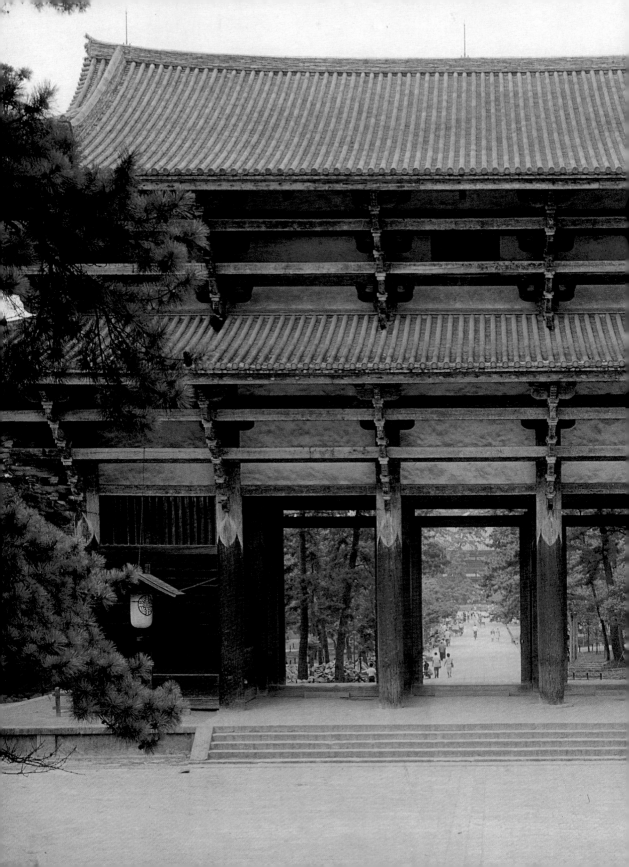

84. South Main Gate, Todai-
ji, Nara. Frontage, 28.8 m.
Reconstructed in 1199.

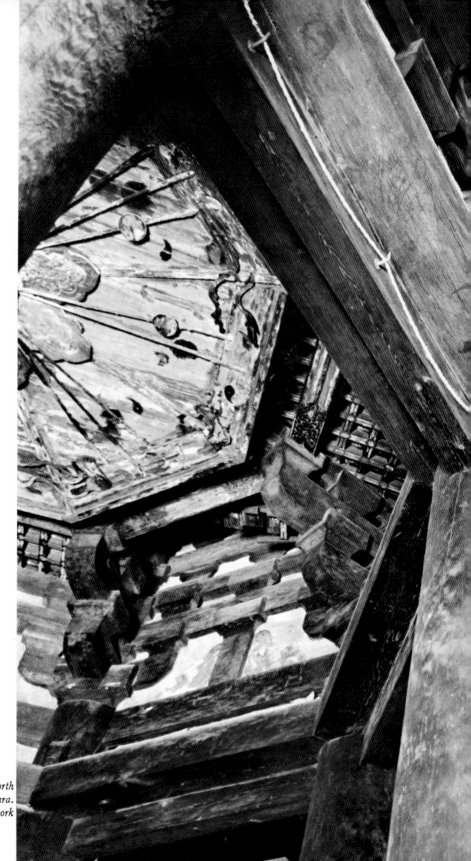

85. *Interior structure of North Round Hall, Kofuku-ji, Nara. Second remodeling; framework completed in 1210.*

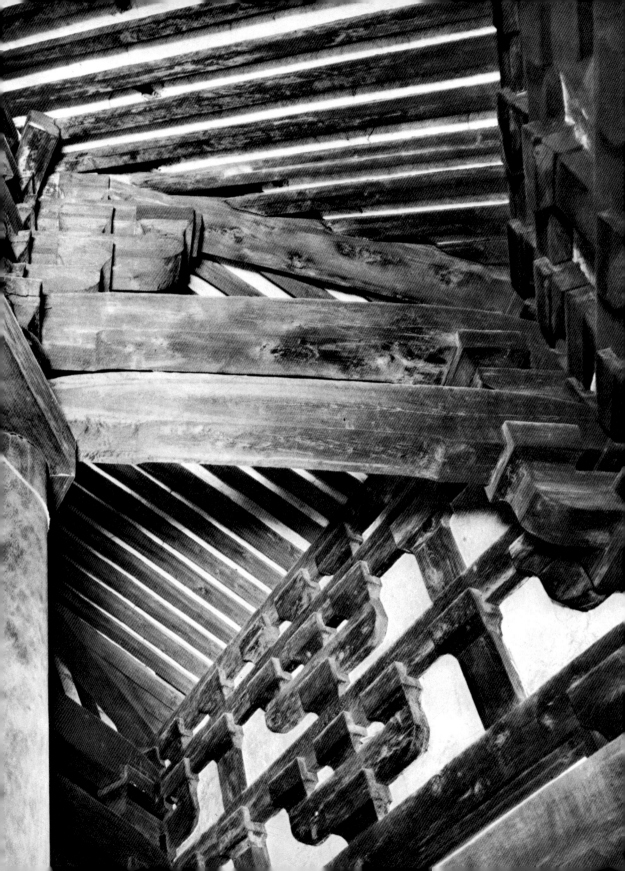

86. Detail of interior of Three-storied Pagoda, showing paintings of one thousand Buddhas, Kofuku-ji, Nara. Reconstructed in first half of thirteenth century.

87. Three-storied Pagoda, Kofuku-ji, Nara. Dimensions of first story, 4.8 m. by 4.8 m. Reconstructed in first half of thirteenth century.

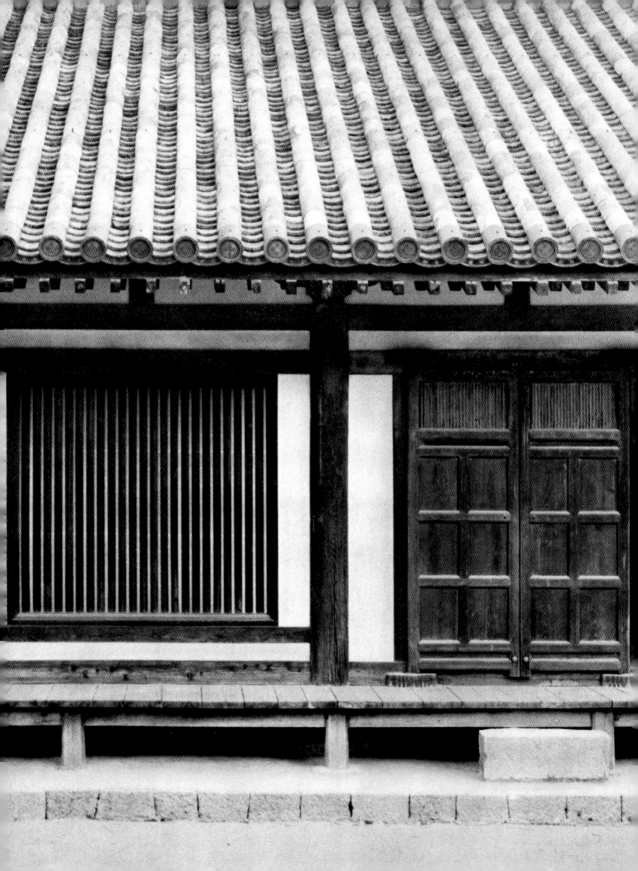

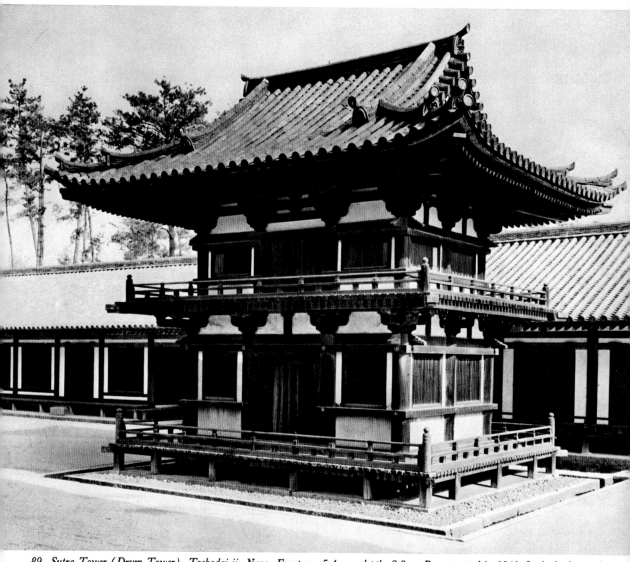

89. *Sutra Tower (Drum Tower), Toshodai-ji, Nara. Frontage, 5.4 m.; depth, 3.9 m. Reconstructed in 1240. In the background is a section of the East Wing.*

◁ 88. *Detail of East Wing, Toshodai-ji, Nara. Total length of structure, 50 m. Eighth or ninth century; remodeled in 1202 and 1283.*

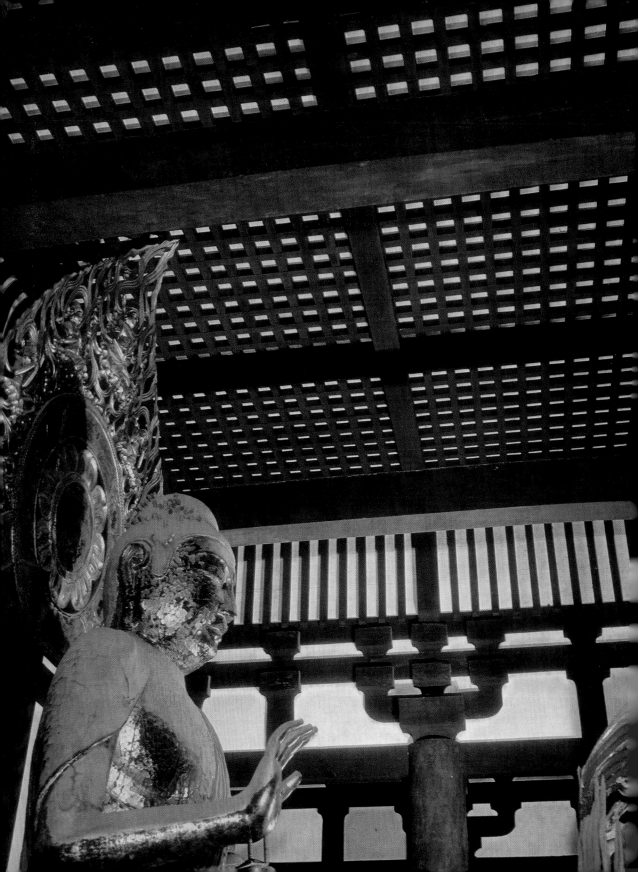

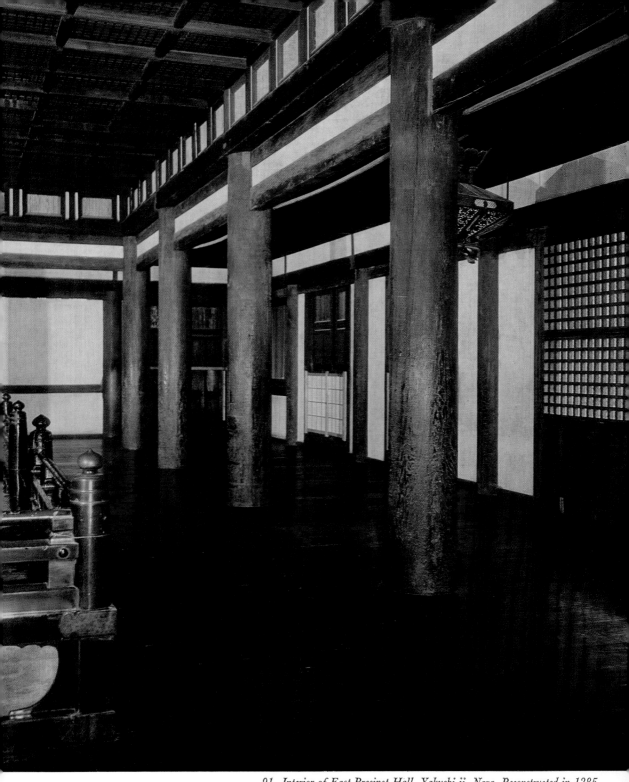

91. Interior of East Precinct Hall, Yakushi-ji, Nara. Reconstructed in 1285.

◁ 90. Ceiling of inner sanctuary, Golden Hall, Taima-dera, Taima,
Nara Prefecture. Reconstructed in second half of thirteenth century.

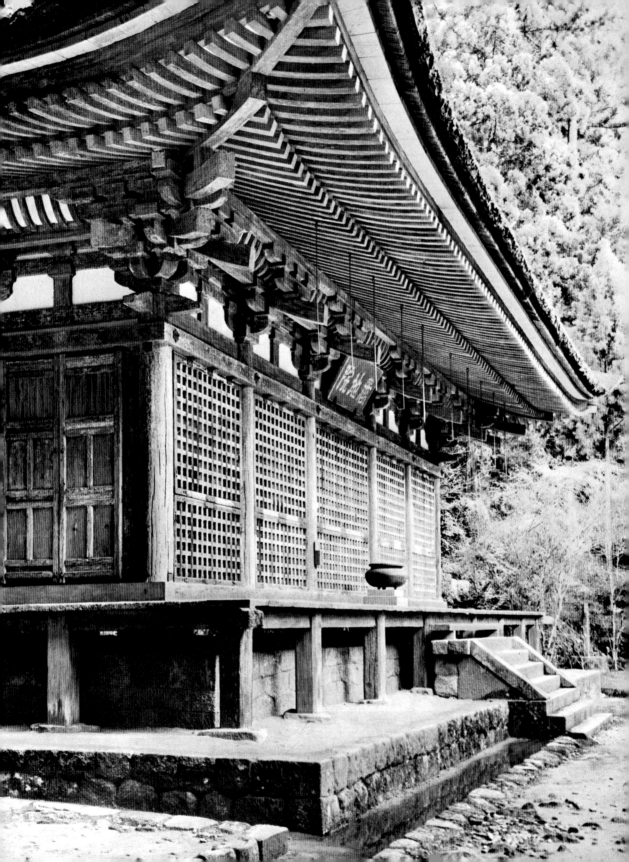

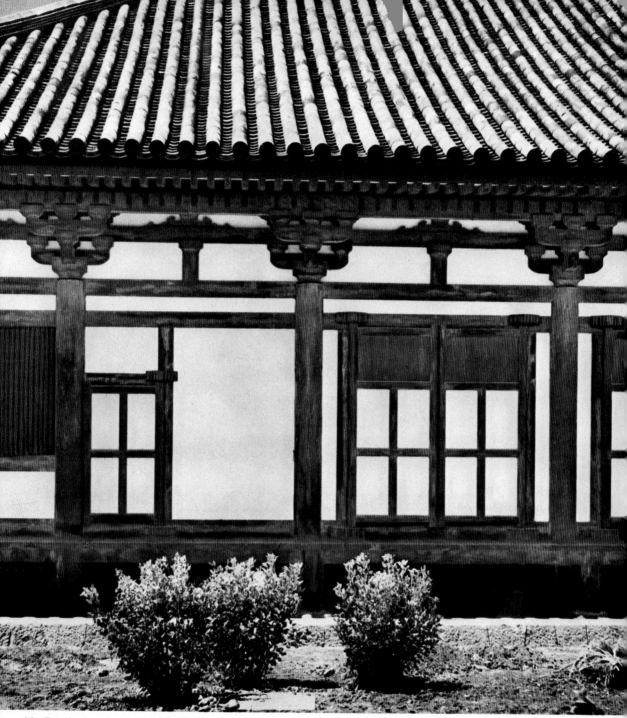

93. *Detail of south side of Main Hall, Gokuraku-bo, Gango-ji, Nara. Greatly remodeled in 1244 with use of original wooden members from eighth century.*

◁ 92. *Main Hall (Initiation Hall), Muro-ji, Muro, Nara Prefecture. Second half of thirteenth century.*

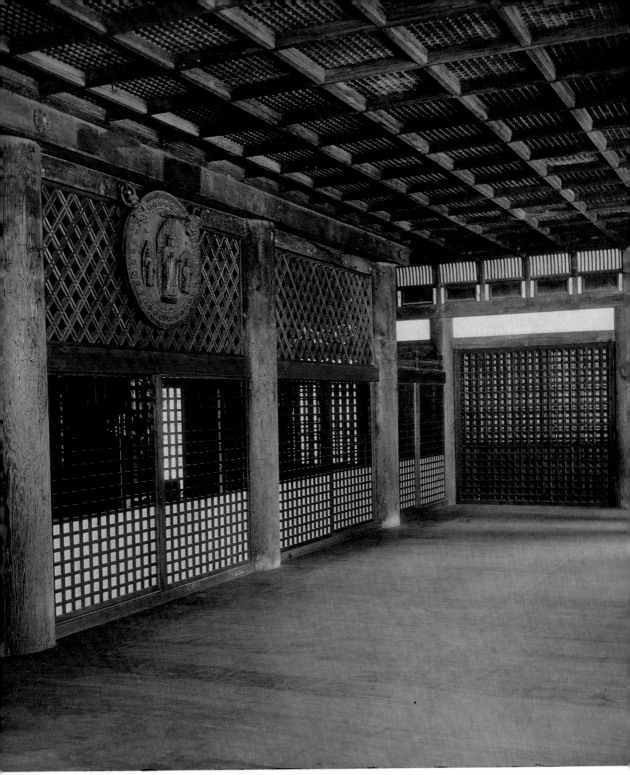

94. Outer sanctuary of Main Hall, Ryozen-ji, Nara. Dated 1283.

95. Lecture-hall floor plans of principal temples. Scale, ▷
1:1,000; dimensions given in Nara shaku (1 shaku =
29.59 cm.).

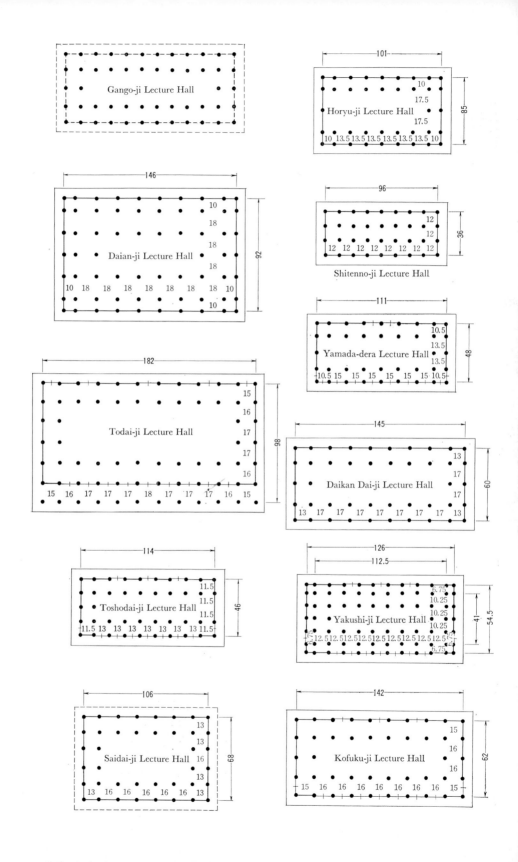

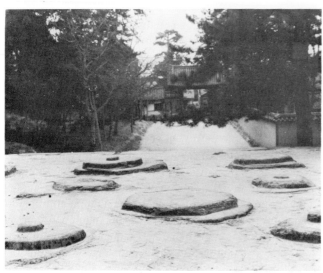

96. Ruins of East Pagoda, Saidai-ji, Nara. Second half of eighth century.

97. Altar furnishings of Great Buddha ▷ Hall (Golden Hall), Todai-ji, Nara. Left: silver jar with lid; diameter 6.6 cm. Right: silver-gilt cicada-shaped lock; length, 7.8 cm. About mid-eighth century.

clearly states that "[the inner sanctuary of] the Golden Hall is five bays long and is surrounded by the outer sanctuary on its four sides, and the tiled roof of each story is accompanied by another roof— that is, the whole structure appears as if it were four-storied." The fact that the Golden Hall was furnished with secondary roofs is attributable to the general scheme of designing the Yakushi-jt temple compound, as is illustrated by the Easi Pagoda (Fig. 39).

Like the East Pagoda, the Golden Hall probably utilized the technique of three-handed bracketing in the core structure and three-block bracketing for the secondary roofs. It is difficult to imagine the interior construction of the hall because of its un-usual overall design, but it does seem to have been exceptional, as implied by the fact that the upper story was carried away in a great windstorm in 989. There are no sources available for enlightening us concerning the roof shape of this building, but if one tries to restore the front view of the Golden Hall in a drawing, it becomes clear that the roof would not fit the structure it surmounted unless it was a hipped-and-gabled roof. Obviously, how-ever, this does not seem to be the correct surmise,

for most of the halls of other Nara temples, as far as our present knowledge goes, had hip roofs—for example, the Middle Golden Hall, the East Golden Hall, and the West Golden Hall of the Kofuku-ji; the Great Buddha Hall and the Lotus Hall of the Todai-ji; and the Golden Hall of the Toshodai-ji. Nevertheless, since the Gango-ji Golden Hall had a hipped-and-gabled roof, as we have noted above, the Yakushi-ji Golden Hall was not necessarily an isolated case. Moreover, there is a common factor to be observed in these two halls—namely, that among the golden halls of Nara temples they alone stood independently within the temple courtyard without being connected to other structures by the corridor (Fig. 80). Hence it seems highly plausible to suppose that a golden hall had a hipped-and-gabled roof if it was an independent building in the courtyard. The Horyu-ji Golden Hall supplies the only factual evidence to support this hypothesis, but in terms of the designing of the temple com-pound the hypothesis is quite reasonable. If a golden hall is connected by a corridor on both sides, the front view of the hall becomes more im-portant, and it is necessary to shape its roof in such a way that it maintains an integral harmony with

the corridor on either side. Only a hip roof will be adequate in such a case. On the other hand, an independent golden hall in the courtyard must be viewed from all angles, and the sense of depth will be enhanced by the use of a hipped-and-gabled roof. Thus the hipped-and-gabled roof seems to have been the only possibility for the Yakushi-ji Golden Hall.

In comparison with the golden halls of other national, or first-class, temples, the Yakushi-ji Golden Hall was relatively small. There appear to be three reasons for this. First, although it became possible, as architectural techniques progressed, to build temples on a larger scale, the Yakushi-ji buildings inherited the size of those originally constructed at the Fujiwara capital in the early Nara period. Second, since the Yakushi-ji Golden Hall was built as an independent structure within the courtyard, its size was much restricted in view of the overall balance. The restriction was all the more severe because the pagodas were also built within the courtyard. Third, since all the buildings of the temple complex, including the twin pagodas, the Lecture Hall, and the Golden Hall, were to be exquisitely designed with secondary roofs, the con-

struction of such buildings on a large scale would have created an impression of excessive elaborateness and would thereby have destroyed the effect of compactness.

The Todai-ji, needless to say, was built on a scale unprecedented in Japanese architectural history. This was especially true of its Golden Hall, or Great Buddha Hall, as it is commonly called, which may be properly designated as the ultra-first-class golden hall. Restoration research on the hall and its surrounding area was carried out by the late Dr. Tadashi Sekino (1870–1935). The complete layout, including the Lecture Hall, the Monks' Quarters, the Refectory, and the pagodas, was the subject of intensive study by the late Dr. Shun'ichi Amanuma, and restoration models of these structures have been made (Figs. 31, 36). The original Great Buddha Hall measured eleven bays (290 *shaku*, or 88 meters) by seven bays (170 *shaku*, or 51.5 meters)—that is, with a one-bay secondary roof around the nine-by-five-bay core structure. There is some difficulty in comparing the size of this hall with the sizes of golden halls at other national temples, but there is no doubt in assuming that it was in the lineage of the golden halls of the

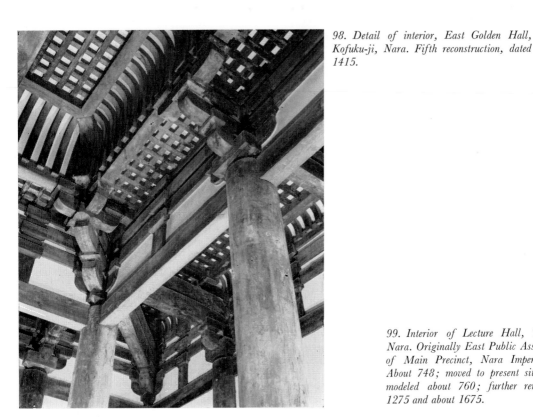

98. Detail of interior, East Golden Hall, Kofuku-ji, Nara. Fifth reconstruction, dated 1415.

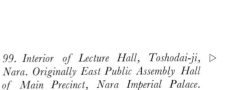

99. Interior of Lecture Hall, Toshodai-ji, ▷ Nara. Originally East Public Assembly Hall of Main Precinct, Nara Imperial Palace. About 748; moved to present site to be re-modeled about 760; further remodeling in 1275 and about 1675.

Kofuku-ji, the Gango-ji, and the Yakushi-ji, all of which had secondary roofs. Its principal roof, as evidenced by the length of the ridgepole in the Kamakura-period reconstruction, was apparently hipped.

The last example among first-class golden halls is that of the Saidai-ji. Again this was an exceptional case. The Saidai-ji was the earliest of all the Nara temples to suffer a downfall. When Oe no Chikamichi made his pilgrimage there in 1140, many of its halls had already vanished, and, to make the situation worse, the Kamakura-period revival of Nara Buddhism by the monk Eison (1201–90) changed the appearance of the temple completely. As already noted, the ruins of the East Pagoda and the West Pagoda have been excavated, but since the heart of the temple compound is now occupied by private residences, it is quite difficult

to conduct a satisfactory survey. The only method of examination, then, is to rely on the *Record of the Saidai-ji Temple Property*.

There were two buildings at this temple that were referred to as golden halls—the Golden Hall of Yakushi and the Golden Hall of Miroku—but since the latter was actually a lecture hall, we shall investigate only the former here. The *Record* states that the Golden Hall of Yakushi was 119 *shaku* (about 35 meters) long and 53 *shaku* (about 16 meters) deep. Though it was not quite an exception in this respect, it did have a long frontage compared to its depth. In fact, it had the largest ratio of frontage to depth among all the Nara-period golden halls that have been studied. There must have been a reason for this proportion.

A reference to the item in the *Record* dealing with the Buddha and Bodhisattva images in the Golden

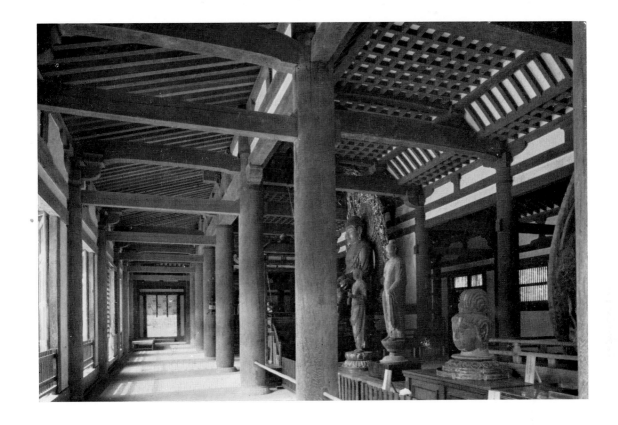

Hall of Yakushi reveals that a tableau of the Pure Land (the paradise of Amida Buddha) with seven icons of Yakushi was painted on a seven-bay wall. This wall could have been no other than the rear wall of the inner sanctuary, and accordingly the inner sanctuary had to have a width of at least seven bays. The building therefore had a total width of nine bays. In all probability this was the factor responsible for the unusual proportion in the dimensions of the hall.

The next question to be asked is whether it was a one-story or a two-story hall. The fact that the *Record*, in a specially provided note, describes the Golden Hall of Miroku as "double-layered" (we do not know whether this means "two-storied" or "one-storied with a secondary roof") but mentions nothing about the Golden Hall of Yakushi leads us to suspect that it was a one-story hall without a secondary roof. This seems to be a logical conclusion if we assume the dimensions given in the *Record* to be correct, for the 16-meter depth of the hall, as against its 35-meter length, would allow only a very narrow band of space for the "upper layer" and would produce an exceedingly awkward perspective. It is therefore correct to surmise that such a queer design must have been avoided. As to the bay dimensions, there is no way but to guess. The roof must have been hipped, for the *Record* mentions only the ridge ends and says nothing about gables or bargeboards.

As a result of our examination of the golden halls of these six temples, we have discovered that among the first-class national temples of the Nara capital, the Kofuku-ji, the Gango-ji, and the Yakushi-ji had golden halls of seven bays by four bays with one-bay secondary roofs. If we include the Great Buddha

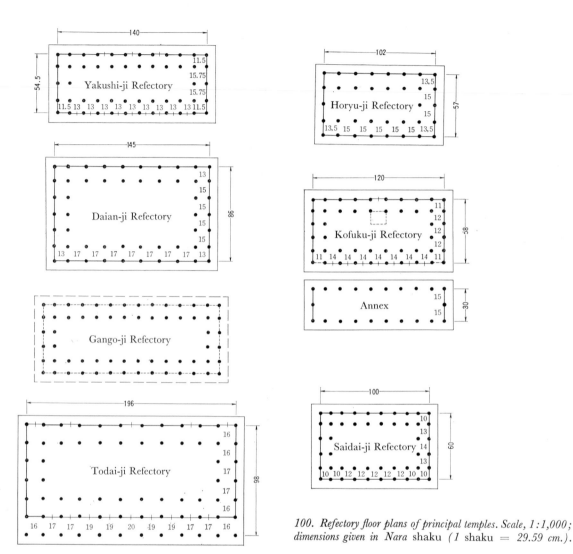

Yakushi-ji Refectory
140
54.5
11.5
15.75
15.75
11.5 13 13 13 13 13 13 13 13 11.5

Daian-ji Refectory
145
86
13
15
15
15
15
13 17 17 17 17 17 17 17 13

Gango-ji Refectory

Todai-ji Refectory
196
98
16
16
17
17
16
16 17 17 19 19 20 19 19 17 17 16

Horyu-ji Refectory
102
57
13.5
15
15
13.5 15 15 15 15 15 13.5

Kofuku-ji Refectory
120
58
11
12
12
12
11 14 14 14 14 14 14 14 11

Annex
30
15
15

Saidai-ji Refectory
100
60
10
13
14
13
10 10 12 12 12 12 10 10

100. *Refectory floor plans of principal temples. Scale, 1:1,000; dimensions given in Nara* shaku *(1* shaku = *29.59 cm.).*

101. *South Main Gate, West Precinct, Horyu-ji, Ikaruga, Nara Prefecture. An eight-legged gate with a hipped-and-gabled roof. Dated 1438.*

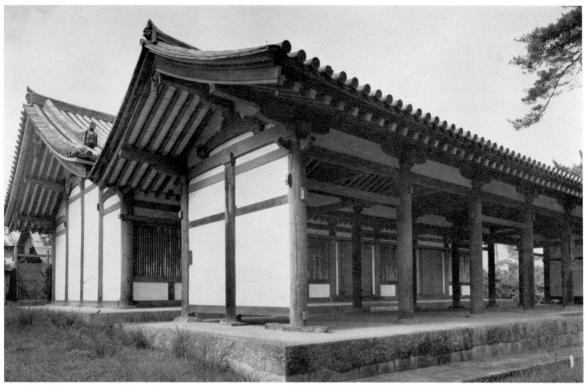

102. *Refectory (rear) and Annex (front), West Precinct, Horyu-ji, Ikaruga, Nara Prefecture. Refectory (perhaps originally an office), eighth century; Annex, about thirteenth century.*

Hall of the Todai-ji in this group, it follows that since four of the six temples had golden halls with secondary roofs, this must have been the standard style for golden halls of the first-class temples.

Now let us turn to the second-class golden halls. Aside from the already mentioned Golden Hall of the Toshodai-ji, no seven-by-four-bay halls from the Nara period are extant, but various documentary sources and the remains of foundation stones reveal that several other halls were of this type—for example, the Kofuku-ji East Golden Hall, restored in medieval times (Fig. 75), and West Golden Hall (known from records); the Yakushi-ji East Precinct Hall, restored in accordance with the original ground plan during the Kamakura period (Fig. 76); and the Hall of the Amida's Pure Land Precinct at the Hokke-ji (known from records).

The frontages of these second-class golden halls were all around 90 *shaku* (about 27 meters), and their scale may be explained in terms of the origin of the Toshodai-ji.

The priest Ganjin (Chien Chen), who introduced the Ritsu sect of Buddhism into Japan, was renowned for both his scholarly erudition and his religious conviction and was so respected by the government and the people that the imperial court granted him land for building the temple. Without doubt the Toshodai-ji was a highly regarded temple, but since the most important temples of this period were those under direct government control, it naturally came next to them in rank, as is evidenced by its having been allotted a second-class temple ground—an area of four blocks.

The fact that the East Golden Hall and the West

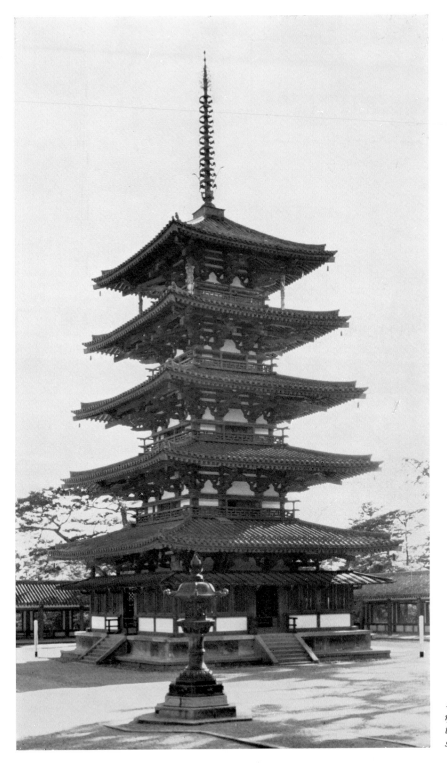

103. Five-storied Pagoda, Ho-ryu-ji, Ikaruga, Nara Prefecture. Height, 32.56 m. Late seventh to early eighth century.

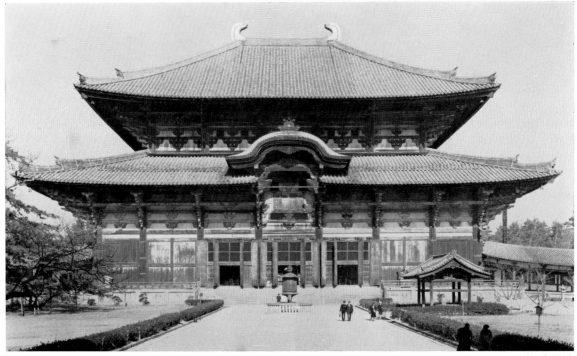

104. Great Buddha Hall (Golden Hall), Todai-ji, Nara. Frontage, 57 m.; height, 48.5 m. Second reconstruction, dated 1708.

Golden Hall of the Kofuku-ji were smaller in scale than the Middle Golden Hall is evidence that they were second-class halls. The East Golden Hall was originally built in 726. The present one is a reconstruction dating from 1415, but it was built on the principle of out-and-out restoration, and every effort was made to preserve the original dimensions. Moreover, except for the format of details and the overall appearance somewhat influenced by the new age in which it was reconstructed, it was fashioned in entirely the same structural style as the Toshodai-ji Golden Hall: the seven-by-four-bay ground plan, the one-bay front portico, the three-handed bracketing, the hipped roof, the greater rainbow beams and coved-and-latticed ceiling of the inner sanctuary, and the latticed ceiling of the outer sanctuary. These features are all indicative of the strong conservatism of the Kofuku-ji. At the

same time they are evidence that the one-story seven-by-four-bay style was indeed one of the standard styles for Nara-period golden halls. In view of the early origin of the Kofuku-ji East Golden Hall, we may surmise that its style was established during the early phase of the Nara capital and was used throughout the Nara period.

In considering the architecture of important Nara-period temples, whether of the first or the second class, it is important to observe that many of them used the technique of double raftering for the eaves—that is, flying (or upper) rafters and base (or lower) rafters. In some structures the flying rafters were square in cross section and the base rafters were round (Figs. 16, 22, 58 top, 74), and in others both were square (Fig. 171). The use of round base rafters was actually an imitation of the old Chinese practice of employing logs for long

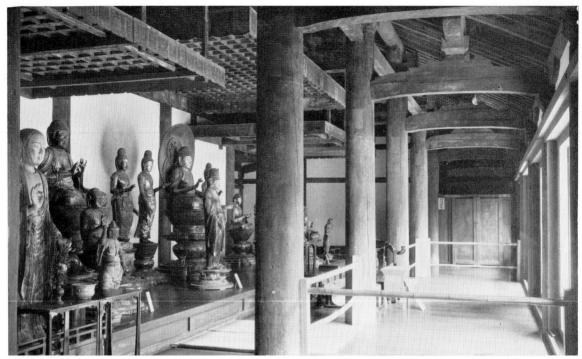

105. Interior of Lecture Hall (Dempodo), Horyu-ji, Ikaruga, Nara Prefecture. Early eighth century; moved to present site to be remodeled in 739.

base rafters as a way of economizing on wood, but since the Nara period was one in which Chinese culture was vigorously copied, the round base rafters constituted a highly prestigious style. It is also widely recognized that the bracket system that became standard for important Nara-period buildings was the three-handed system with slanting struts in the ceiling of the lesser eaves—the gridlike arrangement seen in Figure 58. Available sources indicate that the roofs were generally hipped.

To study an example of the third-class golden hall, let us look at the Todai-ji Lotus Hall (Fig. 44), for it is a small building of the golden-hall type and in fact bears some resemblance to the Toshodai-ji Golden Hall in its structure. What is peculiar about this building is that in front of the five-by-four-bay main hall is attached a five-by-two-bay worship hall. Originally each of these two

parts had a roof of its own, and along the joint of the two roofs was placed an eaves trough. The two structures were enclosed within one wall, and the inside was made into one whole. The prototype of such a complex structure was called a "side-by-side hall," and since there are some such examples mentioned in the *Record of the Saidai-ji Temple Property*, it must have been a style extensively used in the Nara period, although few examples have survived. An example of a hall of similar type is the complex of the Refectory at the Horyu-ji, composed of the Refectory itself and an adjacent long, narrow annex built in front of it (Fig. 102). The Kofuku-ji Refectory also had an annex, but in neither of these two cases were the interiors of the two parts made into a single whole.

The worship-hall section of the Todai-ji Lotus Hall was completely rebuilt during the Kamakura

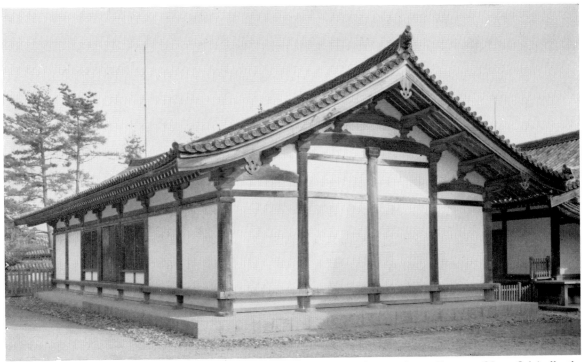

106. Lecture Hall (Dempodo), Horyu-ji, Ikaruga, Nara Prefecture, viewed from northwest. Frontage, 25 m. Originally the residence of Lady Tachibana in early eighth century; moved to present site to be remodeled in 739.

period, and the two roofs were connected in a T shape to cover both the main-hall and the worship-hall sections. In the interior of the main-hall section, the inner sanctuary is covered with a coved-and-latticed ceiling, and greater rainbow beams are used (Fig. 78). The only departures from the Toshodai-ji Golden Hall are that the latter uses two-handed bracketing to support its greater rainbow beams, whereas the Lotus Hall uses the one-handed system instead (Fig. 23), and that the rafters lower than the coved ceiling are exposed on the interior side instead of being covered with boards (Fig. 33). But these are modifications of minor importance due only to the necessity of simplifying the internal structure according to the relative smallness of the hall, and the building is no exception to the standard style of Nara-period golden halls. In fact, as we shall see later, this modified

internal structure was handed down in the Heian-period Phoenix Hall of the Byodo-in at Uji, near Kyoto (Fig. 60)—a convincing argument for the firmness of the standard golden-hall styles formulated in the Nara period.

Unusual though it may be, the Todai-ji Lotus Hall, without the worship-hall section, is an independent five-by-four-bay hall, two bays less than the normal second-class hall. Although there are very few extant examples of five-by-four-bay halls, it is obvious that this style existed, as is evidenced by the central hall of the Kawara-dera—admittedly an Asuka-region and not a Nara temple but an example nevertheless. Thus it is quite reasonable to conclude that a typical third-class golden hall measured five by four bays.

A case that might be considered problematic is that of the Kiko-ji Main Hall of the Muromachi

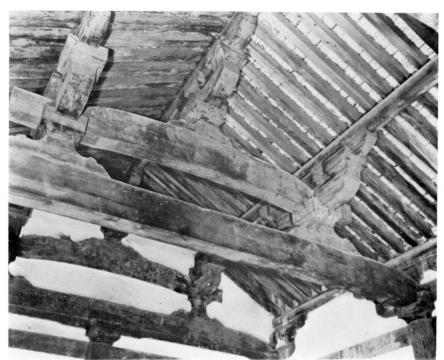

107. *Detail of interior, West Golden Hall, Kairyuo-ji, Nara, showing support structure using double rainbow beams and frog-crotch struts. Eighth century.*

108. *West Golden Hall,* ▷ *Kairyuo-ji, Nara. Frontage, 8.9 m. Eighth century.*

period (1336–1568). The building is composed of a three-by-two-bay core structure plus a one-bay secondary roof. As a whole, it is a five-by-four-bay hall. It deserves mention here because it has such Nara-period elements as its ground plan and its front porch (Figs. 117, 127). If we base our judgment on its ground plan only, we can classify it as a third-class golden hall like the Todai-ji Lotus Hall, but because of its "double-roof" style the structure is far larger than an ordinary five-by-four-bay hall. Its temple ground is that of a second-class temple. Our surmise here is that among second-class temples there were some five-by-four-bay golden halls with secondary roofs in addition to the regular seven-by-four-bay halls.

There are scarcely any sources to provide us with information about the golden halls of small temples with one-block temple grounds. The only clue is offered by the Kairyuo-ji, whose West Golden Hall

retains the original Nara-period scale. This building has a length of three bays (30 *shaku*, or about 9 meters) and a depth of two bays (20 *shaku*, or about 6 meters). The bays have an equal width of 10 *shaku* each, as was the case in most of the simple structures of the Nara period. The Kairyuo-ji, of course, was in the style of golden-hall triplets. The size of the Middle Golden Hall is yet to be discovered, but it was probably a small building of three or five bays (Figs. 107, 108).

Beginning with the Golden Hall of the Toshodai-ji, we have looked at the golden halls of various temples of the Nara capital. We have noted especially that most of these halls were designed and constructed according to set criteria and were highly stylized. The sizes of golden halls of the first, second, and third classes are indicated in Figures 71 and 79. Aside from the Golden Hall (Great Buddha Hall) of the Todai-ji, which is con-

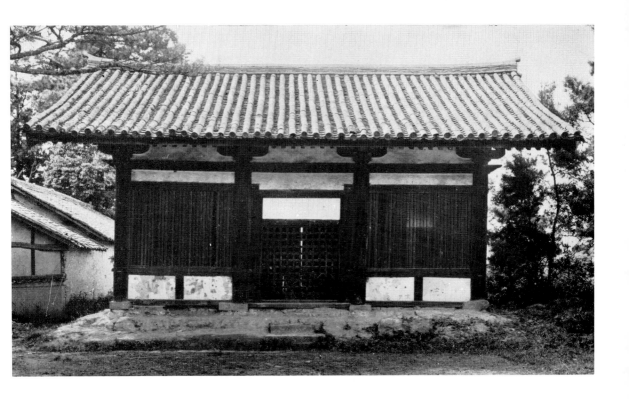

sidered to be a special case, most of the golden halls of the first-class, or national, temples were seven by four bays and had secondary roofs, although there were some exceptions, and their frontages measured around 120 *shaku*. The standard second-class hall measured seven by four bays and had no secondary roof, the frontage being around 90 *shaku*. The third-class golden hall was five by four bays in size, and its frontage was much shorter. Among first-class golden halls, that of the Yakushi-ji was smaller than others for the reasons stated above.

THE LECTURE HALL　There are even fewer sources for the study of lecture halls, and only two among the extant halls from the Nara period are used as lecture halls today: the Toshodai-ji Lecture Hall and the Lecture Hall (called the Dempodo, or Preaching Hall) in the East Precinct of the Horyu-ji. The one at the Toshodai-ji, however, did not originate as a lecture hall but was converted from the East Public Assembly Hall in the Main Precinct of the Nara Imperial Palace—a precinct used for the audiences and ceremonies of the imperial court and as a center for all sorts of governmental affairs. Nor was the Horyu-ji Dempodo originally a lecture hall. It was first the residence of Lady Tachibana no Michiyo (?–733), then the Lecture Hall of the Horyu-ji Round Hall Precinct (as will be noted later), and therefore cannot be regarded as representing the standard lecture hall of a regular temple compound. In short, no example of a Nara-period structure that originated as a lecture hall can be found today. Because of these circumstances there is no way to consider the character of lecture halls of temples in Nara times except to start with the complete foundation-stone remains of the Kofuku-ji Lecture Hall.

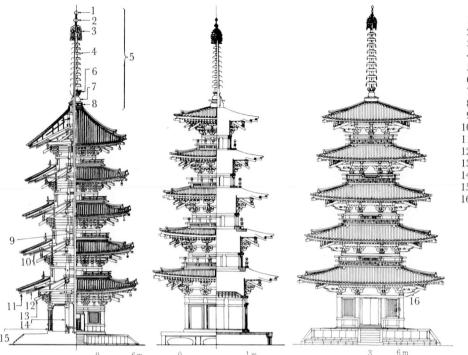

KEY TO THE PLAN
1. Sacred jewel
2. Dragon vehicle
3. Water flame
4. The nine rings
5. Finial
6. Lotus flower
7. Inverted bowl
8. Dew basin
9. Central pillar
10. Three-handed bracketing
11. Flying rafter
12. Base rafter
13. Tail rafter
14. Interior pillars
15. Outer-wall pillars
16. Cloud-shaped bracketing

109. *Elevations of five-storied pagodas. Left to right: Kofuku-ji Five-storied Pagoda, rebuilt in 1426; Kairyuo-ji Five-storied Pagoda, late seventh to early eighth century; Horyu-ji Five-storied Pagoda, late seventh to early eighth century.*

The Kofuku-ji Lecture Hall was a nine-by-four-bay hall measuring 142 *shaku* (approximately 42 meters) in length and 62 *shaku* (approximately 18 meters) in depth. The pillars of the seven-by-two-bay inner sanctuary stood at intervals of 16 *shaku*, and the width of the surrounding outer sanctuary was 15 *shaku* (Fig. 95). It is probably correct to assume that it was a standard practice in the Nara period to use bays of equal size for the inner sanctuary and to surround it with smaller bays. This constitutes a contrast with some of the Asuka-period lecture halls, in which all the bays were of equal size and an even number of bays composed the front and the rear (Fig. 95), but such styles were no longer used in the Nara period. In any case, what is important is the fact that whereas golden halls were designed so that their bay widths gradually decreased toward the sides, no such subtlety can be found in lecture halls. In other words considerable care was taken in the design of golden halls as the central symbols of temples, but that of lecture halls, more utilitarian in function, was all the more simplified. The dais was quite small, and the interior must have been rather spacious, since it served as a place for religious lectures and discussions. An old drawing of the Kofuku-ji Lecture Hall shows the roof to have been hipped and gabled, as was probably true of the original structure. The bracket system is surmised to have been of the three-block type, since the same system was used in the Horyu-ji Lecture Hall, which perhaps also preserved the original style. Other details of the interior structure of the Kofuku-ji Lecture Hall are not known.

Pagoda	Number of stories	Unit of measure-ment	Total height		First-floor plan (restored)				
			Restored measurement	Actual measurement of extant structure	Length of side	Length of central bay	Length of lateral bay	Source	
Horyu-ji Pagoda	5	Asuka *shaku*	90.0	31.77 meters	18.0	7.5	5.25	Actual measurement	
Yakushi-ji East Pagoda	3	Nara *shaku*	116.0	34.14 meters	24.0 (main structure) 35.5 (including pentroof bays)	8.0	8.0 5.75 (pentroof bay)	Actual measurement	
Kofuku-ji Pagoda	5	Nara *shaku*	151.0	50.11 meters	29.5	10.5	9.5	Actual measurement of extant structure	
Gango-ji Pagoda	5	Nara *shaku*	?		34.0	12.0	11.0	Actual measurement of extant foundation stones	
Todai-ji East Pagoda	7	Nara *shaku*	338.7		55.0	21.0	17.0	Actual measurement of extant foundation stones	
Todai-ji West Pagoda	7	Nara *shaku*	336.7		55.0	21.0	17.0	Actual measurement of foundation stones	
Saidai-ji East Pagoda	5	Nara *shaku*	150.0		28.0	10.0	9.0	Actual measurement of extant foundation stones	
Kairyuo-ji Model Pagoda	5	Nara *shaku*	135.0	4.01 meters	26.0	9.5	8.25	Actual measurement (ten times model pagoda)	
Gango-ji Gokuraku-bo Model Pagoda	5	Nara *shaku*	190.0	5.61 meters	33.0	11.0	11.0	Actual measurement (ten times model pagoda)	

110. Data for pagodas of principal temples.

When the Toshodai-ji Lecture Hall was still the East Public Assembly Hall of the Imperial Palace, it was nine bays (117 *shaku*) long, each bay being 13 *shaku* wide, and four bays (46 *shaku*) deep, each bay being 11.5 *shaku* wide. The roof was gabled. Instead of three-block bracketing, a much simpler form called one-block bracketing was used—a form involving a bracket arm and a base bearing block below it, with no superior bearing blocks. There was no pentroof at the front of the hall.

When the hall was moved to the Toshodai-ji, it was modified by shortening the lateral bays by 1.5 *shaku*, so that its total length became 114 *shaku*. An earthen pentroof was added, and the main roof was changed to the hipped-and-gabled style. One-block bracketing was changed to the three-block form, and some of the frog-crotch struts above in-terior rainbow tie beams were removed to the exterior and inserted under block-on-strut posts to adjust their height. The greater rainbow beams in the combination of double rainbow beams and frog-crotch struts were maintained, but the open-timbered interior of the roof, in which all the rafters had been exposed, was underlaid with a coved-and-latticed ceiling.

In the thirteenth century, however, a large-scale remodeling took place and changed the appearance of the hall considerably, and finally, in the seventeenth century, the earthen pentroof was removed. Still, in spite of these numerous alterations, the hall is priceless as the only extant example of Nara-period palace architecture, for its original style remains recoverable. Nevertheless, for the purpose of restoring the style of Nara-period lecture halls in

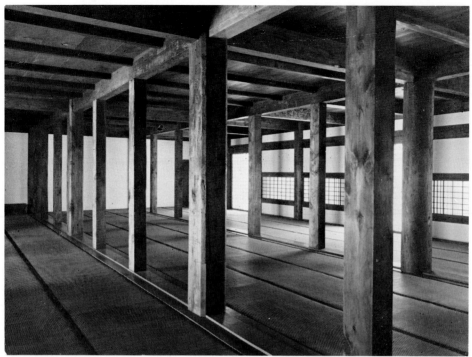

111. *Interior of Meditation Room (remains of Monks' Quarters), Gokuraku-bo, Gango-ji, Nara. Eighth century; greatly remodeled in early thirteenth century.*

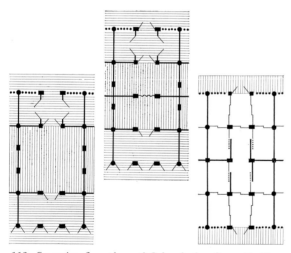

112. *Successive floor plans of Gokuraku-bo, Gango-ji, Nara. left to right: Nara period, Heian period, Kamakura period.*

general, it must be used with great caution (Figs. 25, 38, 99). The fact that the original gabled roof was changed to the hipped-and-gabled style, coupled with the fact that the lecture halls of the Kofuku-ji and the Horyu-ji also had hipped-and-gabled roofs, seems to suggest that the style was in general use for lecture halls. Similarly, the one-block bracketing was changed to the three-block type because the latter was the standard.

What about the lecture halls of other temples? Very little concrete information is available. Examination of the records of several national temples yields the following scanty data. The Daian-ji Lecture Hall was 146 *shaku* long and 92 *shaku* deep. The Yakushi-ji Lecture Hall was 126 *shaku* long and 54.5 *shaku* deep and was furnished with a secondary roof. The Todai-ji Lecture Hall was 182

113. *Main Hall (perhaps originally a refectory), Shin Yakushi-ji, Nara. Frontage, 22.7 m. Second half of eighth century.*

shaku long and 98 *shaku* deep, while that of the Saidai-ji, which, as we have noted, was called the Golden Hall of Miroku, was 106 *shaku* long and 68 *shaku* deep and was "double-layered"—that is, either two-storied or one-storied with a secondary roof.

As is clear from the preceding discussion, the details of lecture halls have not been as well investigated as those of golden halls. To draw a general conclusion, however, the lecture halls of large temples were oblong with a nine-bay frontage, the roofs were hipped and gabled, and the three-block bracketing system was used. The interior structure is still less clear, but it may be reasonably surmised that fully equipped lecture halls had coved-and-latticed ceilings, as the remodeling of the Toshodai-ji Lecture Hall indicated. A summary of available data on lecture halls is presented in Figure 95.

PAGODAS Pagodas extant from the age before Nara became the capital are the Five-storied Pagoda of the Horyu-ji, the Three-storied Pagoda of the Hokki-ji, and possibly the East Pagoda of the Yakushi-ji. The Horin-ji had a pagoda similar to that of the Hokki-ji, but it was destroyed in 1944 in a fire caused by lightning. The cloud-shaped bracketing used in the Horyu-ji Five-storied Pagoda has already been mentioned. The present pagoda measures 32.56 meters in height, but from the hypothetically calculated pitch of the fifth-roof slope the height of the original is estimated to have been a little shorter—around 31.77 meters. This measurement corresponds roughly to 90 Asuka-period *shaku*, which seems to have been

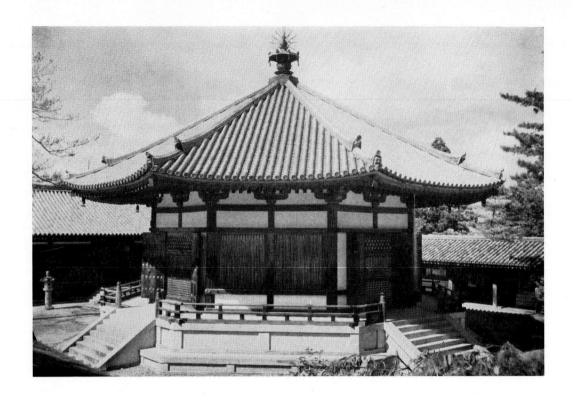

quite a likely scale. The Yakushi-ji East Pagoda has a height of about 116 Nara-period *shaku* (34.14 meters). Both of these pagodas are much smaller in scale than those subsequently built in the Nara capital.

The standard number of stories for pagodas in Nara is thought to have been five. Seven-storied pagodas were erected only at the extraordinarily large-scale Todai-ji and at the Daian-ji, both of which had a tradition of large-scale pagodas. The eccentric plan of building seven-storied octagonal pagodas at the Saidai-ji was changed to that of the standard five-storied ones. The Yakushi-ji East Pagoda is three-storied because of its secondary-roof design, but its overall proportion is that of a regular five-storied pagoda. The present Five-storied Pagoda of the Kofuku-ji is 50.11 meters tall, but the original must have been in the 150-*shaku* (approximately 45 meters) class, for it is described

in the historical records of the temple as having been 151 *shaku* tall. This must have been the standard height, since the Saidai-ji East Pagoda was also 150 *shaku* tall. The standard floor plan for the first story made its side a little less than 30 *shaku* (about 9 meters), but that of the Gango-ji Five-storied Pagoda was 34 *shaku* (about 10 meters)—a fairly large first-floor plan. Tradition says that although this pagoda was located on low ground, it stood as high as the one at the Kofuku-ji, and this is a good indication that it was in the 180-*shaku* (about 54 meters) class.

Two miniature models of pagodas survive, one at the Gango-ji and the other at the Kairyuo-ji. Traditionally the Gango-ji Five-storied Model Pagoda has been regarded as a one-tenth-scale reproduction of the temple's Five-storied Pagoda, but this is hardly believable, for despite the 1-*shaku* difference between the widths of the central and

◁ 114. *Yumedono (Dream Hall), East Precinct, Horyu-ji, Ikaruga, Nara Prefecture. Length of one side, 4.76 m. Dated 739; greatly repaired in early thirteenth century.*

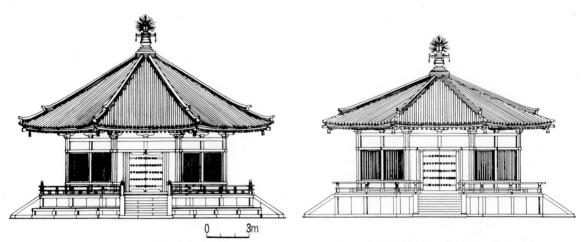

0 ___ 3m

115. *Architectural drawings of Yumedono (Dream Hall), East Precinct, Horyu-ji, Ikaruga, Nara Prefecture. Left: present structure; right: restoration of original structure.*

the lateral bays according to the restored ground plan based on the extant foundation stones (which is compatible with the standard floor plan), the pillars of the model pagoda are evenly spaced. Since the pagodas of national branch temples built in the provinces were of this type, the model pagoda may be related to them in some unknown way. Nevertheless, it is an invaluable miniature because no other original Nara-period five-storied pagodas are extant. Although its eaves are slightly warped, it is a pagoda with a feeling of composure and dignity. The bracket system is the three-handed type with slanting struts (Fig. 47). The dimensions of this model pagoda given in Figure 110 are multiplied by ten for the sake of comparison, although they may be quite inaccurate because the finial is not the original one.

The Kairyuo-ji Five-storied Model Pagoda was found in the West Golden Hall, but it is not known upon which pagoda it was modeled (Fig. 48). The feeling of stability created by the strong rate of diminution in the size of its stories and roofs and the sense of well-knit structure conveyed by its slender body endow it with a beauty shared by the East Pagoda of the Yakushi-ji. In fact, its three-handed bracketing without the use of slanting struts is exactly the same as that used in the latter pagoda. The finial of this model pagoda was added during the Meiji era (1868–1912), and thus, as in the case of the Gango-ji Five-storied Model Pagoda, we do not know the exact height of the original.

Among Nara-period temples, the Taima-dera is the only one where both of the twin pagodas survive (Fig. 64). The temple is located in quite a hilly area, but the Nara-period temple-compound layout is well preserved. We have no way of knowing whether it had surrounding corridors. The East Pagoda dates from the Nara period, while the

116. *Remains of garden of the Kofuku-ji subtemple Dai-jo-in, Nara.*

West Pagoda is a work of the Heian period. Both incorporate three-handed bracketing and slanting struts, since this was the preferred style of the period, and both convey a strong feeling of stability.

Apropos of this temple, the *Taima-dera Engi* (History of the Taima-dera), dating from the late Heian period, states that an image of Miroku was enshrined in the Golden Hall at the wish of Prince Maroko, son of Emperor Yomei, and that Taima no Mahito Kunimi moved the Golden Hall and rebuilt it at its present site in 681. The explanations given in the *History* include a number of legendary elements, but they are well substantiated by other existing evidence. The image of a seated Miroku in painted clay and the statues of the Four Guardian Kings in dry lacquer (with the wooden cores removed) were produced in the early Nara, or

Hakuho, period. The image known as the Sixteen-Shaku Buddha (the measurement designates a standard size of the age) and the small image of Amida, both placed in the Lecture Hall and both made of joined sections of wood, are from the end of the Fujiwara (late Heian) age (897–1185). Besides these, there are two standing images of the Bodhisattva Jizo (Ksitigarbha), each carved from a single segment of wood, the one dating from early Fujiwara and the other from Kamakura; an early-Fujiwara standing image of Kissho Ten (Sridevi); and a mid-Fujiwara statue of the Eleven-headed Kannon (Ekadasamukha). The subtemples of the Taima-dera contain an imposing number of valuable statues from the Fujiwara and Kamakura periods. All these works of art are significant testimony to the once prosperous state of the temple.

Figures 109 and 110 present comparative charac-

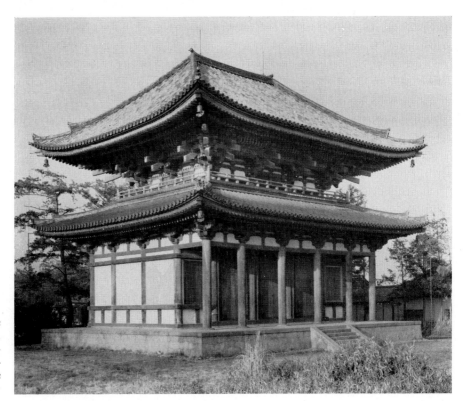

117. Main Hall (Golden Hall), Kiko-ji, Nara. Frontage, 14 m. Reconstructed between late fourteenth and early fifteenth centuries.

teristics of the pagodas discussed in this section.

THE REFECTORY Source materials for investigating the refectories of Nara-period temples are even more scanty than in the case of pagodas. The only remaining building referred to as a refectory is the one at the Horyu-ji (Fig. 102), but since the *Horyu-ji Ruki Shizai-cho* (Record of the Horyu-ji Temple Property) of 747 makes no mention of a refectory, it probably had been used for some other purpose at the time it was constructed. In a number of respects, however, it resembles the Refectory of the Kofuku-ji, which in turn stands out as the most important source of information.

The complete ground plan of the Kofuku-ji Refectory was disclosed in recent excavations, and its style is known from the previously mentioned drawing, which includes the one that was reconstructed during the Kamakura period and survived until the Meiji era. The roof of the Refectory was hipped and gabled, and that of the Refectory Annex was gabled. The present Kofuku-ji National Treasure Museum is my own restoration of the Refectory and the Annex (Fig. 10).

As important places for serving meals to priests and monks, refectories required various facilities. Again the Kofuku-ji provides records concerning such facilities, although none of them have been excavated. In addition to the East Monks' Quarters, the subsidiary buildings, located behind the Refectory, included the well-house, the pantry, the kitchen, the soy-preparation house, the rice storeroom, the warehouse, the cupboard rooms, and the cooking area (an adjunct to the kitchen).

Another building that might be considered under

the heading of refectories is the Shin Yakushi-ji Main Hall. It is related that the temple was established by Komyo (701–60), consort of the emperor Shomu, to enshrine seven statues of the Buddha Yakushi. The original function of this Nara-period hall is not definitely known, but most probably it was a refectory. It is a seven-by-five-bay hall with a hipped-and-gabled roof and uses the one-block bracketing method—a hall of quiet simplicity with its walls totally plastered in white except for the doorways (Fig. 113). The interior has an open-timbered ceiling—the underside of the roof with its structural members exposed—and the main beams cross at the ridgepole to form the shape known as "praying hands" (Fig. 51). One of the primary reasons why this hall is surmised to have been a refectory is that while the lecture hall of a large temple usually had a coved-and-latticed ceiling, the open-timbered ceiling was used for refectories and other halls of lower rank.

On the round dais in the inner sanctuary sits a statue of Yakushi, the main image in the hall, and arranged around it are the Twelve Godly Generals, or Juni Shinsho (Fig. 51). The Yakushi statue is from the early Heian period, and the Twelve Godly Generals are works of the late Nara period. It is not known whether the latter were made first to be enshrined in this hall or whether they were moved here from another temple. Within the temple compound stand the Belfry, the South Gate, the East Gate, and the Jizo Hall, all built during the Kamakura period.

The circumstances of the refectories of other temples are not clearly known, and we must rely on such documents as the records of temple property. The Gango-ji Refectory was eleven bays long and had a hip roof. The Daian-ji Refectory was 145 *shaku* long and 86 *shaku* deep. The Yakushi-ji Refectory was nine bays, or 126 *shaku,* long and 54 *shaku* deep and had a hip roof and a secondary roof. The Todai-ji Refectory had a corridor in front of it, as was established by the late Dr. Amanuma from old drawings and actual surveys of its site. The Saidai-ji Refectory was 100 *shaku* long and 60 *shaku* deep.

Refectories were situated either to the east of lecture halls, as they were at the Kofuku-ji and the Todai-ji, or to the north, as at the Gango-ji, the Daian-ji, and the Yakushi-ji. Restored dimensions of refectories are shown in Figure 100.

THE MONKS' QUARTERS Since Nara-period Buddhism was the state religion, it enjoyed rich government patronage. The livelihood of monks and nuns was supplied by the government, their social status was high, and their life was secure. At the same time, their existence was strongly regulated by the government penal and administrative codes, and the rigid Buddhist precepts demanded strict religious training. The ordinary low-ranking monks who lived within the temple grounds were also regulated and supported by the same kind of rules.

Not very much had been known about the scale

119. Detail of eaves (top) and overall view (bottom) of Golden Hall, Kanshin-ji, Osaka. Eclectic style, combining Japanese, Great Buddha, and Zen-sect styles. About 1375.

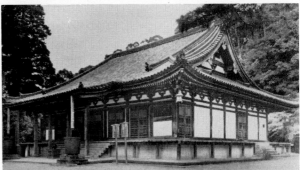

and structure of monks' quarters until the subject was clarified by the dismantling and repair of the Horyu-ji Higashimuro (East Wing) and the Gango-ji Gokuraku-bo, the latter of which (Fig. 111) was rebuilt in the Kamakura period with the use of Nara-period materials. Monks were usually housed in a long structure divided into many small rooms. The length of the building varied from 50 to 80 meters, and an extremely long one may have exceeded 100 meters. The standard arrangement of the monks' quarters called for a double row of the major-cell wing and the minor-cell wing built parallel to each other and a short distance apart. The major-cell wing was from 10 to 15 meters deep and the minor-cell wing from 3 to 4 meters. Monks' quarters were generally built close to the lecture hall or the refectory, but the arrangement differed from temple to temple. In the case of the Gango-ji

Gokuraku-bo the core structure was 22.5 shaku (6.7 meters) deep, and on each of its sides was a penthouse 10.25 shaku (about 3 meters) wide. The three-block bracketing system and the double-raftering technique used for the eaves add to the imposing appearance of the building.

Buildings of the monks'-quarters type were divided into rows of two- or three-bay rooms. Since the same system of division was applied to both the major-cell wing and the minor-cell wing, a single living unit consisted of a pair of major and minor cells. Let us look more closely at these units, taking the Gango-ji Gokuraku-bo as an example. Here the length of major cell is 43 shaku (about 13 meters), and the width of one living unit, consisting of three bays, is 22.5 shaku (about 6.7 meters). The size of a minor cell is not known.

At the Horyu-ji Higashimuro a major cell, con-

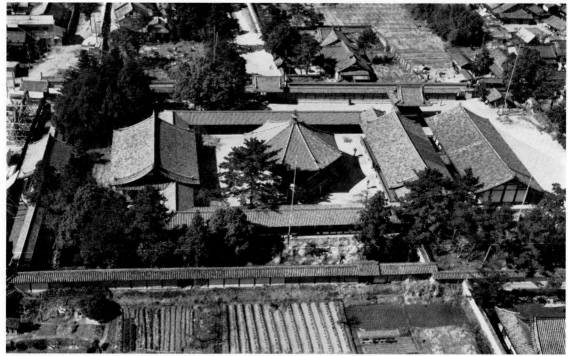

120. *Aerial view of East Precinct compound, Horyu-ji, Ikaruga, Nara Prefecture, from east. Left to right: South Gate, Worship Hall, Yumedono (Dream Hall), Reliquary and Picture Hall, Lecture Hall (Dempodo).*

sisting of two bays, is 37 *shaku* (about 11 meters) long and 21 *shaku* (about 6.3 meters) wide. The length of a minor cell is of course equal to the width of a major cell, and its width is 13 *shaku* (about 4 meters). The two rows are built 17 *shaku* (about 5 meters) apart. The minor-cell row of the Horyu-ji Monks' Quarters is usually called the Higashimuro Annex, while the major-cell row is known simply as the Higashimuro.

At the Kofuku-ji the width of major cell was 22.5 *shaku* (about 6.7 meters) and the length 45 *shaku* (about 13.5 meters). These dimensions, since they are roughly the same as those at the Gango-ji, give us an approximate idea of the standard size of a major cell at a large temple. The minor cells at the Kofuku-ji were 15 *shaku* (about 4.5 meters) wide, and the area between the major-cell and the minor-cell rows was 32 *shaku* (about 9.5 meters) wide.

What was the plan of each unit like? In the major-cell floor plan of the Gango-ji Monks' Quarters (Fig. 112), it is easily recognizable that in the Nara period the central section of the room was more or less closed off, while the penthouse sections were more open, thus suggesting nighttime and daytime use respectively. It is also interesting to observe the successive changes in the plan that were made each time repair work was carried out. In the Kamakura period, sliding doors were

121. *Detail of façade, Great Buddha Hall (Golden Hall), Todai-ji, Nara. Height of building, 48.5 m. Second reconstruction,* ▷ *dated 1708.*

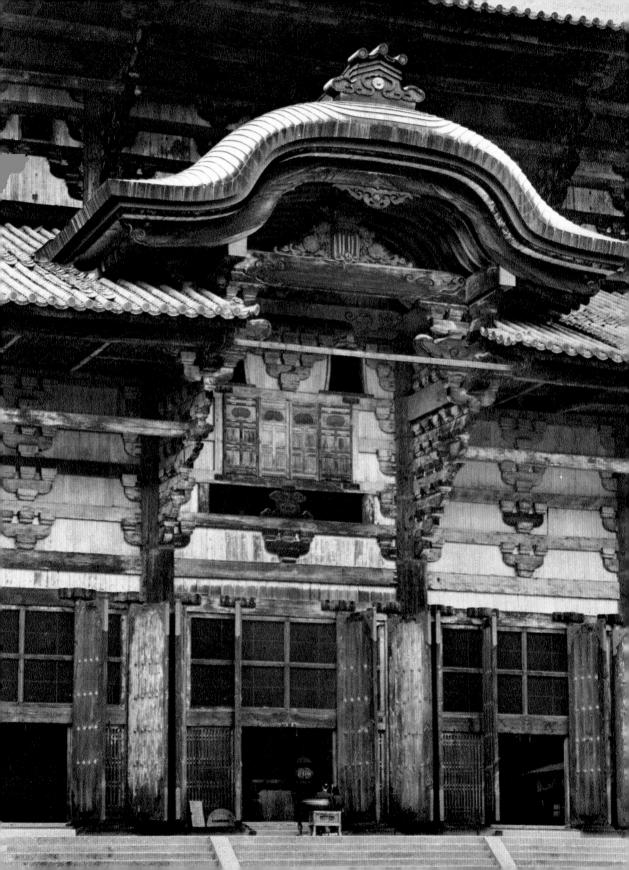

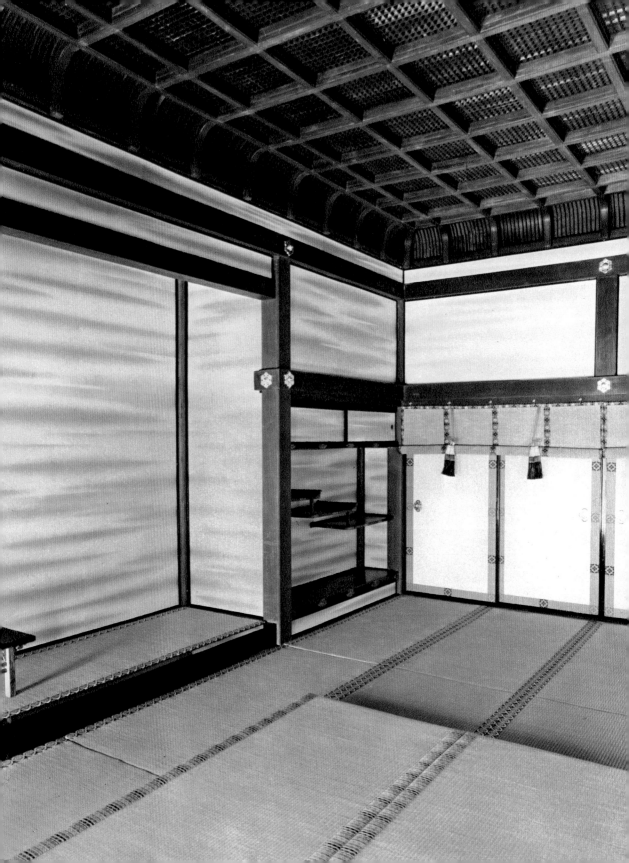

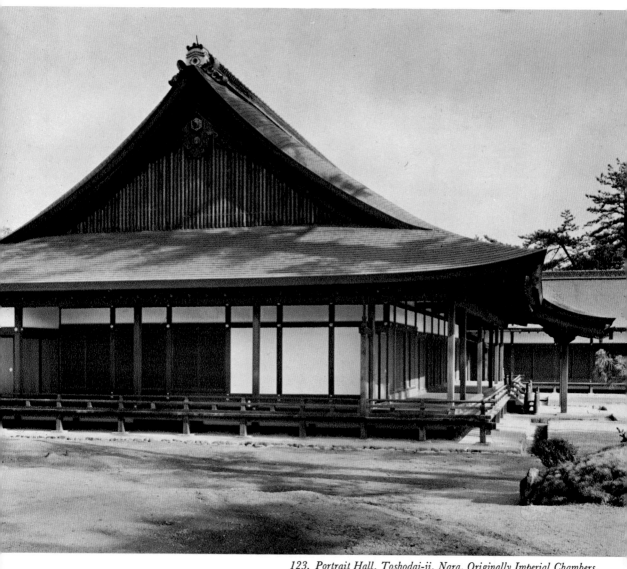

123. *Portrait Hall, Toshodai-ji, Nara. Originally Imperial Chambers, Ichijo-in, Kofuku-ji, Nara. Dated 1650; moved to present site in 1964.*

◁ 122. *Audience chamber, Portrait Hall, Toshodai-ji, Nara, dated 1650.*

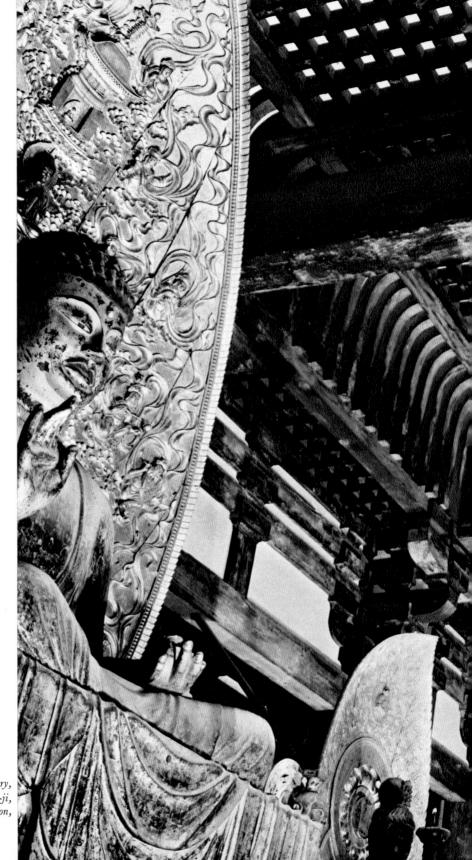

124. Ceiling of inner sanctuary, East Golden Hall, Kofuku-ji, Nara. Fifth reconstruction, dated 1415.

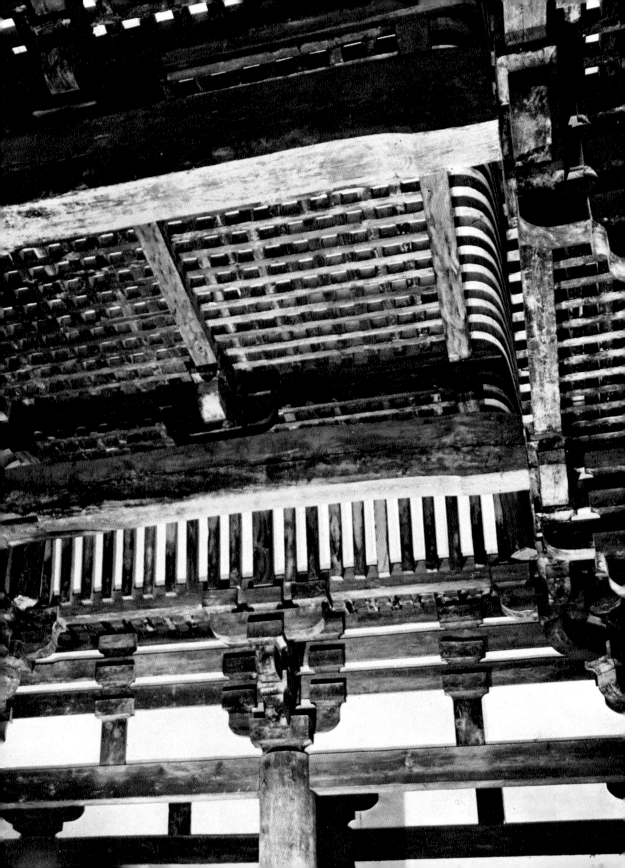

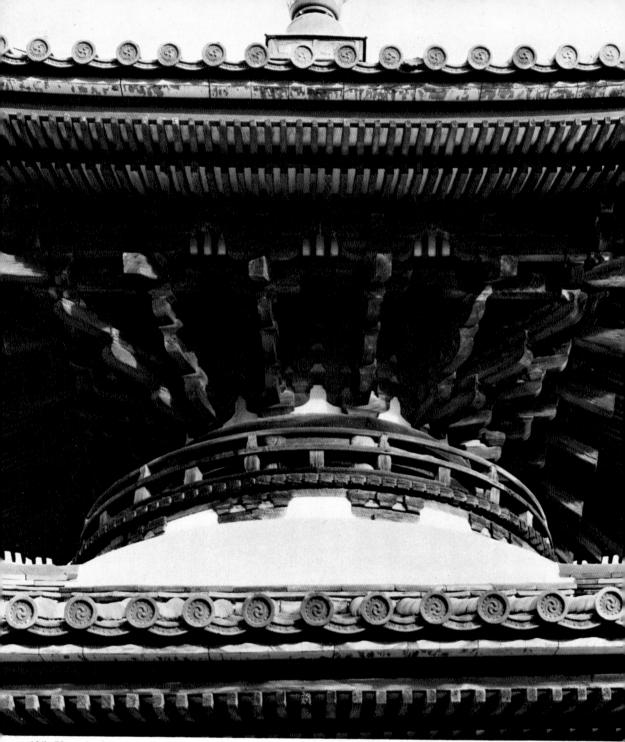

125. *Upper-level bracket complexes of Taho-to (Prabhutaratna Pagoda), Kichiden-ji, Ikaruga, Nara Prefecture. Dated 1463.*

126. *Thirteen-storied Pagoda, Danzan Shrine, Saku-* ▷
rai, Nara Prefecture. Height, 16.2 m. Dated 1532.

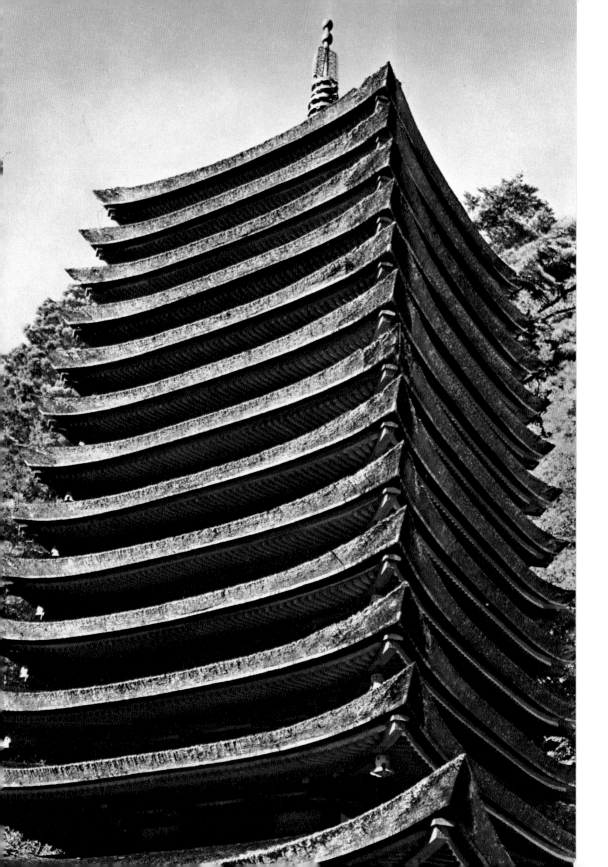

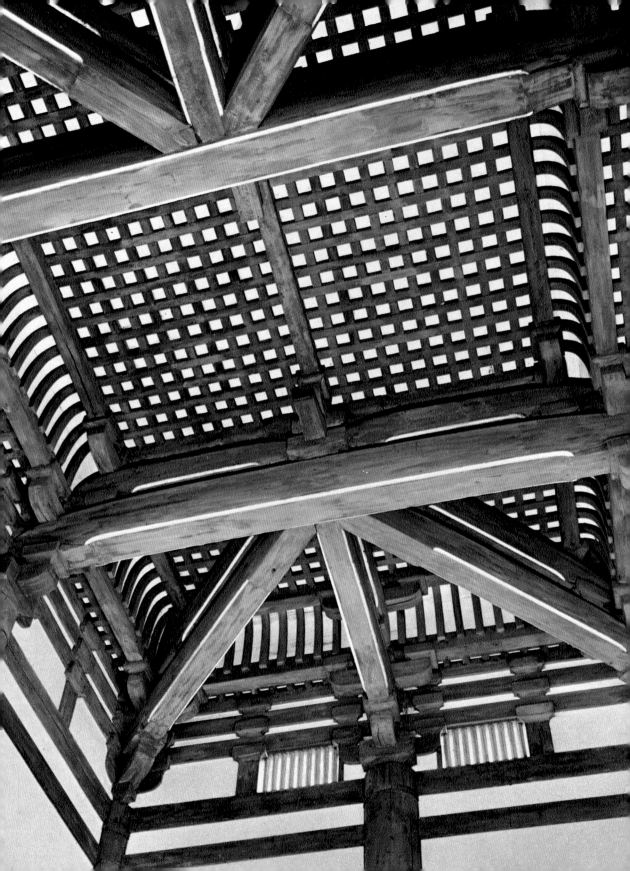

◁ *127. Ceiling of inner sanctuary, Main Hall (Golden Hall), Kiko-ji, Nara. Reconstructed between late fourteenth and early fifteenth centuries.*

128. Treasury, Shoso-in, Todai-ji, Nara. A side-by-side storehouse. Frontage, 33 m. Eighth century.

installed to make the living more convenient.

At both the Horyu-ji and the Gango-ji the number of residents in one living unit was from eight to twelve. Since these people were assigned to either the major or the minor cell, the area per person was equal to that of between four and a half and six mats in a modern *tatami*-floored house. Although we know that the Gango-ji Monks' Quarters had a board floor, it is generally assumed that those of the Horyu-ji, the Daian-ji, and the Todai-ji had only dirt floors, and it therefore seems that chairs and beds were in general use in monks' quarters. As evidenced in a few other respects as well, the monks' mode of living was quite a primitive and simple one.

SUBTEMPLES WITH ROUND HALLS The Horyu-ji East Precinct, constructed on the site of Prince Shotoku's Ikaruga Palace (built in 601), is a subtemple of the Horyu-ji whose compound is laid out in the so-called round-hall style, a round hall being any polygonal hall with six or more sides (Figs. 114, 120). Standing in the center of the precinct is the octagonal hall known as the Yumedono (Dream Hall), surrounded by a corridor that extended to

the north side of the precinct when it was first built. To the north, behind the Yumedono, are the Seventy-Foot Hall (presently a combination of the Reliquary and the Picture Hall) and the East Precinct Lecture Hall (Dempodo). Of these buildings the Yumedono and the Dempodo are the original Nara-period structures, the others having been rebuilt during the Kamakura period. Although the reconstructed buildings have been remodeled to some extent, the layout of the compound remains basically unchanged. In the Nara period the round-hall style was one of the frequently adopted temple-compound layout styles. Another octagonal hall at the Horyu-ji is the West Round Hall, which was built in 1250.

In 721, a year after Fujiwara Fuhito's death, a round-hall precinct was constructed in his memory to the north of the Kofuku-ji West Golden Hall. Again the style was that of an octagonal hall enclosed by a corridor. The hall acquired the name of North Round Hall when another octagonal hall was built to the south of it in 813. The present North Round Hall, as we shall see later, was rebuilt early in the Kamakura period (Fig. 139).

Another round hall may be seen at the Eizan-ji in Gojo, at the southwest tip of the Nara Basin

SUBTEMPLES WITH ROUND HALLS · *129*

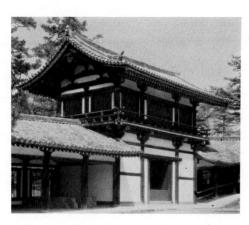

129. Sutra Repository, West Precinct, Horyu-ji, Ikaruga, Nara Prefecture. Frontage, 9.2 m. Eighth century.

130 (opposite page, left). Four-legged Gate, Sogen-ji, ▷ Horyu-ji, Ikaruga, Nara Prefecture. Dated 1237.

131 (opposite page, right). Gatehouse, Hannya-ji, ▷ Nara. A one-bay turret gate. Early thirteenth century.

(Fig. 46). The hall is said to have been built by Fujiwara Nakamaro (706–64) in memory of his father, Muchimaro (680–737). If this is true, it means that it was built before 764, the date of Nakamaro's death. The compactness of the hall made it necessary to achieve an effective use of the limited space. The inner sanctuary is thus square in shape, and the method of joining the pillars of the wall and those of the inner sanctuary displays extreme skill (Fig. 45). The painted designs of the interior remain quite distinct. It is not known whether the hall was enclosed by a corridor.

What was the significance of building a round hall? The fact that the Horyu-ji Yumedono was constructed for Prince Shotoku, the Kofuku-ji North Round Hall for Fujiwara Fuhito, and the Eizan-ji Octagonal Hall for Fujiwara Muchimaro implies that round halls were memorial structures for the deceased. In relation to this surmise, it is of interest to note that the roof of the Yumedono has a funeral urn at its top.

REPOSITORIES The repositories of Nara-period temples were basically storehouses for temple property. They fall into two groups: sutra repositories and treasuries.

Only a few repositories survive from the Nara period. The Sutra Repository of the Horyu-ji West Precinct, built in the so-called turret-structure style, is three bays long and two bays deep and in fact is sometimes referred to as the Sutra Turret. It is a two-story building, but instead of a first-story roof it has a veranda around the second story (Fig. 129). Some belfries and gatehouses are also in this style. The Toshodai-ji has sutra repositories in both the turret style (Fig. 89) and the log-cabin style (Fig. 68).

As the name suggests, treasuries are storehouses for temple treasures. The chief style of the Nara-period treasury was the log-cabin style, in which logs were interlocked to form a square structure known as a "single-unit log cabin." The "side-by-side log-cabin" structure was composed of two single-unit log cabins built one bay apart and connected in the middle. The building looked as though three log cabins had been connected, and it was commonly referred to as a "triple-unit log cabin." The Shoso-in Repository (Fig. 128) is the only extant example of the side-by-side log-cabin type, all other extant treasuries being of the single-unit type. Among the latter, the Shoso-in Sacred Word Repository is considered to date from the

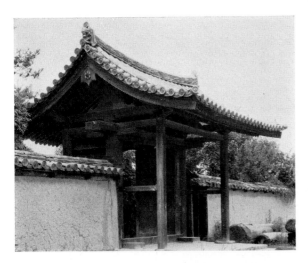

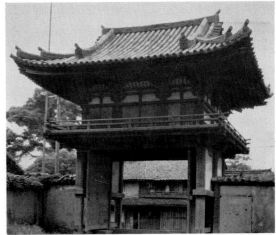

Heian period, but the others are all from the Nara period. The Horyu-ji Government-sealed Repository is an example of the three-by-two-bay planked treasury thought to date from the Nara period, although there are some minor problems in connection with the dating. It was extensively repaired in 1308 and again in 1523–24, and a complete restoration to its original state has now been accomplished.

A treasury allowed to be unsealed only by permission of the Sanko, a government bureau in control of temples, was called a government-sealed repository. One that could be unsealed only by permission of the emperor was known as an imperial-sealed repository.

GATES There is considerable variety in the structure of temple gates. An "eight-legged" gate is a one-story three-by-two-bay gate. Since it is three bays long, four pillars stand lengthwise along the central axis, four in the front, and another four in the back. The name of the gate style comes from these last eight pillars, or legs. In Nara-period temple compounds, south main gates were of five-by-two-bay style, while other gates facing boulevards and alleys were eight-legged gates of three by two bays, which became the standard fixed

form. Thus the Todai-ji Tegai Gate (Fig. 35), to which bracketing was added in the Kamakura period, and the Horyu-ji East Main Gate (Fig. 204) are in the same style despite their apparent difference in size. Each has a gabled roof, double rainbow beams, and frog-crotch struts. Exposed in their interior is the open-timbered ceiling with purlins on both sides of the ridgepole (called a three-ridge construction). The Horyu-ji Inner Gate has a double roof (Fig. 199). Many other types of gates will be discussed in later chapters.

STONE PAGODAS Multistoried stone pagodas
AND STONE of the Nara period include
BUDDHAS the seven-storied one at the Eizan-ji (Fig. 200), the thirteen-storied one (of which only six stories survive) at To no Mori (Fig. 200), and the thirteen-storied one at the ruins of the Rokutan-ji (Fig. 200). The last of these stands on the Osaka Prefecture side of Mount Nijo, where there was much quarrying of tuff during the Asuka and the Nara periods.

Some interesting stone statues of Buddhas of the Nara period may be found at the Skull Pagoda, a pyramidal earthen stupa in Nara each of whose

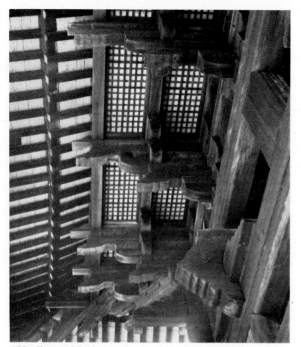

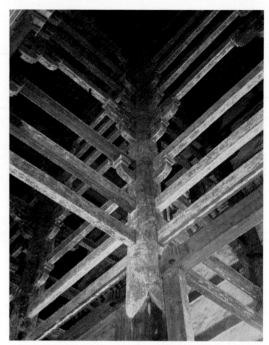

132. *Eaves of Belfry, Todai-ji, Nara. Dated 1207–10.*

133. *Penetrating ties of South Main Gate, Todai-ji, Nara. Reconstructed in 1199.*

sides measures approximately 25 meters. The stupa is said to house the relics of the monk Gembo's skull. Around it were placed stone images of Buddhas, of which thirteen survive today. Stone Buddhas ranging in date from the Nara through the Heian period are preserved in the Jigokudani Caves of the Saints on Mount Kasuga, east of the city of Nara. Other rare examples include the stone-cave Buddhas at the Ishikiri Pass on Mount Kasuga, stone Buddhas on Mount Ho, and the Buddhas carved on the face of a cliff at the Ono-dera.

CHAPTER FOUR

—•—

New Temples for a New Age

WITH THE APPEARANCE of the monk Dokyo in the political arena, the evil of the interference of temple power in national government reached its climax. Despite the strenuous efforts of the emperors Konin (709–81) and Kammu (737–806) to correct the state of corruption, the situation was far from being rectifiable, and finally Emperor Kammu resolved to banish the deep-rooted evil by moving the capital, first in 784 to the temporary capital of Nagaoka and then in 794 to Heian-kyo, the modern city of Kyoto. The former capital of Nara was now on the wane, but this does not mean that its temples and shrines also declined. On the contrary, the temple power of Nara, then called the Southern Capital, was still so strong that the government could not easily overlook it.

THE EMERGENCE OF MOUNTAIN-AREA TEMPLE COMPOUNDS Around this time the great teacher-priests Saicho (767–822) and Kukai (774–835) initiated strong new currents in the world of Japanese Buddhism by introducing from China the Tendai (in Chinese, T'ien-t'ai) and the Shingon (in Chinese, Chen-yen), or True Word, sects respectively. Both of these men, determined not to repeat the evils that emerged in Nara-period Buddhism, carefully selected locations remote enough from the capital for the purposes of adequate religious discipline. Saicho built the Enryaku-ji on Mount Hiei, northeast of Kyoto; Kukai, the Kongobu-ji

on Mount Koya, in present-day northeast Wakayama Prefecture. It was these temples that marked the origin of mountain-area temple-compound layouts, in which there was no fixed pattern and in which the halls were placed freely according to the conditions imposed by the topography. Of course many temples were also still built in the compound-layout styles of the Nara period—for example, the Kyoto temples Kyo-o-gokoku-ji (also known as the To-ji) and Daigo-ji. Although the Kyo-o-gokoku-ji became a Shingon-sect temple when it was bestowed upon Kukai as a seminary, the layout of its compound was in the traditional style.

Later the Jodo (in Chinese, Ching-t'u), or Pure Land, sect began to flourish, and its influence on architecture immediately expressed itself in the construction of a vast number of halls enshrining images of the Buddha Amida (Figs. 59, 136). A popular yearning for the paradise of the Pure Land led especially to the building of many halls that were supposed to be copies of Amida's palace in this paradise. There were two variations in this new style. One of these had a corridor coming out of both sides of the golden hall and extending its two wings southward to reach the two towers—that is, the belfry and the sutra repository—as was the case at the Hossho-ji in Kyoto (Fig. 138) and the Motsu-ji in Hiraizumi, Iwate Prefecture. The other variation had corridor wings coming out of both sides of a central structure. Examples of the latter are the Phoenix Hall of the Byodo-in at Uji

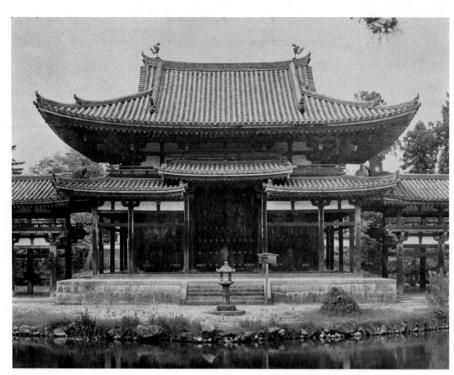

134. Central structure of Phoenix Hall, Byodo-in, Uji, Kyoto Prefecture. Frontage, 14.2 m. Dated 1053.

135. Inner sanctuary, Golden Hall, Muro-ji, Muro, Nara Prefecture. Ninth century. ▷

in Kyoto Prefecture (Fig. 134), the Yofuku-ji in Kamakura, and the Muryoko-in in Hiraizumi. Although this new style became the characteristic one during the late Heian period, its influence was not strongly reflected in Yamato Province (the present Nara Prefecture), where the mainstream of temple architecture preserved the tradition of Nara-period Buddhism. The only example of a mountain-area temple in the province is the Muro-ji.

The remnants of the Muro-ji are located among the hills of Uda County (Nara Prefecture). The temple is associated with the Shinto shrine Ryuketsu-jinja and is said to have been founded by the Kofuku-ji priest Kengyo late in the eighth century. Its halls and pagodas are laid out in conformity with the topography. The surviving buildings from the Heian period are the Five-storied Pagoda and the Golden Hall. A charming structure with gentle,

feminine proportions, the Five-storied Pagoda (Fig. 49) is a small one only a little more than 16 meters tall and measures only 2.5 meters on each side of its first story. There is a theory that upholds the Nara-period origin of the pagoda, but if the roofs were originally thatched, as they are now, its Heian-period origin, obvious from the sense of gentleness communicated by its overall appearance, is all the more evident. In place of water-flame ornaments, its sheet-copper finial has a tiered canopy of wheel-like rings overhanging a vessel of the type used for containing the legendary ashes of Sakyamuni. This is an interesting design not seen in other pagodas.

The Golden Hall is a relatively simple one, built on a five-by-four-bay floor plan (Figs. 50, 135). Its roof is hipped, and there is a pentroof in the front, which was repaired during the Edo period. That

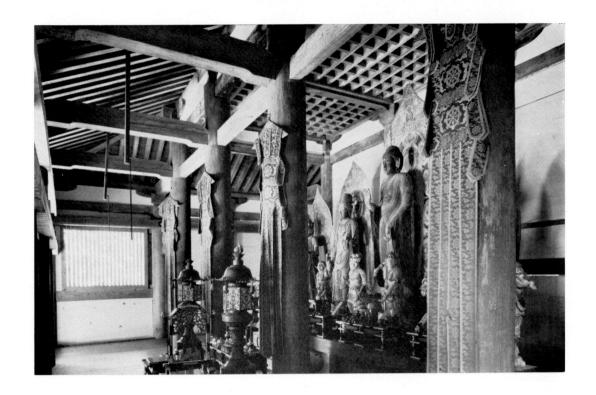

the pentroof is not the product of a recent remodeling is evidenced by an illustration in the Toshodai-ji's *Dempo Kanjo Saho* (Rules for the Initiation Ceremony) of 1303. The roof was formerly hipped and gabled, the ceiling of the core structure was open-timbered, and the bracket system was of the one-block type.

The Muro-ji has many Buddhist statues from the Heian period. The statue of Sakyamuni in the Miroku Hall is a superior work in the typical Heian "rolling-wave style" (in Japanese, *hompa-shiki*), in which ridges and troughs were carved alternately to show the folds of the drapery. In the Golden Hall is a statue of Sakyamuni that heralds the mellowness of sculpture in the late Heian period. The mandorlas of the Muro-ji statues and the Taishaku Ten Mandala painted on the rear wall of the inner sanctuary of the Golden Hall are extremely valuable works of painting from the early Heian period.

THE DESTRUCTION OF NARA'S GREAT TEMPLES

After the middle of the Heian period, Kyoto became the new center of temple-contruction enterprises. In the meantime, Nara endured the challenge of rivalry by holding fast to centuries-old traditions. But this period of coexistence was brief, and a fatal collapse occurred late in the Heian period. Toward the end of the year 1180 a fire started by the army of Taira Shigehira completely destroyed the great temple compounds of the Kofuku-ji and the Todai-ji. The prosperous temple of the Fujiwara clan and the dignified monastery that had been a symbol of national Buddhism since the late Nara period were turned to ashes in a single night. Fujiwara Kanezane (1149–1207) describes

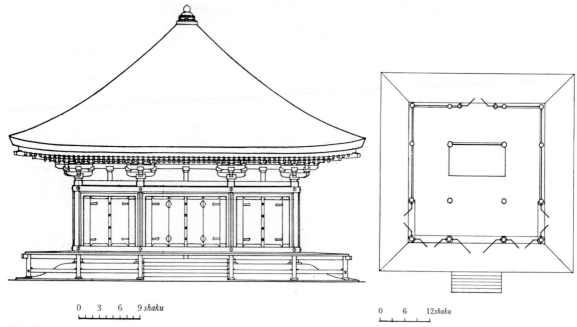

0 3 6 9 shaku

0 6 12 shaku

136. *Front elevation and floor plan of Shiramizu Amida Hall, Ganjo-ji, Fukushima Prefecture. Dated 1160.*

in his diary *Gyokuyo* the thoroughness of the destruction in the old capital: "Everything was lost with the exception of the Zenjo-in temple, a few nearby huts, a few others on Mount Kasuga, and some cottages to the west of the Shin Yakushi-ji." In an expressive phrase that symbolizes the fall of Nara, he speaks of the disaster as the "fiery catastrophe of the Southern Capital."

TEMPLE ARCHITECTURE OF THE HEIAN PERIOD

In the Heian period, when several hundreds of years had gone by since the introduction of continental styles of architecture into Japan in the mid-sixth century, the time was ripe for native Japanese trends to emerge. Especially after the practice of sending envoys to T'ang China was discontinued in 894, the cessation of

direct cultural exchange with the Asian mainland stimulated the naturalization of all phases of the culture. Architecture was no exception to this trend. Many buildings with distinctive features of the Heian period, such as the Phoenix Hall of the Byodo-in (Fig. 134), were constructed when the nobility were at the zenith of their prosperity. Artistic and luxurious designs were favored, and the taste for extravagance and technical intricacy created a drastic change in the overall appearance of the structures. The basic architectural design, however, was the one that had been developed and standardized in the Nara period. The double-raftering technique was employed for the eaves and the three-handed system with slanting struts for the brackets of important buildings—exactly the same construction as seen in the Toshodai-ji Golden Hall (Fig. 58). In the interior as well, the Nara-period

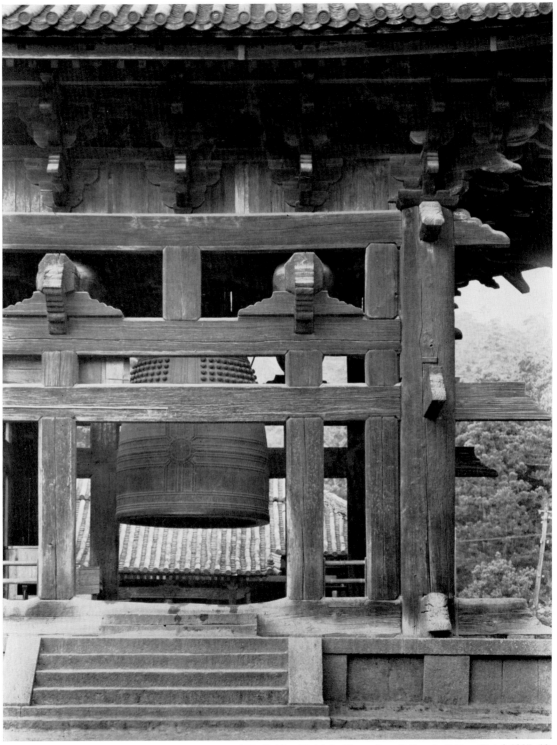

137. *Belfry, Todai-ji, Nara. Area, 7.5 m. by 7.5 m. Dated 1207–10.*

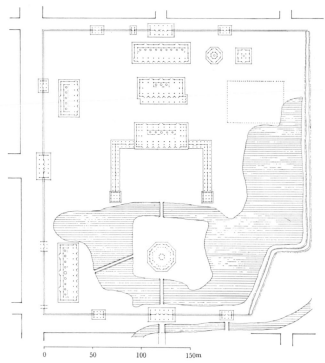

138. *Layout plan of Hossho-ji, Kyoto, as restored by Dr. Toshio Fukuyama. The temple was originally completed in 1077 and was restored after having burned down in 1342, but it is no longer extant.*

heritage can be readily observed in the use of the coved-and-latticed ceiling with greater rainbow beams and frog-crotch board struts—for example, in the Phoenix Hall. In short, as far as basic techniques of construction are concerned, the temple architecture of the Nara and the Heian periods comprises one lineage.

During the Heian age many small halls were built. Obviously a one-by-one-bay hall was the simplest, but except for special cases it could not serve adequately as a Buddha hall. In general, a Buddha hall of the smallest size consisted of a one-by-one-bay inner sanctuary and a one-bay-wide space around it. Many of the Amida halls of the Heian period were of this type (Fig. 59).

Some of the structures of Nara-period temple compounds were not built until the Heian period, and some were simply repaired, remodeled, or completely rebuilt. The Horyu-ji Lecture Hall and Belfry were destroyed by fire in 925 but were rebuilt in 990 and 990–94 respectively. The Taima-dera West Pagoda and the Toshodai-ji Worship Hall (East Wing), used as monks' quarters, were built in late Nara or early Heian times.

Works in stone created during Heian times include the Taima Five Elements Stone Pagoda, consisting of five parts representing air, wind, fire, water, and earth; the famous Citron Tree Lantern at the Kasuga Shrine, surmised to have been made in 1137 (Fig. 202); the Muro-ji Sutra-offering Pagoda, at the foot of which a "jewel of satisfaction" was buried; and the Butsuryu-ji Stone Chamber, in which a five-elements stone pagoda is housed. Some of the stone Buddhas in the Jigoku-dani Caves of the Saints are also from the Heian period.

CHAPTER FIVE

Reconstruction and Reformation

AFTER THE "fiery catastrophe of the Southern Capital," the reconstruction of national temples was planned. These were temple monasteries of long tradition and were too great to be left neglected. But the temples of the old capital of Nara were no longer under the patronage of the government, and the immensity of the task of rebuilding them seemed almost insurmountable. It was only the Kofuku-ji and the Todai-ji that were fortunate enough to find powerful supporters: the Fujiwara and the Minamoto clans.

A CASE OF RESTORA-
TION: KOFUKU-JI
The reconstruction of the Kofuku-ji was begun by the Fujiwara clan around 1181. By the autumn of that year a temporary refectory had been built, and under its unfinished roof was held the Yuima-e, an annual series of lectures on the *Yuima-gyo* (Vimalakirti Nirdesa Sutra), a sutra concerning Yuima (Vimalakirti), a lay follower of the historical Buddha. The reconstructed Refectory survived until the Meiji era.

The rebuilding of the temple proceeded rapidly after Fujiwara Kanezane became regent in 1186. By 1194, most of the principal structures had been completed, and opening ceremonies were held. As we have noted in relation to the East Golden Hall and the Middle Golden Hall, the new construction of the Kofuku-ji was carried out in an extremely conservative manner. Among the buildings re-

stored immediately after the "fiery catastrophe," however, only the North Round Hall and the Three-storied Pagoda survive today.

The North Round Hall (Fig. 139) was among the first buildings to be reconstructed. Inside its principal statue is an inscription dating from 1210, and in that same year the "sacred ball" and the "dew basin" were placed atop its roof. The ground plan is believed to be identical with that of the original, and no techniques representing new styles were employed. In the details of the building, however, the influence of current trends is apparent (Figs. 85, 144, 145). In bracketing, for example, a reassuring sense of serenity had been characteristic of the Nara style, while the Kamakura-period version is bulky, tightly built, and stiff. The sense of voluminosity is further enhanced by the laborious piling up of the bracket complexes. The triple-raftering technique of the eaves is rather unusual, but it helps to break the monotony of the underside of the eaves, as was supposedly intended, by making it look a bit crowded. The hexagonal shape of the base rafters is an inheritance from the round rafters of the Nara period, and the use of a specially thick section of wood for the central member of the base rafters on each side seems to have been a device to create a strong sense of support, not only at the corners but also in the center. The roof is slightly swollen at the peak and shapes into a curve near the lower edge. This effective technique of giving a gentle look to the slope of the roof, prob-

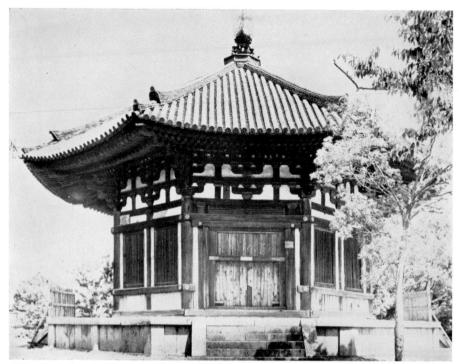

139. *North Round Hall, Kofuku-ji, Nara. Length of one side, 4.9 m. Second remodeling; framework completed in 1210.*

ably used from the Heian through the Kamakura period, can also be seen in the Choju-ji in Shiga Prefecture and in the miniature bronze pagoda, inscribed with the date of 1172, of the Matsuzaki Shrine in Yamaguchi Prefecture. The North Round Hall is a superior structure whose overall shape most decidedly conveys a feeling of bulkiness and stability.

The Three-storied Pagoda was originally built in 1143 at the request of Emperor Sutoku's consort, Koka-mon'in (1122–81). Although the exact date of its rebuilding has not been ascertained, there is no question that it was rebuilt after the fire of 1180. In contrast with the North Round Hall, which is bulky and heavy-looking, this pagoda is slender, delicate, and quite gentle in appearance (Fig. 87). It is not clear at all why there is so great a difference

in style between the two buildings despite the small difference in their dates of construction. Perhaps the stylistic difference is attributable to the late-Heian-period origin of the pagoda and its association with Koka-mon'in. The original pagoda is said to have had a "swelling" on the topmost roof similar to that of the North Round Hall.

Most of the Buddhist statuary of the Kofuku-ji has now been collected and placed on display in the Kofuku-ji National Treasure Museum, although the chief statues of the respective halls, together with a few other images, still remain in their places. In addition to the previously mentioned Tempyo sculpture, much of the temple's Kamakura-period sculpture has fortunately survived—particularly works by sculptors of the school of Unkei (died 1223), the artist who contributed

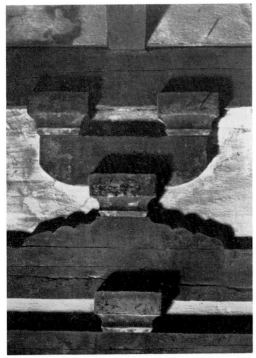

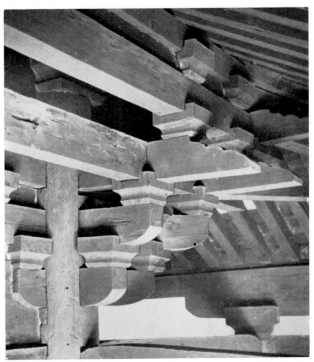

140. *Two-block bracket in Great Buddha style, Founder's Hall, Todai-ji, Nara. About 1199.*

141. *Bracket complex in Great Buddha style, Founder's Hall, Todai-ji, Nara. About 1199.*

greatly to the establishment of Kamakura sculpture in its aspects of restoration and realism.

The statues of the Fukukenjaku Kannon (Amoghapasa), the Four Guardian Kings, and the Six Patriarchs of the Hosso Sect (Hosso Rokuso), enshrined in 1189 in the South Round Hall, are all works by Unkei's father, Kokei. Those of Miroku, his disciple Mujaku (Asanga), and Mujaku's brother Seshin (Vasubandhu), all originally in the North Round Hall, bear inscriptions stating that they were produced by Unkei and his followers in 1208. They are superlative examples of the perfected artistry of the mature Unkei, and the images of Mujaku (Fig. 142) and Seshin, in particular, display a vivid realism and an excellent sense of volume. The statue of Monju (Manjusri), the Bodhisattva of Wisdom, produced by Unkei's col-

league Kaikei around 1202, is one of the famous so-called Three Monju of Japan, and those of the Kongo Rikishi (Vajrapani) are also said to be from his hand. The works of Unkei's follower Jokei include the images of the layman Yuima, dated 1196 (Fig. 143), and Bon Ten, dated 1202. Both are characterized by a strong human touch and have a startlingly lifelike look. The unrestrained craftsmanship of Unkei's third son, Koben, created the richly humorous Demon Shouldering a Lantern (Tento-ki) and Demon Carrying a Lantern on His Head (Ryuto-ki).

The firmly rooted tradition of the Kofuku-ji is still vividly felt through these sculptures, even though the Kamakura period, when the reins of government shifted to the hands of the warrior class, no longer witnessed the same glorious Fuji-

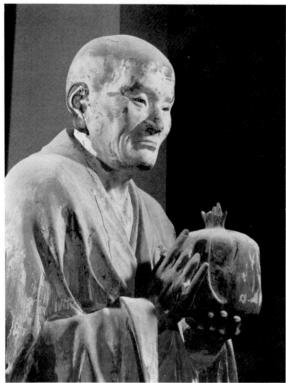

wara clan that had dominated Japan during the preceding Heian period.

A CASE OF INNO-VATION: TODAI-JI In contrast with the reconstruction of the Kofuku-ji, which was accomplished by the conservative Fujiwara clan, that of the Todai-ji was sponsored by the newly risen Minamoto clan. It was Chogen (?–1195), a monk of the Jodo sect, who was appointed and held responsible for the restoration of the Todai-ji. In order to avoid the economic and technical difficulties that he foresaw in a gigantic enterprise of this sort, he adopted a new style of architecture called the Daibutsu-yo (Great Buddha style) or Tenjiku-yo (Indian style) —a style that he developed from the techniques he had learned in China during the dynasty of the Southern Sung (1127–1279). Although most of the temple compound reconstructed by Chogen was destroyed by fire in 1567, the South Main Gate survived, and through it we can get to know the features of the Great Buddha style (Figs. 81, 84, 156). In my view, priority was given to efficiency of construction, which Chogen considered the most important factor for the completion of the undertaking. More specifically, he standardized the building materials, employed a simple method of engineering, and made extensive use of penetrating ties: long tie beams that pierced the pillars (Fig. 133). The reason why penetrating ties were used was that they were extremely economical. Even a few of them were sufficient to strengthen the structure, for which purpose a large quantity of material had been necessary in earlier methods of building.

142 (opposite page, left). Mujaku (Asanga), disciple of Miroku (Maitreya), by Unkei, North Round Hall, Kofuku-ji, Nara. Colors on wood; height of entire statue, 194 cm. Dated 1208.

143 (opposite page, right). The Buddhist layman Yuima (Vimalakirti), by Jokei, East Golden Hall, Kofuku-ji, Nara. Colors on wood; height of entire statue, 89 cm. Dated 1196.

144. False frog crotch in North Round Hall, Kofuku-ji, Nara. Such decorations were usually painted or sculptured on the wall on both sides of block-on-strut posts, as shown at top right.

My view is further substantiated by the fact that the standardization of materials was more thoroughly carried out for the South Main Gate than for other projects in which Chogen followed the same practice—for example, the Pure Land Hall of the Jodo-ji in Ono, Hyogo Prefecture (Figs. 157, 158). In design, Chogen gave priority to structural beauty—a beauty no longer in the realm of the "artistic refinement" of Heian-period architecture. The two statues of the Kongo Rikishi in the South Main Gate are the works of Unkei and Kaikei.

The Great Buddha Hall was completed in 1195, a little earlier than the South Main Gate, but it burned down in the fire of 1567. Figure 146, based on reliable sources, pictures the building as it was reconstructed by Chogen. In the autumn of 1187, Fujiwara Kanezane wrote in his diary Gyokuyo:

"As regards the lumber gathered for the construction, there were three core-structure pillars that measured 65 shaku in length and 5.2 shaku in diameter; two pentroof pillars 75 shaku in length and 4.8 shaku in diameter; two rainbow beams of which one was 50 shaku long and 5 shaku in diameter and the other 50 shaku long and 4.8 shaku in diameter; the ridgepole, which measured 130 shaku in length and 2.2 shaku in thickness; and eight rafters, the long ones being 52 shaku in length and the short ones 47 to 48 shaku." The Todai-ji Zoritsu Kuyoki (Commemorative Record of the Todai-ji Construction) records in its entry for the twenty-seventh of the seven month in 1190 that "first, two core-structure pillars of the Great Buddha Hall were erected. They were 91 shaku long and 5 shaku in diameter." The large-scale reconstruction of the

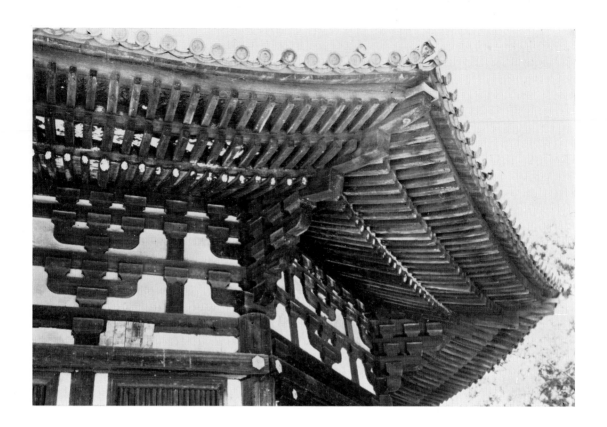

central part of the temple compound was more or less completed by the end of the twelfth century.

According to the *Namu Amida Butsu Sazenshu,* a work in which the virtuous deeds of Chogen are recounted, the Founder's Hall was built around 1199, completely in the Great Buddha style (Figs. 140, 141). The Belfry was built around 1210 by Eisai (also called Yosai; 1141–1215), the founder of Japanese Zen Buddhism. The employment of the Chinese Sung-dynasty style in the Belfry is quite apparent, although the same style cannot be seen in other structures (Figs. 82, 132, 137). The Lotus Hall North Gate was probably built after the repair of the Worship Hall early in the Kamakura period. Within the precinct of the Second Month Hall are the Water-offering House (a wellhouse), the Rice-offering House (a cooking area), and the Retreat House (to which a refectory was attached). The last of these, built during the

thirteenth century, is the monks' quarters used every March for the Shuni-e ceremonies of praying for peace and prosperity. Perhaps the most well known of the Shuni-e rituals is the Omizu-tori, in which the monks go to the Water-offering House to get water that is supposed to cure illness. Like the Retreat House, the Lotus Hall Hand-washing House is an example of monks' quarters dating from the Kamakura period. The Invocation Hall (Nembutsudo) and the Contemplation Hall (Sammaido) are both three bays long and three bays deep. The statue of the Bodhisattva Jizo in the former bears an inscription dated 1237. Other works of sculpture produced after the fire of 1180 include Kaikei's statues of Jizo and the Shinto god Hachiman represented as a monk, both of which display the sculptor's graceful taste, and a statue of the Buddhist saint Chogen carved in the style of the Unkei school.

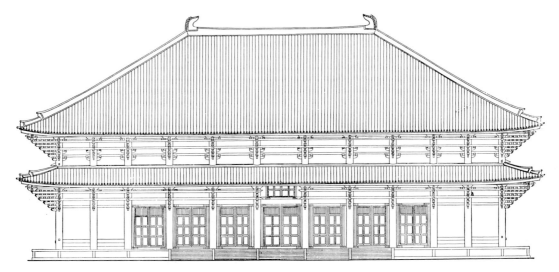

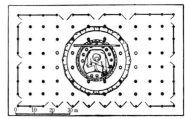

146. *Author's restoration of Great Buddha Hall, Todai-ji, Nara, as reconstructed by Chogen. Scale of elevation: 1:700. Eight central pillars, indicated by white circles in the floor plan, were added in the reconstruction. Completed in 1195; destroyed by fire in 1567.*

◁ 145. *Eaves and brackets of North Round Hall, Kofuku-ji, Nara. Second remodeling; framework completed in 1210.*

THE REFORMATION MOVEMENT IN BUDDHISM: JOKEI AND EISON

As government by the aristocracy began to collapse in the latter half of the Heian period, the authority of Esoteric Buddhism, which had been tied to the aristocracy by its magical element of secret power, was shaken. This trend was furthered by the degeneration of Esoteric Buddhism itself. Movements for religious reform arose as early as the end of the Heian period, and they became more forceful in the early Kamakura period. The introduction of the Zen (in Chinese, Ch'an) sect from China—a sect that emphasized religious discipline in full earnestness—incited a sentiment for the reformation of Nara Buddhism and thereby produced a reactivation of such sects as the Hosso, the Kegon, and the Ritsu. One of the renovations was a revival of the Shaka Nembutsu-e, a ceremony for the invocation of Sakyamuni's name: an expression of longing for the time and aura of the historical Buddha. Another was based on a lesson from the Ritsu sect, the greatest legacy of Nara Buddhism. As the Jodo sect became more powerful during the Heian period, the misapplication of its teachings produced a large number of corrupt monks who did not obey the religious commandments. The precepts of the Ritsu sect called for a movement for the correction of the prevailing loose faith and careless practice of religious disciplines.

Among the leaders of this restoration movement, the most influential were Jokei (1155–1213) and Eison (1201–90). Jokei (not to be confused with the sculptor Jokei) established his base of operations at the Toshodai-ji, Eison at the Saidai-ji. It is interesting to note that both of these temples had been in a state of decline at the end of the Heian period. The circumstances of the Toshodai-ji are

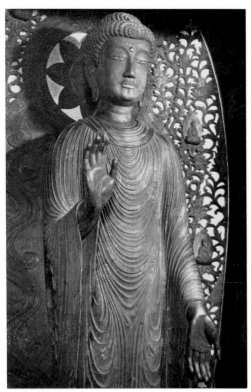

147. *Sakyamuni, the historical Buddha, Worship Hall (East Wing), Toshodai-ji, Nara. Gold-leaf flecks on wood; height, 163.6 cm. Dated 1258.*

the Saidai-ji was in similar circumstances is known from the frequently quoted personal record of Oe no Chikamichi, where we read: "Barely surviving are the Refectory and the Shio-in alone, and even the Refectory is greatly damaged. The mural painting of Miroku's Pure Land in the Golden Hall has also deteriorated. The remaining statues of Buddhas and Bodhisattvas are now installed in the Refectory." The chief motivation for Jokei and Eison to conduct their activities at these two temples is believed to have been the inconveniences they were likely to have met at such other great temples as the Kofuku-ji and the Yakushi-ji, where the traditions, although in decline, were still so strong as to hamper free and innovational pursuits.

Jokei studied the doctrines of the Hosso and Ritsu sects under the supervision of Kakuken (1131–1212) at the Kofuku-ji around the beginning of the Kamakura period. He came to be venerated by the imperial court, but in 1192 he withdrew to the Kasagi-dera in Kyoto. Sixteen years later he moved to the Kaijusen-ji, also in Kyoto. By this time he had reinstituted the Shaka Nembutsu-e at the Toshodai-ji and had propagated the maintenance of faith in Miroku. Among the objects of worship at the Toshodai-ji were three thousand grains of the legendary ashes of Sakyamuni, said to have been brought from China by Ganjin and kept in the Sutra Tower (Fig. 89), a building erroneously known today as the Drum Tower, even though no drum has ever been installed there. Giving attention to the fact that the ashes were kept in this building, Jokei turned the southern half of the East Monks' Quarters, which lay immediately east of the Sutra Tower, into the Worship Hall, so that these sacred relics might be adored from the east in proper fashion. In addition to this innovation, he commissioned a copy of the statue of Sakyamuni at the Seiryo-ji in Kyoto—a work known to have been transmitted from Sung China—and enshrined it in the Worship Hall (Fig. 147). Each time the Shaka Nembutsu-e was held, the ashes were to be moved from the Sutra Tower to the Worship Hall. In these ways Jokei contributed to the revitalization of the Toshodai-ji.

His teachings were inherited by two of his

known from the *Genko Shakusho* (Genko-Era Exegeses) of 1364, a thirty-volume outline of the history of Buddhism from its arrival in Japan up to 1322. This work includes a biography of Nakagawa Jitsuhan (?–1144), a scholarly monk and an earnest advocate of restoring the Ritsu-sect teachings who visited the Toshodai-ji at the beginning of the twelfth century. "After the age of the missionary monk Ganjin," the record tells us, "the temple halls decayed quickly, housing only a few ordinary monks. Covered by weeds, half of the temple yard was eventually turned into rice fields. Not a monk was to be seen inside the temple itself, and the only person to be observed nearby was a bald farmer whipping his ox on as he plowed his field." That

148. *Square-roofed circular pagoda (Ho-to) given by Eison, Saidai-ji, Nara. Iron; height, 172.7 cm. Dated 1283.*

149. *Miniature reliquary pagoda, Saidai-ji, Nara. Gilt-bronze openwork; height, 37 cm. Dated 1249.*

disciples, Kakushin (1207–98) and Kainyo. The former established the Joki-in subtemple of the Kofuku-ji and propagated the precepts of the Ritsu sect. The latter, while teaching moral codes at the Todai-ji, fostered many Buddhist geniuses. Among the most brilliant of his pupils were Kakujo (1194–1249) and Eison. Kakujo, residing at the Toshodai-ji by imperial decree from 1243 on, revived various religious ceremonies that had been discontinued for years and undertook extensive repairs in the temple compound. Among the Buddhist statues produced during this renovation period, the image of Miroku in the Lecture Hall, thought to have been carved in 1287, is a dignified one measuring 8 *shaku* in height. The large drum and the cere-

monial bell also date from the Kamakura period.

Eison, also called Shien (Fig. 150), at first studied the doctrines of the Esoteric Shingon sect at the Daigo-ji in Kyoto and the Kongobu-ji on Mount Koya. The second of these two temples, as we have seen, was established by Kukai, founder of the Shingon sect. Eison, having been greatly moved by Kukai's admonition that no one could truly be a Buddhist if he violated the moral precepts (*vinaya*), devoted himself to the study of these precepts under Kainyo and, in 1235, took up residence at the Saidai-ji. There, under strict observance of moral codes, he succeeded in attracting many believers. More specifically, he adopted the practice of the Shaka Nembutsu-e and commissioned a copy of

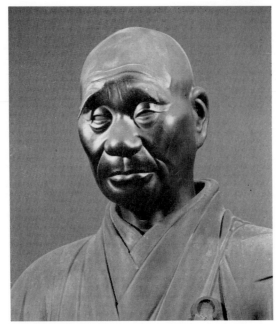

150. Eison, founder of the Shingon Ritsu sect, by Zenshun, Saidai-ji, Nara. Colors on wood; height of entire statue, 89 cm. Dated 1280.

the Seiryo-ji statue of Sakyamuni, just as Jokei had done. In addition, by combining the relevant elements of the Shingon and the Ritsu sects, he created a new sect called the Shingon Ritsu and, with the aid of his disciple Ninsho (1217–1303), strenuously engaged in charity and relief work. This latter activity, though new in form, was old in spirit, for it had been a tradition of Nara Buddhism since the time of Prince Shotoku. By these means the Saidai-ji attracted popular attention and, benefiting from the votive offerings of the faithful, was restored to life, even though it was now smaller in scale than it had originally been.

Next, Eison dispatched Ninsho to the eastern provinces—that is, the Kanto region—to propagate the doctrines of the Saidai-ji. Because Ninsho won great trust among the warriors of the new military-government regime, now established in Kamakura,

Eison himself was finally invited to this city, which had become the de facto capital of Japan. He arrived in Kamakura in 1262. The austerity of his religious precepts and activities made such a deep impression on the warriors that the shogunal regent Hojo Tokiyori (1227–63) even offered him some land to be appropriated to the Saidai-ji. But the stern character of Eison did not permit him to accept the offer, and soon after that he returned to Nara.

Among the artifacts of the Saidai-ji from this period, in addition to the already mentioned statue of Sakyamuni, are more than ten miniature reliquary pagodas (Figs. 148, 149) that speak of the popularity of relic worship. There is also a statue of Aizen Myo-o (Ragaraja) that Eison worshiped by imperial decree in supplication for the repulse of the Mongol invasions of 1274 and 1281.

Temple Architecture
of the Kamakura Period

JUST AS THE REFORMATION movement in Buddhism was reflected in sculpture, so it was natural that it should also be reflected in architecture. We have already observed that the architectural techniques of the Nara and Heian periods belonged to one lineage. During the Kamakura period, however, a number of new developments took place. As we have noted, a new style called the Daibutsu-yo, or Great Buddha style, was employed by Chogen in the reconstruction of the Todai-ji. Next, the technique of Sung-dynasty China was introduced along with Zen Buddhism and was given the name Zenshu-yo—that is, Zen-sect style. Thus the Kamakura period saw the employment of three basic styles of architecture: the Great Buddha style (also called the Indian style), the Zen-sect style, and the native, or Japanese, style (Wa-yo) handed down from the Heian period. Soon the influence of the new styles on the native style led to the emergence of the *setchu-yo,* or eclectic styles. (See Foldout 2.) It is of great importance to grasp the genealogy of these styles in order to fully understand the evolution of Japanese temple architecture.

WA-YO: THE JAPA-
NESE STYLE
By Kamakura times, most of the temples built during the Nara period were more than five hundred years old, and therefore

they called for large-scale repair work, reconstruction, or, for all practical purposes, entirely new construction. It was a natural tendency, not only in the case of repairs but also in the case of completely new construction, to build temple halls and pagodas in a restorative manner—that is, in their original form and style. The North Round Hall and the Three-storied Pagoda of the Kofuku-ji are good examples of this type of rebuilding. The Horyu-ji is no exception to the tendency. For example, the Upper Hall follows the Nara-period style in floor plan as well as in overall structure, and it is only the details of the bracket complexes and the timber allotment that show any trace of Kamakura-period influence (Fig. 151). The same applies to the East Precinct Worship Hall, the corridors, and the Reliquary complex, although their scale has been slightly modified. It applies as well to the Taima-dera Golden Hall (Figs. 90, 152) and Lecture Hall, not to speak of the Mandala Hall built late in the Nara period and remodeled during the Heian and Kamakura periods (Figs. 154, 155). The Akishino-dera Main Hall, formerly a lecture hall, is basically built in a restorative style and incorporates hardly any new techniques, although details may show some Kamakura-period features resulting from a vast remodeling (Fig. 153).

Since the native Japanese style of the Kamakura

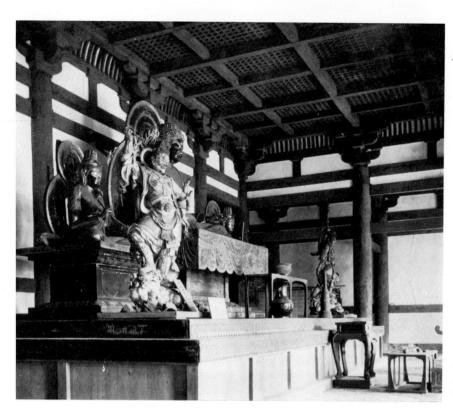

151. *Interior of Upper Hall, Horyu-ji, Ikaruga, Nara Prefecture. Reconstructed in 1318.*

152. *Golden Hall, Taima-dera, Taima, Nara Prefecture. Reconstructed in 1268. Frontage, 12.1 m.* ▷

period inherited the architectural techniques of preceding periods, there were no structural changes of appreciable extent. Artistically, however, certain alterations occurred as the trends of the new age emerged. The main feature of the Kamakura-period Japanese style that distinguishes it from the Nara-period version is its quality of strength—a quality that we may term mechanical vigor. In my opinion there were two structural types that expressed this strength. The first was solidly built with thick wooden members, and its imposing appearance had a kind of overawing effect. The second was not built with thick members, but its parts had organic proportions to one another, comprising a flexible yet firm whole that, together with the tightly braced-up bracketing and the eaves, imparted a feeling of graceful solidity. Examples of the first type are the Taisan-ji in Hyogo Prefecture

and such halls of the early Kamakura period as the Kofuku-ji North Round Hall. These were in the tradition of Nara-period architecture. An example of the second type is the altar of the Horyu-ji Shoryo-in, in which there appears a new form of support structure called the *rokushi-gaku* (literally, "six-limb hanging")—a form in which bracketing, and rafters are more closely related than in former systems (Fig. 171). Having incorporated this new method of bracketing, architecture during and after the Kamakura period took on a look of better organization.

One of the special features of architecture in the Kamakura and later periods was the use of frog-crotch struts in place of intermediary posts like the block-on-strut posts placed between bracket complexes. Whereas the frog-crotch strut of the Nara period had been cut from a thick plank (hence the

name frog-crotch board strut), the new form was embossed and came to be known as a "proper frog-crotch strut." The former was functional as a prop, but the latter was merely ornamental. Proper frog-crotch struts began to be used at the end of the Heian period, and excellent Kamakura-period examples can be seen in the altar of the Horyu-ji Shoryo-in and the Jurin-in.

The fact that the Japanese style survived until as late as the fifteenth century in Nara, as is evidenced by the East Golden Hall and the Five-storied Pagoda of the Kofuku-ji and by the Kiko-ji Main Hall, is due to the special circumstances of Nara itself, where many temples were built on the basis of restoring the traditional style. In other parts of the country, however, most of the structures of the late fourteenth century show the influence of the new styles in one way or another, and, except for

some instances of pagodas, examples of the purely Japanese style are rare. The few examples to the contrary include the Main Hall of the Choju-ji and the Main Hall of the Saimyo-ji in Shiga Prefecture and the Fudo Hall of the Kongobu-ji on Mount Koya, but they all date back to the late twelfth or the thirteenth century. The last of these is a hall in residential style enshrining an icon of Fudo Myo-o (Acala), one of the chief divinities of Esoteric Buddhism.

DAIBUTSU-YO: THE GREAT BUDDHA STYLE The employment of the pure Great Buddha style was confined to structures built by Chogen. After his time the new style was quickly absorbed by the Japanese style, and the buildings connected with Chogen comprised only the halls of the Todai-ji,

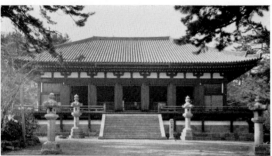

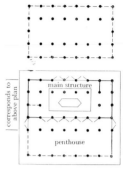

153. Main Hall, Akishino-dera, Nara. Restorative (Nara-period) style. Frontage, 17.2 m. Late twelfth to early thirteenth century.

154. Main Hall (Mandala Hall), Taima-dera, Taima, Nara Prefecture. Restorative (Nara-period) style. Frontage, 21.03 m. Originally constructed in late eighth century; greatly remodeled in ninth to tenth century and in 1161.

155. Successive floor plans of Main Hall (Mandala Hall), Taima-dera, Taima, Nara Prefecture. Left to right: late eighth century, remodeling of ninth to tenth century, remodeling of 1161.

constructed during the early phase of the restoration movement, and seven branch temples built in other parts of the country. Of these, only the Pure Land Hall of the Jodo-ji in Ono, Hyogo Prefecture (Figs. 12, 157, 158), and the South Main Gate and the Founder's Hall of the Todai-ji survive.

In the Great Buddha style, penetrating ties and bracket-arm extensions (long bracket arms that go through pillars) are used in abundance and, when combined with rainbow beams, provide strong support for the overall framework (Figs. 156, 157). The eaves are supported by the bracket complexes that rest on bracket-arm extensions. In the case of the Todai-ji South Main Gate, penetrating ties are extended outward to take the place of some of the bracket-arm extensions. Because of the enormous size of the South Main Gate, seven tiers of bracket-arm extensions, on which the bearing blocks are vertically lined up in orderly fashion, are piled up in order to support the girder. In the case of the Jodo-ji Pure Land Hall, however, only three tiers of bracket arms are used for the same purpose. In

comparison with the construction scheme of the Pure Land Hall, that of the South Main Gate displays less sense of freedom. This limitation is a result of the simplification of the construction work through the use of standardized materials for the purpose of achieving efficiency, which took precedence over all other considerations.

One of the peculiarities of the Great Buddha style is that its bracket complexes never spread sideward but extend only forward—a feature not seen in other styles. The bearing block used in this form of construction is called a *sarato*, or bearing block with a saucer-shaped base—a type that can be found in Chinese and Korean temples and has, in fact, long existed in China. In Japan there had been a break between the time when it was used in the Horyu-ji and the time when it was resurrected through the introduction of the Sung-dynasty style.

The two-block bracketing seen in the Todai-ji Founder's Hall (Fig. 140) was adopted for the first time in the Great Buddha style. On the rainbow

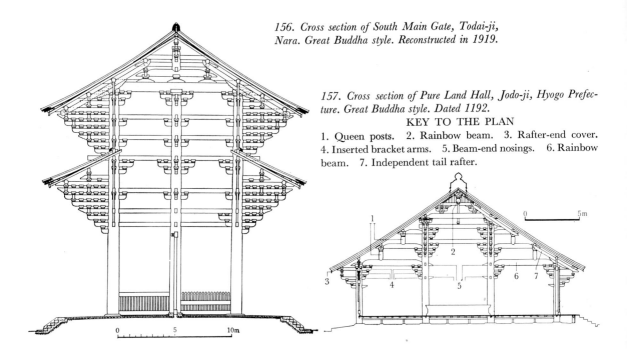

156. Cross section of South Main Gate, Todai-ji, Nara. Great Buddha style. Reconstructed in 1919.

157. Cross section of Pure Land Hall, Jodo-ji, Hyogo Prefecture. Great Buddha style. Dated 1192.
KEY TO THE PLAN
1. Queen posts. 2. Rainbow beam. 3. Rafter-end cover. 4. Inserted bracket arms. 5. Beam-end nosings. 6. Rainbow beam. 7. Independent tail rafter.

beams stood bottle-shaped props (technically known as queen posts) as part of the structure supporting the purlins. Both the rainbow beams and the props were round in cross section for purposes of economy—that is, the wood was used in more or less natural shape to avoid excess expenditure for finishing. Carved on the underside of each rainbow beam was a groove symbolizing a monk's staff—another innovation of the Great Buddha style, since members of the support structure had not been previously decorated in this fashion.

The eaves of buildings in the Great Buddha style also have a distinctive feature: the fan-rib method of raftering, in which the rafters on or near the corners of the roof spread out like the radiating ribs of a folding fan. This technique has a great advantage because the radiating rafters are less vulnerable to load than rafters set in parallel formation, of which the ones close to a roof corner (called hip rafters) simply hang on to the hip ridge and do not yield much force forward. Fan-rib

rafters have long been in common use in China. The rafters are all straight, with no "swelling" or "curving" as was the general style in the medieval age, and their ends are covered by a section of board. Thus they differ from those in other cases, in which the rafter tips are exposed. This device, called the "rafter-end cover," also facilitates the efficiency of construction work, for there is no need to set the rafters evenly before they are fixed in place. All that is required is to cut off the rafter tips evenly after they have been set. The rafter-end cover adequately conceals any irregularity that results from poor cutting, and thus a great amount of labor can be dispensed with.

It was also a distinctive feature of the Great Buddha style to ornament the tips of bracket arms and rainbow beams with a uniform pattern of molding (Figs. 141, 159)—a type of decoration that was subsequently favored by the Japanese style. A frog-crotch strut, of course, is actually a combination of two moldings put togther.

There was also a new development in doors. The

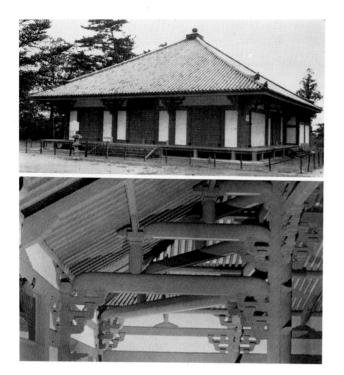

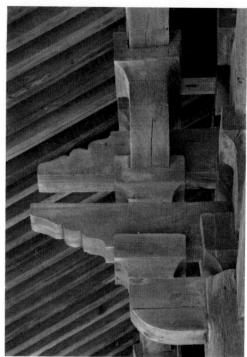

doors of temple halls before and during the Heian period had plain, flat surfaces, and those of the Horyu-ji were all made of single planks. Larger doors were made of several planks held together by crosspieces nailed on the back, as at the Toshodai-ji, or of boards spread on both sides of a previously assembled frame, as at the Byodo-in Phoenix Hall. But during the Kamakura period a new form of door called the "ledged-panel door" made its appearance. This type of door is composed of thin panels inserted in a frame made of large cleats. The ledged-panel doors of the Great Buddha style, as seen in the Todai-ji Founder's Hall and the Jodo-ji Pure Land Hall, are distinguished by their cleats (ledges), which have a ridge in the center, and by the swell of the panels inserted in the frame.

That the Great Buddha style was structurally superior to other styles is clear from the deliberate care given to the building of the Todai-ji South

Main Gate. Again, a study of the Jodo-ji Pure Land Hall conducted during recent repairs showed that the dovetailing had been most skillfully done—so skillfully, in fact, that despite the large size of this building (three by three bays, each bay being about 6 meters wide), there had been little warping of the wood throughout the long span of time since its construction. Nevertheless, there was no elaborate working out of details in the Great Buddha style, for its chief objective was efficiency and the rationalization of materials, and it was quite indifferent to minor matters of appearance. Its beauty lay in boldness of structure and not in embellishment or ornamentation. The visitor who stops to look up at the eaves of the South Main Gate and the interior support structure of the Pure Land Hall is certain to be struck by their grandeur.

Still, the Great Buddha style had virtually no existence after the death of Chogen and left no

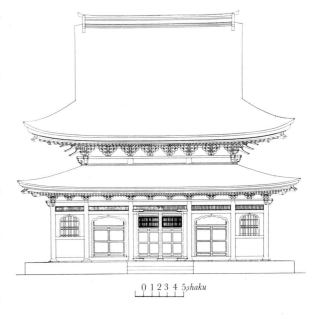

◁ *158 (opposite page, left). Overall view (top) and interior structure (bottom) of Pure Land Hall, Jodo-ji, Hyogo Prefecture. Area 18.2 m. by 18.2 m. Dated 1192.*

◁ *159 (opposite page, right). Moldings in Great Buddha style, worship-hall section of Lotus Hall, Todai-ji, Nara. Dated 1199.*

0 1 2 3 4 5 *shaku*

legacy beyond its influence on the Japanese style, for its boldness did not conform to the tastes of the Japanese people, who preferred the subtlety of exquisite details. It is true, however, that some large-scale temples employed it after Chogen's time— for example, the Great Buddha Hall of the Hoko-ji in Kyoto, built in 1586 by the military dictator Toyotomi Hideyoshi (1536–98); the Kyo-o-goko-ku-ji Golden Hall; and the eighteenth-century reconstruction of the Todai-ji Great Buddha Hall.

ZENSHU-YO: THE ZEN-SECT STYLE

The arrival of Zen Buddhism in Japan meant more than the institution of its religious doctrines. Other aspects of the Sung-dynasty culture such as annual rites and ceremonies and codes of manners were also imported, and it was only in such a context that Sung-dynasty architecture reached Japan.

It was the priest Eisai who introduced the Rinzai sect of Zen Buddhism into Japan, but whether his temple the Kennin-ji, founded in Kyoto in 1202, adopted the new style of architecture or not is doubtful, for Eisai's own religious attitude inclined toward the ritual and magical practices of Esoteric Buddhism, and the Enryaku-ji, headquarters of the Esoteric Tendai sect on Mount Hiei, opposed the Zen sect so strenuously that the Kennin-ji had to be built as a Tendai-sect branch temple. There is no question, however, that Eisai introduced a new architectural style, for the layout of the Kennin-ji temple compound clearly exhibits continental features, and the Todai-ji Belfry, built by Eisai, displays evidences of the Sung-dynasty style. Still, these styles differed from the more consolidated form of the Zen-sect style of later years.

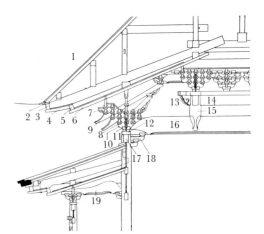

KEY TO THE PLAN

1. Roof. 2. Eaves finish. 3. Eaves support. 4. Flying rafter. 5. Flying-rafter support. 6. Base rafter. 7. Fist-shaped nosing. 8. Small bearing block. 9. Tail rafter. 10. Bracket arm. 11. Large bearing block. 12. Head frame. 13. Beam-end nosing. 14. Head penetrating tie. 15. Queen post. 16. Greater rainbow beam. 17. Head penetrating tie. 18. Inserted bracket arm. 19. Lobster-shaped rainbow beam.

160. Front elevation (top) and cross section (bottom) of Reliquary, Engaku-ji, Kamakura. Zen-sect style. Late fourteenth to early fifteenth century.

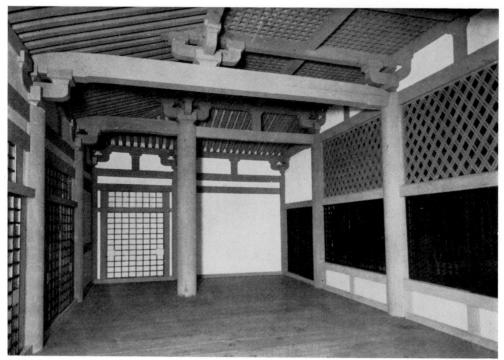

161. Outer sanctuary of Main Hall, Matsuno-o-dera, Yamato Koriyama, Nara Prefecture. Dated 1337.

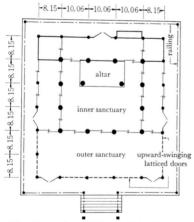

162. Floor plan of Main Hall, Ryozen-ji, Nara. Kamakura style. Frontage, 14.2 m.; depth, 14.8 m. Dimensions given in shaku (1 shaku = 30.03 cm.). Dated 1283.

163 (opposite page, top). Main Hall, Ryozen-ji, ▷ Nara. Frontage, 14.2 m. Dated 1283.

164 (opposite page, bottom left). Taho-to (Prabhuta- ▷ ratna Pagoda), Kichiden-ji, Ikaruga, Nara Prefecture. Height, 12 m. Dated 1463.

165 (opposite page, bottom right). Thirteen-storied ▷ Pagoda, Danzan Shrine, Sakurai, Nara Prefecture. Height, 16.2 m. Dated 1532.

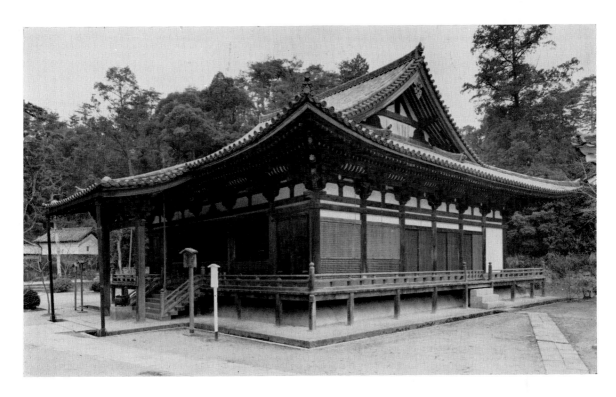

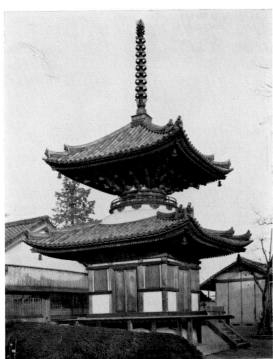

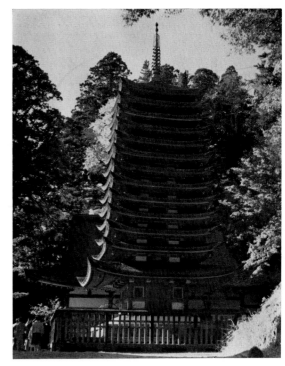

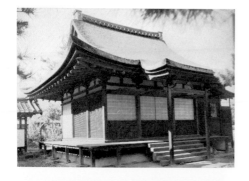

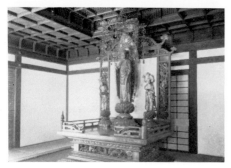

166 (top left). Main Hall, North Wing Precinct, Horyu-ji, Ikaruga, Nara Prefecture. A three-bay hall. Dated 1494.

167 (bottom left). Interior of Main Hall, North Wing Precinct, Horyu-ji, Ikaruga, Nara Prefecture. Dated 1494.

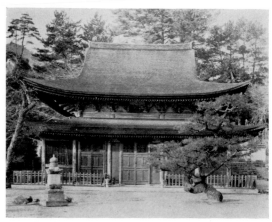

168. Buddha Hall, Kozan-ji, Yamaguchi Prefecture. A five-bay hall in Zen-sect style. Dated 1320.

The Sennyu-ji, a Ritsu-sect temple in Kyoto, has a Chinese-style layout. Certain records indicate that it was a copy of the Sung-dynasty style, thereby furnishing more evidence that a new style had been introduced. Examination of an old drawing of the temple compound seems to indicate a hybrid of the Japanese style and a new style. These facts suggest that in the early thirteenth century the Zen-sect style was not yet firmly established and that there were variations among the new styles. The Kosho-ji in Kyoto, the first Sodo-sect Zen temple—founded by Dogen (1200–1253) in 1233—incorporated the elements of a new style, but not much can be known about its early phases, for the present temple compound is a rebuilding of 1648. The Tofuku-ji in Kyoto, founded by Enni (also called Ben'en; 1202–80) but not completed until some forty years after it was first planned in 1236, does not seem to fall within our conception of the Zen-sect style. It seems, instead, closer to the Great

Buddha style, to judge from its Meditation Hall, built in the Kamakura period, and its Salvation Gate (the inner gate of a Zen temple is called by this name), rebuilt during the Muromachi period (1336–1568). Such evidence tells us that a consolidated form of the Zen-sect style had not yet developed at this point.

After the mid-thirteenth century, however, the situation appears to have changed drastically. It is highly probable that elements of the Sung-dynasty style were abundantly introduced in the construction of the Kencho-ji in Kamakura, for it was built in 1253 under the supervision of Lan-ch'i Tao-lung (in Japanese, Rankei Doryu; 1213–78), a priest from Sung-dynasty China, and there were no obstacles or interferences with regard to its planning and construction. In old drawings depicting the circumstances of its reconstruction late in the Kamakura period, the ingredients of the Zen-sect style are apparent. It is generally believed today

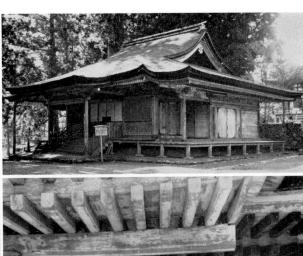

170 (right). *Overall view (top) and interior detail (bottom) of Fudo Hall, Kongobu-ji, Mount Koya, Wakayama Prefecture. Combination of pure Japanese and residential styles. Frontage, 12.8 m.: depth, 10.6 m. Thirteenth century.*

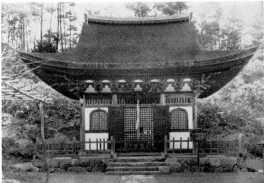

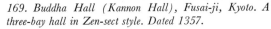

169. *Buddha Hall (Kannon Hall), Fusai-ji, Kyoto. A three-bay hall in Zen-sect style. Dated 1357.*

that the Zen-sect style was established with the building of the Kencho-ji—first, because drawings of the Kencho-ji were used as references for the reconstruction of the Tofuku-ji late in the Kamakura period and, second, because the temple-compound layout of the Tenryu-ji in Kyoto is an exact copy of that of the Kencho-ji. It is also argued that the Kencho-ji served as a model for all the succeeding Zen temples because it had been built after the fashion of the Chinese Ching-shan Wanshou-ssu temple in Chekiang Province: one of the Five Great Temples of the Sung dynasty. But I am still skeptical as to whether the Kencho-ji was really in the standardized Zen-sect style, for the techniques in our conception of the Zen-sect style are extremely exquisite and, with the added ingenuity of Japanese craftsmen, cannot be considered to have been a mere carbon copy of those of the Sung-dynasty style.

As Zen Buddhism gradually came to be propagated throughout the country, other temples were built. The construction of the Kencho-ji was followed by that of the Engaku-ji (or Enkaku-ji) in Kamakura and the Nanzen-ji in Kyoto. By the end of the thirteenth century the Five Great Temples of Kamakura—the Kencho-ji, the Engaku-ji, the Jochi-ji, the Jomyo-ji, and the Jufuku-ji—were all in existence. A little later, during the age of the Southern and Northern Courts (1336–92), when the imperial succession was split into two lines, the Five Great Temples of Kyoto were established: the Nanzen-ji, the Tofuku-ji, the Manju-ji, the Tenryu-ji, and the Shokoku-ji (or Shogoku-ji). The construction of these great temples gave impetus to the rapid development of the Zen-sect style.

Research into architecture in the Zen-sect style is extremely difficult, for despite the once flourishing state of the two groups of Five Great Temples, none of their original structures seem to have survived. Until recently the Engaku-ji Reliquary was

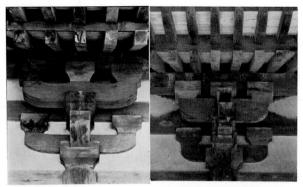

171. Transition in one-handed brackets of Lotus Hall, Todai-ji, Nara. Left: main-hall section; about 747. Right: "six-limb hanging" in worship-hall section; dated 1199.

172. Main Hall, Taisan-ji, Ehime Prefecture. Eclectic style, combining Japanese and Great Buddha styles. Dated 1305.

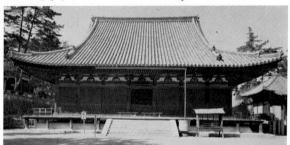

KEY TO THE PLANS
(opposite page)

KENCHO-JI: 1. Hall of Thousand-armed Kannon. 2. Kannon Hall. 3. Moon-catching Tower. 4. Aged monks' quarters. 5. Abbot's quarters. 6. Worship room. 7. Small kitchen. 8. General monks' quarters. 9. Lecture Hall. 10. Buddha Hall. 11. Warehouse. 12. Meditation Hall. 13. Corridor. 14. Corridor. 15. Office. 16. Millhouse. 17. Toilet. 18. Salvation Gate. 19. Practice Hall. 20. Temporary belfry. 21. Lavatory. 22. Bathhouse. 23. General Gate. TOFUKU-JI: 1. Tea Hall. 2. Abbot's quarters. 3. Lecture Hall. 4. Buddha Hall. 5. Meditation Hall. 6. Lavatory. 7. Salvation Gate. 8. Shrine of Shinto tutelary god. 9. Bathhouse. 10. Pond. 11. General Gate. TENRYU-JI: 1. Sleeping quarters. 2. Lecture Hall. 3. Altar. 4. Founder's Hall. 5. Shrine of tutelary god. 6. Buddha Hall. 7. Corridor. 8. Salvation Gate. 9. Pond. 10. General Gate.

thought to have been built around the 1280s, and most students of architecture had used this small hall as a basis for discussing what the standard Zen-sect style must have been, but it was then discovered that the present building was transferred from another temple sometime after the original had been lost in a fire in 1563. This discovery led to the downfall of most of the arguments on the Zen-sect style based on the Engaku-ji Reliquary. But a new perspective has now been established, and there are good signs that the Reliquary will be used as one of the criteria. With this in mind, let us go on to an exposition of the basic techniques and details of the Zen-sect style insofar as our present knowledge of them allows.

Since Zen temples began to deteriorate after the Muromachi period, none of the original temple compounds remain, but restorations made from old drawings and other sources indicate that most of them had a shipshape layout quite in conformity with the continental style (Fig. 173). A special feature not seen in other styles was that the entire compound was hidden from outside view by an embankment in front of the front gate (usually called a general gate) or by having the entryway turned sideways, as at the Tofuku-ji. After passing through the general gate, one reached the salvation gate (so called because it symbolized entrance into the state of enlightenment), in front of which was a pond or an arrangement of two ponds. The salvation gate, the Buddha hall, and the lecture hall were lined up along the central axis of the compound, and from both sides of the salvation gate extended a corridor that reached the Buddha hall. Outside the surrounding corridor were the bathhouse, the lavatory, the monks' hall (for medita-

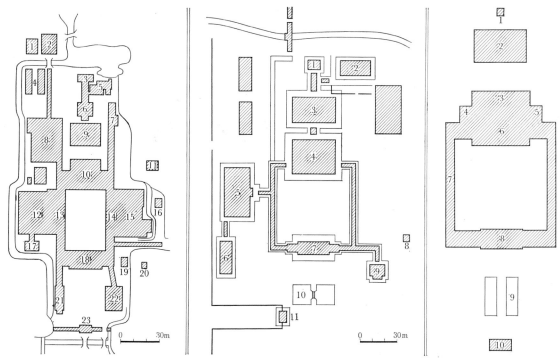

173. *Layouts of Zen-temple compounds. Left to right: Kencho-ji, Kamakura; Tofuku-ji, Kyoto; Tenryu-ji, Kyoto.*

tion), and the temple office. The abbot's residence was located behind the lecture hall.

As a general rule, the basic structure of a temple was formed of vertical pillars and horizontal timbers in what is known as post-and-lintel construction. Before and during the Heian period, however, only the topmost timber was inserted into the pillars, and the timbers in other positions were simply spiked to the inner or the outer side of the pillars to tie them. It was mainly the role of the walls to prevent a sidewise sway. In the new style, on the other hand, the use of penetrating ties made it possible to construct a tighter framework. This framework was not only structurally but also economically advantageous because the wood for the penetrating ties did not need to be very thick. In principle these ties comprised the head penetrating ties (at the uppermost reach of the pillars), the

flying (or upper) penetrating ties (just above the doors), the dado penetrating ties (just below the windows), and the floor (or base) penetrating ties (the lowest). On top of the pillars and the head penetrating tie was the architrave, made more or less of flat lumber. The architrave and the head penetrating tie protruded beyond the corner pillars, and their ends were molded, but the molding on the end of the head penetrating tie was different in shape from that of the Great Buddha style. Both the top and the bottom of the pillars were slightly rounded, and a plinth was set in below the pillars.

The bracket system of the Zen-sect style also requires mention. Both ends of the bracket arms were shaped like a quadrant, differing in this respect from the more angular Japanese style. The upper surface of the bracket arms was carved with grooves in a pattern of bamboo grass—a type of

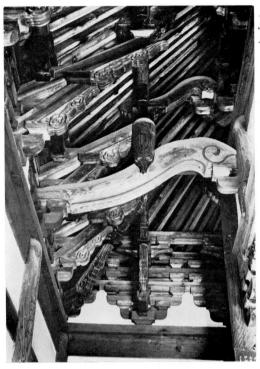

174. Interior support structure of Main Hall, Shuon-an (Ikkyu-ji), Kyoto. Zen-sect style. Dated 1506.

176. Interior structure of Reliquary, ▷ Engaku-ji, Kamakura. Zen-sect style. Late fourteenth to early fifteenth century.

175. Compact bracketing in Founder's Hall, Eiho-ji, Gifu Prefecture. Zen-sect style. Dated 1352.

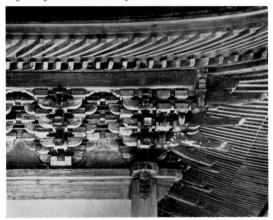

carving that had been in popular use during the Nara period but not during the Heian period. The bracketing directly above the base bearing block was of the three-block type. Above the three bearing blocks was another bracket arm, a little longer than the one below—another deviation from the Japanese style. This arrangement made the entire bracket system appear wide open toward the top and added an effect of liveliness. Moreover, since the same sort of bracket complex was placed between those on top of the pillars (the so-called compact-bracketing method), the underside of the eaves looked even more crowded and imparted a sense of repletion (Fig. 175). While in the Japanese style there is a feeling that each bracket complex on the pillar supports the eaves, in the Zen-sect style one gets the impression that the entire bracket system supports them.

Wooden "noses" (or beam tips) with molding and simple carving were attached to bracket arms. The tail rafters were thin and strongly curved and had a ridge in the upper surface—an entirely different shape from that employed in the Japanese style. Another special feature was that the tail rafters extended diagonally up into the interior of the roof and there received other members supporting the rafters (Fig. 160). Beyond these members was another set of bracket complexes, also with molding and simple carving. A few of the central rafters were laid parallel, but all the others were laid in the fan-rib method. The curvature of the eaves was very strong.

As for the composition of the interior, the center of the ceiling was formed of flat planks supported by bracketing. Around the center was an open-timbered ceiling. Since the center was high and the

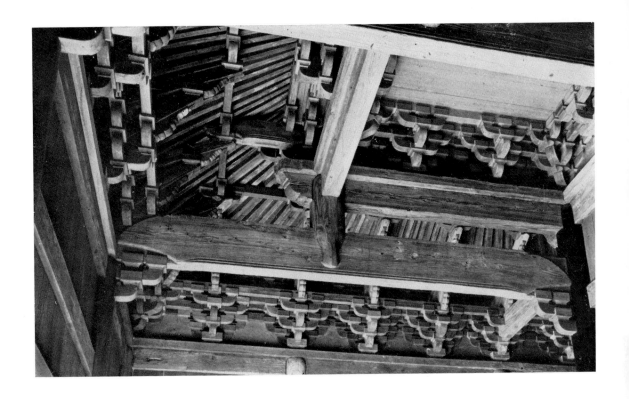

periphery was low, there was a sense of convergence (Fig. 176). Where the presence of a pillar seemed annoying, a greater rainbow beam and bottle-shaped queen posts were used instead to give support, but the shape of the queen posts differed from that of the ones used in the Great Buddha style. The rainbow beams were rectangular in cross section, and groups of lines called "eyebrows" were carved near the bottom on each side. As in the Great Buddha style, the underside of each of these beams was carved with a monk's-staff groove. The ends of the beams were supported by bracketing using an inserted bracket arm whose bearing blocks hemmed the specially cut edges of the beams. This "cuff cutting," as it was called, was another feature not seen in the Japanese style. Also, a beam called a "lobster-shaped beam" was used below the open-timbered ceiling (Fig. 174). Another feature of the interior structure was the use of small beams called "flint beams" at a 45-degree angle in the corners.

Doors in the Zen-sect style were usually ledged-panel doors, but their cleats (ledges) were not ridged up as in the Great Buddha style. Windows were of the type designated as the cusped window, so called because there was a cusp at the top—a design that came to Japan from India by way of China and was sometimes also used for doors, as at the Engaku-ji. There was also a structural feature known as the "wavy mullioned transom": a band of narrow wavy slats inserted vertically and at regular intervals between the head penetrating ties and the flying penetrating ties. The transom served a decorative function somewhat similar to that of the frieze in classical Greek architecture, but with a feeling unique to the Zen-sect style.

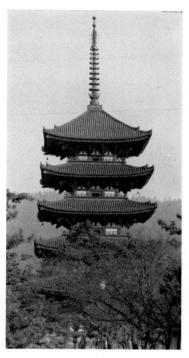
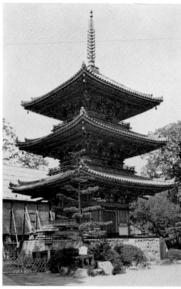
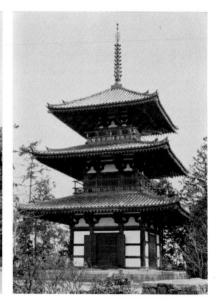

So much for fixtures. In overall appearance the Zen-sect style imparts the sensation of a standing or perhaps a looming posture in contrast with the Japanese style, which calmly maintains a "squatting" position. Because of its use of thick timber, the early Zen-sect style conveyed a feeling of bulkiness, but as time went on and thinner and narrower structural members came to be used, it gradually began to display a certain delicacy. Although both the Great Buddha style and the Zen-sect style were greatly influenced by the Sung-dynasty architecture of China, it should be noted that whereas the former was in the southern lineage of Chekiang and Fukien provinces, the latter inherited the style of Northern Sung. This geographical factor was the main reason why they developed as distinct styles in Japan in spite of the fact that they both derived from the architecture of Sung-dynasty China.

After the Zen-sect style had become firmly established, as exemplified by the Engaku-ji Reliquary, there were no conspicuous alterations in it up to the Edo period, except for sculptural details, which tended to become more and more lighthearted. The reason for the permanence of the style probably lies in its elaborate and refined forms, which were consistent with the tastes of the Japanese people. That Zen Buddhism flourished to a remarkable degree late in the Kamakura period is known from such structures as the Kannon Hall of the Eiho-ji in Gifu Prefecture (1314), the Buddha Hall of the Kozan-ji in Yamaguchi Prefecture (1320), the Sakyamuni Hall of the Zempuku-in in Wakayama Prefecture (1327), and the Buddha Hall of the Seihaku-ji in Yamanashi Prefecture (1334). Remains of Zen temples built after the Kamakura period include the Founder's Hall of the Eiho-ji (1352), the Buddha Hall of the Ten'on-ji in Aichi Prefecture (1362), the Buddha Hall of the Shofuku-ji in Tokyo (1407), the Main Hall of the

177 (opposite page, left). Five-storied Pagoda,
Kofuku-ji, Nara. Restorative (Nara-period)
style. Height, 50.1 m. fifth reconstruction, dated
1426.

178 (opposite page, center). Three-storied Pa-
goda, Minami Hokke-ji (Tsubosaka-dera),
Takatori, Nara Prefecture. Muromachi style.
Height, 23 m. Dated 1497.

179 (opposite page, right). Three-storied Pagoda,
Hokki-ji, Ikaruga, Nara Prefecture. Asuka style.
Height, 23.95 m. Between 685 and 706.

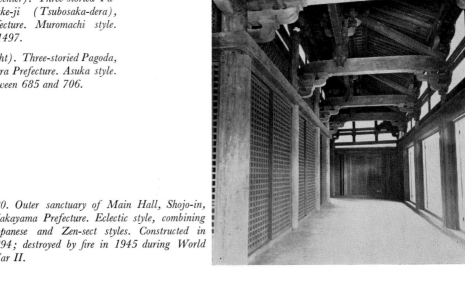

180. Outer sanctuary of Main Hall, Shojo-in,
Wakayama Prefecture. Eclectic style, combining
Japanese and Zen-sect styles. Constructed in
1294; destroyed by fire in 1945 during World
War II.

Shuo-an (also called the Ikkyu-ji) in Kyoto (1506),
and the Golden Hall of the Fudo-in in Hiroshima
Prefecture (1540).

SETCHU-YO: ECLECTIC STYLES

Since it was in such a huge undertaking as the recon-
struction of the Todai-ji that
the Great Buddha style was employed, we might
suppose that it exerted great influence on the tem-
ple architecture of Nara. But the conservative na-
ture of Nara Buddhism did not permit a headlong
rush toward adoption of the new style. In most
cases its effect was seen only in the attachment of
wooden "noses"—the beam-end moldings that
were a distinguishing feature of the Great Buddha
style—to the ends of head penetrating ties. And
this adoption was made simply because it was
structurally advantageous to have the tips of the
head penetrating ties jut out of the side pillars
(which had not been the case in the Heian period)

in order that the combination of the tie beams and
the pillars would constitute a firmer means of fixing
the frame. Other features of the Great Buddha
style—for example, the bold internal support
structure—simply were not adopted.

Perhaps the earliest example of a Japanese-
style hall influenced by the Great Buddha style is
the Worship Hall section of the Todai-ji Lotus
Hall, remodeled in 1199. In this case even the
internal support structure employs some special
devices that cannot be considered to be in the pure
Japanese style, but of course the case is an excep-
tional one (Figs. 83, 159). There are many in-
stances in which the head penetrating ties are
ornamented with molding in the Great Buddha
style. The Meditation Room of the Gango-ji
Gokuraku-bo, for example, has wooden "noses,"
although the original timbers were used in its
large-scale reconstruction early in the Kamakura
period. This, too, is one of the earliest examples of

183. Structural details decorated in Momoyama style, front ▷
pentroof (worshipers' shelter) of Main Sanctuary, Hachiman
Shrine, Yakushi-ji, Nara. Dated 1603.

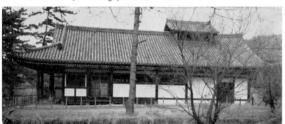

181. Bathhouse, Todai-ji, Nara. Dated 1408.

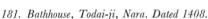

182. East Monks' Quarters Annex (Tsumamuro), West Precinct, Horyu-ji, Ikaruga, Nara Prefecture. Remains of minor-cell wing. Late eighth to early ninth century.

the influence of the Great Buddha style. The To-shodai-ji Sutra Tower, or Drum Tower, as it is commonly called (Fig. 89), rebuilt in 1240, and the Futai-ji Taho-to (Prabhutaratna Pagoda), of which only the lower level remains, are examples of the same sort of adaptation. The Yakushi-ji East Precinct Hall, rebuilt in 1285 according to the original Nara-period ground plan, also employs the beam-end moldings of the Great Buddha style, but this building, since it has an end-to-end ceiling in its interior, gives more of the feeling of the Kamakura period than of the Nara period (Fig. 91).

During the Nara period, roofs were constructed by laying tiles on the rafters with only a filler of earth in between. From the Heian period on, however, there developed the method of providing a sheathing on which the tiles were laid, and a space was created between the sheathing and the rafters below it. Since the attic, or hutlike structure resting on girders above the ceiling, could not be

seen from inside the hall, it permitted freedom in the way the ceiling was constructed. The technique of the coffered ceiling came into use as early as the Heian period, but it was not until the Kamakura period, as its form became more or less consolidated, that it began to enjoy popularity. The unique mood created by a coffered ceiling can be felt in the interior of the Horyu-ji Shoryo-in.

Unlike the Great Buddha style, which was eventually incorporated into the Japanese style, the Zen-sect style was not well received in Nara. Its unpopularity was a concomitant of the conscious rejection of the new religion of Zen Buddhism itself. The only exceptions seem to be the Kairyuo-ji Lecture Hall and the Todai-ji Bathhouse (of the Muromachi period; Fig. 181), but these are not typical examples, since it is only the curvature of the bracket arms in the two structures that conveys (if it does so at all) any sense of the Zen-sect style. And the exceptional incursion of a characteristic of

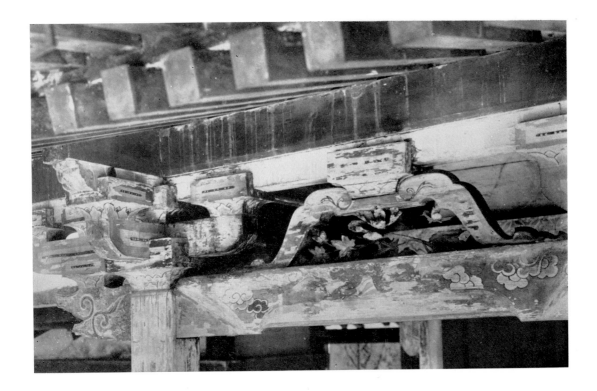

the Zen-sect style in the Kairyuo-ji Lecture Hall was no doubt an accidental occurrence due to the fact that the temple's rebuilder, Eison, maintained a good relationship with the warrior-politicians of Kamakura, one of the important centers of Zen Buddhism.

The first example of the influence of the two new styles on the Japanese style outside of Nara is the Main Hall of the Daizen-ji in Yamanashi Prefecture (Fig. 184). One of the pillars of this hall bears an inscription dating from 1286. The hall is an excellent Japanese-style structure whose tightly interwoven bracket complexes are in perfect proportion with the framework and whose interior makes ingenious use of space. There appear to be two varieties of beam-end wooden "noses," and flower-shaped bracket arms are used among the details. One variety of beam tips is definitely in the Great Buddha style, but the other, since it has a ridge, is not. The style of the floral bracket arms is difficult to determine. Judging from their forms, although the matter is debatable, the best estimate would be that it is a blend of the two new styles. The sole problem involved in determining the date of this hall is that only the pillar bearing the inscription is made of zelkova.

The next example is the now vanished Main Hall of the Shojo-in in Wakayama Prefecture (Figs. 180, 195). Although the hall was burned down in 1945 during World War II, its date has been established as 1294, as was indicated in India ink on the bearing blocks of its bracketing. Characterized by an extremely refined treatment of its details, the hall maintained a good balance between interior and exterior, and the elements of the Zen-sect style were very skillfully absorbed—for example, the use of tail rafters extended to reach below the open-timbered ceiling, of the Zen-sect-style rainbow beams and queen posts, and of "flint beams" in the corners. The bracket arms were essentially in

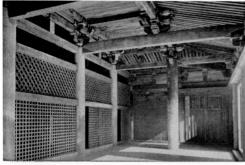

184. Outer sanctuary of Main Hall, Daizen-ji, Yamanashi Prefecture. Eclectic style, combining Japanese, Great Buddha, and Zen-sect styles. About 1286.

186. Inner sanctuary (left) and outer sanctu- ▷ ary (right) of Main Hall, Taisan-ji, Ehime Prefecture. Eclectic style, combining Japanese and Great Buddha styles. Dated 1305.

185. Outer sanctuary of Main Hall, Honzan-ji, Kagawa Prefecture. Eclectic style, combining Japanese and Zen-sect styles. Dated 1300.

the Japanese style and had angular edges, but their strong curvature and the bamboo-grass grooves carved in them created a mood peculiar to the Zen-sect style.

But the merit of this building did not lie merely in its introduction of techniques from the Zen-sect style. Some of the best points of the style were incorporated into the Japanese style in such a way as to create an effective balance in the entire structure. In particular, despite the relative thinness of the wooden structural members, a feeling of firmness was generated through the diversified details and their skillfully proportionate arrangement in the internal support structure. We can infer from this building that around the end of the thirteenth century the novel designs of the new styles stimulated the craftsmen of the Japanese style and enhanced their creativity to such a degree as to open up a whole new field of architecture and

thereby to produce a number of masterpieces. This tendency to combine different styles progressed still further in the fourteenth century, and more freedom came to be enjoyed in the realm of designing. Superior examples of buildings resulting from the trend can be seen in the area along the Inland Sea, and the most representative among them are the Main Hall of the Honzan-ji in Kagawa Prefecture (1300) and the Main Hall of the Taisan-ji in Ehime Prefecture (1305).

The floor plan of the Honzan-ji Main Hall is of the basic Kamakura style (see below), in which the inner and the outer sanctuaries were clearly demarcated from each other (Fig. 185). Around the beginning of the fourteenth century a new trend in the composition of the interior emerged—namely, to elaborate the support structure of the outer sanctuary but to simplify that of the inner sanctuary, at the same time making the altar strikingly

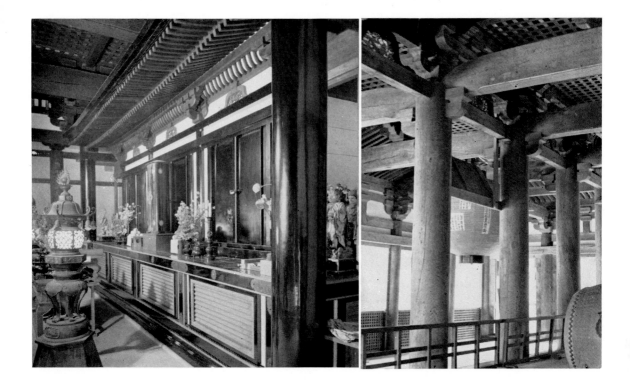

splendid. The carpenters who built this hall introduced the new styles only moderately, but great care was taken with regard to the proportion of the parts to one another in the use of space in the outer sanctuary. A firm and steady technique was employed for the altar in the inner sanctuary, and the entire structure deserves to be viewed as a distinguished masterwork.

In contrast with the Main Hall of the Honzan-ji, that of the Taisan-ji has a most ambitious design (Figs. 172, 186). The artistry demonstrated here makes a completely new departure in the spatial composition of the outer sanctuary through the ample use of pillars, rainbow beams, and penetrating ties and does so quite successfully, not to speak of such details as the frog-crotch struts. The building is indeed an excellent relic. Features of the Great Buddha style seen in the details imply that this part of the country had extensive cultural ex-

change with Nara through the agency of Chogen. This is a reasonable surmise, for some of the Todai-ji carpenters migrated to the Jodo-ji in Hiroshima Prefecture to propagate the Great Buddha style and there built the Main Hall (1327), the Taho-to (1329), and the Amida Hall (1345).

A NEW STYLE OF MAIN HALL As the revival of Nara Buddhism proceeded during the Kamakura period, many temples were renovated, and most of these restorations were conservative in nature. The oblong halls were shallow in depth in proportion to their length. From around the end of the Heian period and throughout the Kamakura period, however, another form of the Buddha hall was popular: a building termed a main hall to distinguish it from the golden hall of the Nara period, although its function was still the same. The new style, called

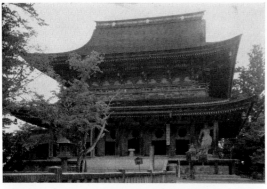

187 (top left). Zao (Vajrasattva) Hall (Main Hall), Kimpusen-ji, Yoshino, Nara Prefecture. An example of a large-scale main hall with a Kamakura-style floor plan. Dated 1455.

188 (bottom left). Outer sanctuary of Main Hall, Chokyu-ji, Ikoma, Nara Prefecture. Kamakura style. Dated 1279.

189. Second Month Hall (Kannon Hall), Todai-ji, Nara. A ten-bay hall. Reconstructed in 1669.

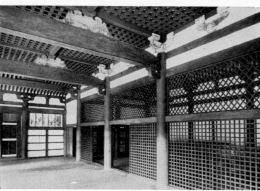

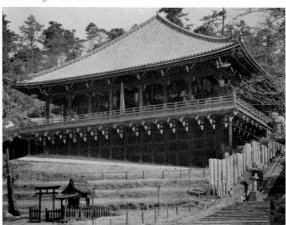

the Kamakura style, called for a deeper building in order to clearly divide the space into the inner sanctuary, where the Buddhist images were enshrined, and the outer sanctuary, which was an area for worshipers. The structure had a hipped-and-gabled roof (Fig. 162 and Foldout 3). In Nara and its environs, not many Buddha halls were built in this style, but we can name the following: the Taima-dera Main Hall, dating from 1161 (Figs. 154, 155); the Chokyu-ji Main Hall, dating from 1279 (Fig. 188); the Ryozen-ji Main Hall, dating from 1283 (Figs. 94, 162, 163); the Gango-ji Goku-raku-bo Main Hall; the Nammyo-ji Main Hall; the Okura-ji Main Hall; the Muro-ji Main Hall (also called the Initiation Hall), dating from the mid-thirteenth century (Fig. 92); the Matsuno-o-dera Main Hall, dating from 1337 (Fig. 161 and Foldout 3); the Kimpusen-ji Main Hall, dating

from 1455 (Fig. 187); and the Hase-dera Main Hall, dating from 1650 (Fig. 191). It is characteristic of all these halls that they were built basically in the Japanese style but incorporated details from the Great Buddha style.

It was the climate of Japan that brought about the new style of main hall. Because of the frequent rainy weather there had been a desire to build Buddha halls large enough to contain the area for worshipers within the main body of the hall. For this purpose, in front of the inner sanctuary, where Buddhist statues were placed and priests conducted their ceremonies, a fairly large outer sanctuary was needed, and accordingly the depth of the hall increased. The more popular Buddhism became among the common people, the greater the need of building this form of hall. Its forerunner was the side-by-side hall, as exemplified by the Todai-ji

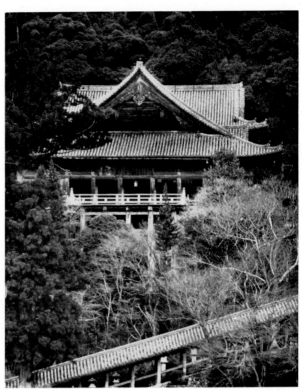

191. Main Hall, Hase-dera, Hase, Nara Prefecture. Frontage, 26 m. Dated 1650.

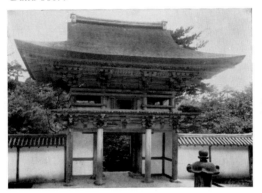

190. Gatehouse, Enjo-ji, Nara. A three-bay turret gate. Dated 1467.

Lotus Hall. The artificiality of having two roofs for such a structure was avoided by deepening the floor plan and covering the entire hall with a single hipped-and-gabled roof. This new form, established in the Heian period, became prevalent during the Kamakura period and subsequently served as a standard for most main halls in Japan.

The Ryozen-ji Main Hall, built in 1283, is a typical example of the new style in Nara (Figs. 94, 162, 163). As required in a standard hall of this type, a diamond-lattice transom and square-lattice doors were installed in the border between the inner and the outer sanctuaries, so that the hall displays characteristic traits of the new style. But in a departure from the standard style, no transom or wall was installed in the upper left and right corners of the border between the two sanctuaries. This particular detail was devised to achieve a sense of

spaciousness, and indeed the spatial composition here is exceedingly artful. At the same time, the details of the hall show the influence of the Great Buddha style.

The Chokyu-ji Main Hall, built in 1279, only a few years before the Ryozen-ji Main Hall, has a similarly deep floor plan, but its interior has a slightly different air (Fig. 188). The Main Hall (or Initiation Hall) of the Muro-ji (Fig. 92), built in the mid-thirteenth century, includes among its decorations an Esoteric Buddhist mandala in the form of a mural. The beam-end "noses" are molded in the Great Buddha style, and the rainbow beams and bottle-shaped props used in the gables add to the beautifully finished appearance of the structure. Another well-built main hall is that of the Matsuno-o-dera (Fig. 161 and Foldout 3).

The Hase-dera Main Hall (Fig. 191) and the

Todai-ji Second Month Hall (Fig. 189) are unusual in that each was built at the edge of a cliff, the worship-hall section overhanging the drop and the pillars that support it extending to great length down its face. The technique employed here is known as stage construction or overhang construction. Most of the halls built in this style are Kannon halls—an indication that the style has something to do with popular faith in the divinity Kannon.

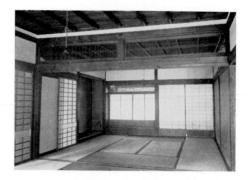

The sanctuary of the subshrine of the Omiwa Shrine in Nara Prefecture was originally the Main Hall of the Daigorin-ji (or Omiwa-dera), a combination of a Buddhist temple and a Shinto shrine. After this Nara-period hall had been remodeled, another hall was attached to it late in the Kamakura period to form a building of oblong shape. This is the hall that housed the famous Nara-period statue of the Eleven-headed Kannon (Fig. 24), now enshrined at the Shorin-ji. The Enjo-ji main hall is also oblong in shape, but its character is somewhat different.

While it is true that deep halls developed from the side-by-side hall as represented by the Lotus Hall of the Todai-ji, it should also be noted that halls with front pentroofs began to be built around the beginning of the Heian period. The remodeling of the Taima-dera Main Hall early in the Heian period is evidence of this new development, and there is a possibility that the pentroof innovation was another source from which the deep hall sprang. In a word, since the broad pentroof at the front of a hall hung so low as to be obstructive, it came to be replaced by a large roof that covered the entire structure, thereby increasing its depth. The pentroof of the Muro-ji Golden Hall, although it is said to have been added during the Edo period, may safely be considered to have been provided in the very beginning, for old drawings of the Kamakura period indicate the existence of such a roof. It should also be noted here that the Jurin-in Main Hall of the mid-thirteenth century and the Horyu-ji East Precinct Worship Hall, rebuilt in 1231, are both independent worship halls.

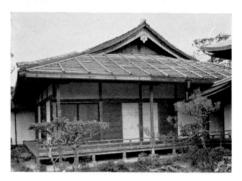

As in the Heian period, three-by-three-bay halls continued to be built during the Kamakura period. Subsidiary halls like the Okura-ji Daishi (Great Teacher) Hall, the Todai-ji Founder's Hall, the Todai-ji Contemplation Hall, the Todai-ji Invocation Hall, and the Muro-ji Portrait Hall, as well as main halls of subtemples like the Saion-in New Hall at the Horyu-ji and the Fukuchi-in Main Hall are of this size. The last of these examples is rather exceptional in that its sides and rear give it the appearance of a four-bay hall, but since it is composed of a one-bay inner sanctuary and a surrounding secondary roof, it is basically a three-bay hall. Under special circumstances, as in the case of the Shin Yakushi-ji Jizo Hall, where a small structure sufficed to enshrine a statue of the Bodhisattva Jizo that common people worshiped, one-by-one-bay halls were built. Another example is the Chogaku-ji Five Wisdoms Hall (Fig. 197). Here, at the center, is a thick column said to represent the five Buddhas corresponding to the five wisdoms of Esoteric Buddhism, and the entire hall is simply a canopy for the column.

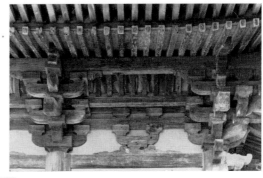

◁ *192. Guesthouse, Yakushi-bo, Horyu-ji, Ika-ruga, Nara Prefecture. Fifteenth to sixteenth century.*

◁ *193. Guesthouse, Saion-in, Horyu-ji, Ikaruga, Nara Prefecture. Late sixteenth to early seventeenth century.*

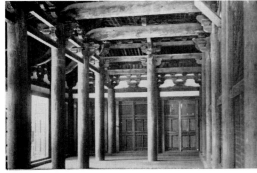

194. Detail of eaves (top) and outer sanctuary (bottom) of Main Hall, Kakurin-ji, Hyogo Prefecture. Eclectic style, combining Japanese, Great Buddha, and Zen-sect styles. Dated 1397.

OTHER ASPECTS OF KAMAKURA TEMPLE ARCHITECTURE There are next to no pagodas in Nara that were built during the Kamakura period. In addition to the previously described Three-storied Pagoda of the Kofuku-ji, we have only the Futai-ji Taho-to, or Prabhutaratna Pagoda, from the mid-Kamakura period. The Taho-to, as a type, was a two-storied pagoda, usually consisting of a circular section on top of a square first-floor section, and its chief object of worship was the Esoteric Buddhist divinity Dainichi Nyorai (Vairocana or Mahavairocana), the Buddha of the Great Sun. At the Futai-ji unfortunately only the lower section of the pagoda remains. The wood used in its construction was relatively thin, and the proportions of its parts are excellent. The beam-end "noses" employed in this pagoda are molded in the Great Buddha style.

It should be noted here that the Sangyo-in (West Wing) of the Horyu-ji is an important example of the monks' quarters of this period. The West Round Hall, also dating from the Kamakura age, is of course an octagonal hall.

A new form developed among the sutra towers and belfries of the Kamakura period. At the Horyu-ji, for example, although the Sutra Repository is in the conventional style, the East Precinct Belfry has a kind of skirting that hangs below the upper-floor veranda (Fig. 198). This form, probably established during the Heian period, became very popular in Kamakura times. Another example is the Shin Yakushi-ji Belfry. The Toshodai-ji Drum Tower (actually a sutra tower) is a three-by-two-bay turret-style structure typical of a Nara-period temple compound, and the fact that it does not have a skirting is due to a surviving traditional convention. Among independently built belfries there was the commonly used type represented by the Todai-ji Belfry (Fig. 137), which is a large-scale example of

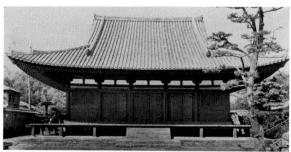

195. *Main Hall, Shojo-in, Wakayama Prefecture. Eclectic style, combining Japanese and Zen-sect styles. Constructed in 1294; destroyed by fire in 1945 during World War II.*

it. Two other buildings dating from the Kamakura period are the Kasuga Shrine Plank Storehouse and the Kairyuo-ji Lecture Hall, the latter of which is thought to have been built as a sutra repository.

A number of gates and gatehouses survive from this period. The Chogaku-ji Gatehouse, built in the turret style, is actually a belfry-gatehouse because its upper story once housed a bell. Also in the turret style is the one-bay Hannya-ji Gatehouse (Fig. 131). Four-legged gates of the period include the Gango-ji East Gate, the Jurin-in South Gate, the South and the East Gate of the Shin Yakushi-ji, the Lotus Hall North Gate of the Todai-ji, and two gates at the Horyu-ji: the Sogen-ji Four-legged Gate (Fig. 130) and the East Precinct Four-legged Gate. Frog-crotch board struts were often used in the gables of these gates.

Many works in stone also survive from the Kamakura period. The Hannya-ji Thirteen-storied Stone Pagoda and the Maki Thirteen-storied Stone Pagoda are examples of multilayered pagodas. Five-elements stone pagodas include those at the Enjo-ji (Fig. 201), the Gakuan-ji, the Saidai-ji, the Todai-ji (Fig. 201), and the Muro-ji. The Todai-ji Five Elements Stone Pagoda seems to indicate that those made under the supervision of Chogen (or otherwise connected with him) had a triangular "umbrella."

Another form of stone pagoda that became pop-ular during the Kamakura period is the Hokyoin type seen at Arisato, at the Empuku-ji (Fig. 201), and at the Yamaguchi Yakushi Hall. The Hokyoin pagoda was originally made to house a sutra called the *Karanda Mudra Dharani* (in Japanese, *Hokyoin Darani*), but in Japan the term is now used only to designate the style of the pagoda. Tradition says that Hokyoin pagodas began to be made in Japan following the import of the construction techniques employed for the legendary 84,000 such pagodas built for an ancient Chinese king.

At the Raigo-ji is a square-roofed circular pagoda in the shape of a Taho-to minus its secondary roof. Stone pagodas of this type abound at Esoteric Buddhist temples. Again, in front of the previously noted Thirteen-storied Stone Pagoda of the Hannya-ji, there is a group of roofed stone stupas. The Jewel Ball Pagoda (Manirin-to) at the Danzan Shrine is a unique work in stone dating from the year 1303 (Fig. 202).

Important stone lanterns of the period are the Front Stone Lantern at the Todai-ji Lotus Hall (Fig. 202) and those of the Taima-dera and the Eizan-ji. Stone Buddhist statues include those of the Jurin-in, which occupy an altar dedicated to the Bodhisattva Jizo and date from the early Kamakura period. The worship hall in front of this altar, built during the 1260s or the 1270s, is in the residential style of the times and features frog-crotch struts typical of mid-Kamakura style.

CHAPTER SEVEN

The Waning of a Long Tradition

THE DECLINE OF TEMPLE POWER The restoration movement of Nara Buddhism achieved satisfactory results in the Kamakura period because it earnestly followed the traditions of the faith laid down in Nara times. But Nara Buddhism, essentially philosophical, had received the patronage of the nobility from its very beginning and had naturally developed an aristocratic flavor that placed it in sharp contrast with the Jodo, the Nichiren, and the Zen sects, which reached down into the lower levels of society to enroll the masses among the faithful. The great temples of Nara were self-righteous, and they failed to respond to the demands of the masses. The Kofuku-ji, in particular, was excessively self-conscious about being the *genius loci,* so to speak, of Yamato Province—that is, the modern Nara Prefecture.

Most of the Nara temples, which had preserved their existence by means of the Kamakura-period restoration, began to decay rapidly in the succeeding Muromachi period, when trespassing on temple estates became rife. At the Gango-ji, for example, people were building houses within the temple property as early as 1428, and in 1451 the temple was reduced to a pitiful state by uprisings among the peasants. In 1502, the entire compound of the Saidai-ji, including all the halls rebuilt in the Kamakura period, was destroyed by fire, and desolation followed. In another fire in 1528, the Yakushi-ji lost its original West Pagoda and its Golden

Hall, which had been rebuilt after a fire in the early 970s. In similar ways many of Nara's great temples were ruined.

Nevertheless, the Kofuku-ji continued to be venerated as the clan temple of the Fujiwara. As the presiding spirit of Yamato Province, it owned much of the provincial land, which it allocated to itself and its two greatest subtemples, the Daijo-in and the Ichijo-in. The power of the Kofuku-ji was still overwhelming, and all the other temples were subordinated to it in one way or another. After the Onin War (1467–77), in which the chief vassals of the weakened shogunate government, having formed into two hostile camps, fought one another for eleven years, many impoverished and uprooted court nobles fled from Kyoto to Nara. Among them were important government officials like the regent Ichijo Kanera (1402–81), the former regent Takatsukasa Fusahira (1411–72), Takatsukasa Masahira (1444–1517), the former regent Konoe Fusatsugu (1402–88), Konoe Masaie (1446–1505), the former inner minister Kujo Masatada (1439–88), and the former inner minister Saionji Saneto (1434–95). These men moved to Nara because they had sons there in the priesthood residing in the monks' quarters of the Kofuku-ji. For example, Ichijo Kanera's son, the Hosso-sect monk Jinson, was the author of numerous historical records preserved in Daijo-in, and Kanera himself was a pioneer in Japanese literary studies whose works include the *Kacho Yojo* (Lingering Impressions of Flowers and

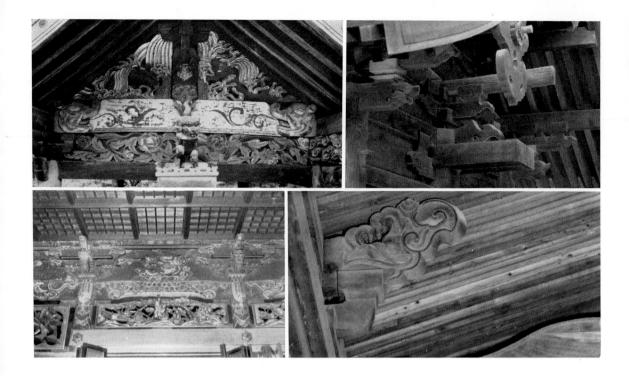

Birds) of 1472, which is a commentary on the celebrated novel *The Tale of Genji,* and the *Nihon Shoki Sanso,* an annotated version of the *Nihon Shoki* (Chronicles of Japan). Kanera was a scholar who appreciated Japanese classical literature and expressed his understanding of it in the simple language of his age.

From circumstances like these, we may conclude that in the late Muromachi period the Kofuku-ji, the Daijo-in, and the Ichijo-in composed the heart of an effort to revive the Japanese culture of classical times. Fortunately there is a building that supports this conclusion: the Shinden, or Imperial Chambers, of the Ichijo-in. Until not long ago it had been used as a local courthouse, but a recent excavation revealed that it had originally been in the architectural style known as the *shinden-zukuri:* a residential style that flourished among the Heian-period nobility. The present structure, rebuilt in 1650, follows the *shinden* style of placing an imperial

chamber, or residential quarters, in the middle and, in a row on either side of it, court officials' bureaus and other structures. In accordance with time-honored custom, plum and mandarin-orange trees were planted in the front courtyard. In 1964 the building was moved and restored as the Toshodai-ji Portrait Hall, and the celebrated Nara-period statue of Ganjin (Fig. 42) was enshrined in it. It is indeed regrettable that the building was transferred from its original site, but its preservation at a new site is a redeeming feature of this unfortunate affair (Figs. 122, 123). Two other temple structures of Nara that illustrate the restorative trend are the Kiko-ji Main Hall and the Futai-ji Main Hall.

The decline of the Kofuku-ji actually began in the mid-fourteenth century with a dispute between the Daijo-in monk Kokaku and the Ichijo-in monk Jitsugen that lasted from 1351 to 1358. During this dispute not only the monks in charge of managing the respective temple grounds but also the common

196. Development of sculptural adornment. Top right: Gate of the Guardian Kings, Honzan-ji, Kagawa Prefecture, mid-thirteenth century. Bottom right: Golden Hall, Fudo-in, Hiroshima Prefecture, dated 1540. Top left: Chinese Gate, Daitoku-ji, Kyoto, late sixteenth century. Bottom left: Koren-ji, Nara, early nineteenth century.

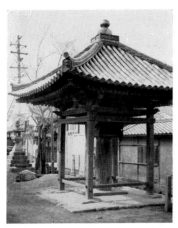

197. Five Wisdoms Hall (Mamendo), Chogaku-ji, Tenri, Nara Prefecture. A one-bay hall. Thirteenth century.

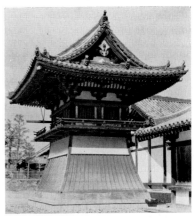

198. Belfry, East Precinct, Horyu-ji, Ikaruga, Nara Prefecture. An example of a belfry with a skirting. Thirteenth century.

people living in their domains became involved in the hostilities. The proliferating quarrels developed into struggles among monks and common people in various districts and eventually resulted in revolts against temple domination. This turn of affairs led to trespassing upon shrine and temple grounds, and the sources of temple revenues thereby vanished. The situation was further aggravated by the Onin War, and the whole of Yamato Province was turned into a battlefield. In 1499, during the dispute between the Hosokawa and the Hatakeyama clans, Nara was invaded by the warlord Akazawa Tomotsune, and in 1582 this long-term Hosokawa-Hatakeyama dispute developed into a sudden insurrection of Jodo-sect monks and laymen, bringing about a further decay of the Kofuku-ji. After 1599, when another warlord, Matsunaga Hisahide, built a castle on Mount Tamon in the northern suburbs of Nara, the power of the Kofuku-ji as the *genius loci* of Yamato Province was virtually nonexistent.

The details of the Bodai-in Main Hall of the Kofuku-ji, constructed in 1579, show some trends of the new era, but the timber used for the pillars is old, the ceiling has never been reconstructed, and the building itself looks abhorrently shabby. One is tempted to ask what ever happened to this great temple, but the situation can be comprehended only in relation to the circumstances described above.

TEMPLE ARCHITECTURE OF THE MUROMACHI PERIOD AND AFTER

The eclectic styles that emerged in the Kamakura period continued during the Muromachi period. As a product of this trend, the Osaka temple Kanshin-ji (Fig. 119) may be cited. According to the *Kanshin-ji Engi Jitsuroku-cho* (Historical Record of the Kanshin-ji), the temple was founded by Jitsue (784–847), a disciple of the great priest Kukai, whom we have already noted as

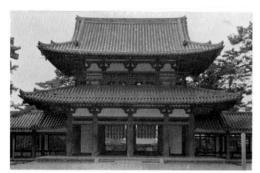

199. Inner Gate, West Precinct, Horyu-ji, Ikaruga, Nara Prefecture. A double-roof gate. Frontage, 12.1 m. Late seventh to early eighth century.

the founder of the Shingon sect of Esoteric Buddhism. The outer and inner sanctuaries of the temple are distinctly separated, and in the latter there is a mural of the Mandala of the Diamond World. The floor plan here is typical of the Esoteric Buddhist temple, but the present structure was built well after the mid-fourteenth century, and elements of both the Great Buddha style and the Zen-sect style are observable. For example, instead of the frog-crotch struts and the intermediary block-on-strut posts of the pure Japanese style, two-block brackets are used in the spaces between bracket complexes. This feature clearly displays the influence of the Great Buddha style, but the arc-shaped curve of the bracket arms indicates the incorporation of the Zen-sect style. The beam-end "noses" are also a blend of both styles. All these features show that adherence to a particular style was no longer a requisite for temple architecture (see Foldout 3).

Eclectic trends were further advanced by the end of the fourteenth century. A glance at the structural

details of the Kakurin-ji Main Hall in Hyogo Prefecture (Fig. 194), built in 1397, will indicate that a two-block bracket of the Great Buddha style is used atop a Japanese-style frog-crotch board strut in the spaces between bracket complexes (see Foldout 3). The altar in the inner sanctuary is rather ornate, and great care has been expended upon the support structure of the outer sanctuary, as is obvious in the new design of rainbow beams—a modification of lobster beams. In this respect the hall may be said to be a product of artifice less stirring than the Taisan-ji Main Hall in Ehime Prefecture, although the artistry exhibited in the gradual modulation of the support structure is remarkable.

Few examples of deliberate and excellent designs of high originality were seen in the eclectic styles after the end of the fourteenth century. Of course small contrivances of minor importance were developed, but they were, on the whole, stereotyped. To summarize the architectural trends up to the end of the fourteenth century, the pure Great Buddha style disappeared after the age of Chogen, excepting only special cases like the Tofuku-ji and the Kibitsu Shrine and large-scale constructions like the Hoko-ji, the To-ji (Kyo-o-gokoku-ji), and the Todai-ji. Accordingly, after the late fourteenth century two architectural styles continued: the Zen-sect style, which survived at full-scale Zen temples down through the Edo period, and the Japanese style, which incorporated the superior elements of the Great Buddha style and the Zen-sect style and also continued until the end of the Edo period (see Foldout 2).

The most conspicuous change that occurred in the eclectic styles of the fifteenth century and afterward was the increasing gaudiness of sculptural adornment. The sculptural details, which had begun as the moldings of the Zen-sect and Great Buddha styles and as other simple carvings (of which the early forms consisting of curved lines were called the *e-yo*, or pictorial style), gradually developed into highly intricate openwork (Fig. 196).

The next most noticeable change was in structure. It had been the standard practice since the

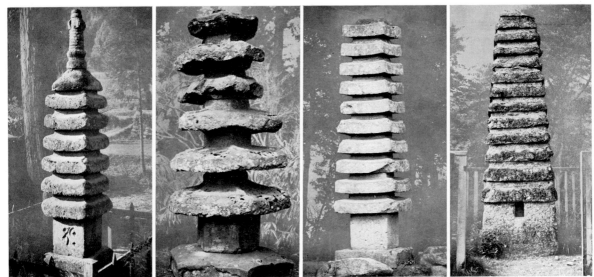

200. *Representative stone pagodas. From left to right: Seven-storied Pagoda, Eizan-ji, Gojo, Nara Prefecture; eighth century. To no Mori Pagoda, Hase, Nara Prefecture; about eighth century. Thirteen-storied Pagoda, Omiashi Shrine, Asuka, Nara Prefecture; eleventh to twelfth century. Thirteen-storied Pagoda, ruins of Rokutan-ji, Mount Nijo, Nara Prefecture; late seventh century.*

Nara period to place pillars both on the periphery of the hall and at a distance of one bay inside the hall, but during the Kamakura period a tendency to dispense with the inside pillars emerged, and in the Muromachi period this tendency progressed rapidly because of its practical advantage. As a result, although there were some contrivances in the supporting devices that might attract attention, there was a gradual decline in eagerness to express the compositional beauty of the support structure— an eagerness that had been prevalent up to the end of the fourteenth century. The overall appearance of the halls, too, lost the vigor of the Kamakura period and became more mediocre.

The tendency to employ abundant sculptural ornamentation reached flood-tide proportions in the Momoyama period. On the one hand, this development was an extension of the trend that emerged in the Muromachi period, but on the other hand it was spurred on by the excessively adorned interiors of the castles and mansions of the military leaders Oda Nobunaga and Toyotomi

Hideyoshi, built to display their power. Such decorative detail exhibited a certain amount of striking novelty and variation in the Momoyama period, but after the mid-1620s it showed little alteration and became rather stale. The fashion for sculptural excessiveness continued throughout the Edo period, but the artists who concentrated on the display of their skillful ornamentation forgot that the objective of sculptural decoration lay in architectural beauty and not in decoration independent of architecture. The designs were no longer of superb quality, and they often lapsed into vulgarity. I have repeatedly emphasized that true beauty in architecture can be achieved only through the harmony of structural members, the proper allotment of space by the support structure, and the balance maintained by the overall integrity of the building. According to these criteria, it must be said that the architecture of the Edo period was not on the right track—the track that traditional architecture had laid.

There was a certain amount of restorative archi-

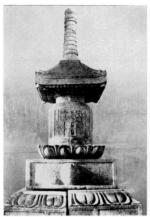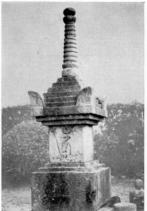

201. Representative stone pagodas. From left to right: Mausoleum Pagoda, Hokaku-ji, Kurotaki, Nara Prefecture; dated 1369. Hokyoin Pagoda, Empuku-ji, Ikoma, Nara Prefecture; dated 1293. Five Elements Pagoda, Todai-ji, Nara; late twelfth to early thirteenth century. Five Elements Pagoda, Enjo-ji, Nara; dated 1321.

tecture in Nara even in the Muromachi period and afterward. For example, the Kiko-ji Main Hall, the Kofuku-ji East Golden Hall, and the Futai-ji Main Hall were all rebuilt in the Muromachi period on the basis of Nara-period floor plans. The Danzan Shrine Hall for the Worship of Confucius, which had formerly been the Lecture Hall of the Myoraku-ji, was restored in the Edo period. Naturally, however, most of the new halls were built with Kamakura-period floor plans. These include the main halls of the Enjo-ji, the Kimpusen-ji, the Zuike-in, the Fudo-in, the Fuki-dera, and the Hodo-ji, all of the Muromachi period, and those of the Amida-ji, the Kontai-ji, and the Sutoku-ji, of the Edo period. The Kimpusen-ji Main Hall of 1455, also called the Zao (Vajrasattva) Hall, is an enormous structure, and its details already show quite gaudy sculptural decoration (Fig. 187). The Main Hall and the Worship Hall of the Hase-dera and the Todai-ji Second Month Hall were restored in the Edo period.

Three-by-three-bay halls dating from the Muromachi period are the main halls of the Empuku-ji, and such subtemples of the Horyu-ji as the Chu-in, the Fukuon-in, and the North Wing of the East

Precinct, as well as the Horyu-ji Jizo Hall and the Shoren-ji Dainichi Hall. The Ensho-ji Main Hall and the Jurin-in Portrait Hall are three-by-three-bay halls of the Edo period, while the Danzan Shrine Sanctuary is a five-by-five-bay hall that was formerly an Amida hall. The five-elements stone pagoda at the grave of Tsutsui Junkei in Yamato Koriyama is housed in an open canopy-like structure of one-by-one-bay size. An inscription on the pagoda bears the date of 1585, but the style of the pagoda seems to be a little older than the date suggests. Perhaps this is an indication that Nara had retained old architectural styles even in such a late period.

The Ryozen-ji Three-storied Pagoda, although it was built in the early part of the Muromachi period, is a typical Kamakura-period pagoda that conveys a sense of compactness and solidity. Although the dais of the principal statue enshrined in the pagoda bears an inscription dated 1356, a number of scholars have ascribed the building to as early as the 1280s. As a rule, the three-storied pagodas of the Muromachi period have thicker bodies and, in fact, give an impression of corpulence, but at the same time they have a unique air. The

202. *Representative stone lanterns, stupas, and a pagoda. From left to right: Citron Tree Lantern, Kasuga Shrine, Nara; about 1137. Front Stone Lantern, Lotus Hall, Todai-ji, Nara; dated 1254. Roofed stupas, Hannya-ji, Nara; dated 1249. Jewel Ball Pagoda, Danzan Shrine, Sakurai, Nara Prefecture; dated 1303.*

uniqueness is not so apparent in the pagodas of Nara because most of them are restorations, but the Three-storied Pagoda of the Minami Hokke-ji (also called the Tsubosaka-dera), built in 1474, clearly displays the new thickness (Fig. 178).

Among pagodas of the Taho-to type, the one at the Kichiden-ji, built in 1463, is the only one in Nara that retains its complete shape (Figs. 125, 164). The Danzan Shrine Thirteen-storied Pagoda (Figs. 126, 165) was originally built as a mausoleum for Fujiwara Kamatari on the hill called Tonomine, where the shrine is now located. Rebuilt in 1532, it is the only example of a thirteen-storied pagoda made of wood. The slender rafters used in this structure create a feeling of delicacy, and this, in turn, may be viewed as another of the sensations conveyed by Muromachi architecture.

Other pagodas of the Muromachi period in Nara include the Anraku-ji Stupa, the Kudara-dera Three-storied Pagoda, and the Kofuku-ji Five-storied Pagoda. It should also be mentioned here that both the Hokke-ji Belfry, built in the Momoyama period, and the Ryozen-ji Belfry, built in the Muromachi period, have skirtings that follow the Kamakura-period tradition.

Perhaps the most important aspect of the Buddhist architecture of the Muromachi period and afterward is the development of abbots' residences and guesthouses. Nara-period monks lived in dormitories, which provided an excellent environment for the practice of religious disciplines. But monks who attained high rank or received great honors gradually slipped into luxury, and by the Heian period a section of the monks' quarters came to have an independent structure as a residence for such monks. In this development we see the origin of subtemples.

Not much is known about the subtemples of the Heian period, but there are some extant examples from the Kamakura period and after. For instance, the North Wing of the East Precinct, a subtemple of the Horyu-ji, has a guesthouse called Prince Shotoku's Hall, an abbot's residence (recently dismantled), and a small Buddha hall. These were the standard accommodations required of a subtemple, irrespective of its size and style. In some cases the guesthouse and the abbot's residence were combined in one building, as at the Yakushi-bo subtemple of the Horyu-ji.

The most representative subtemples of Nara

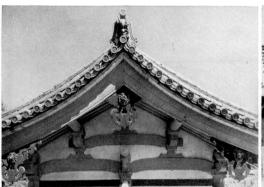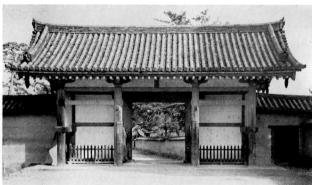

were the Ichijo-in and the Daijo-in of the Kofuku-ji. Although the Daijo-in was dismantled in the Meiji era (1868–1912), the Shinden of the Ichijo-in, as we have noted, survives as the Toshodai-ji Portrait Hall (Figs. 122, 123). It is an important structure for investigating the scale of the guest-house of a first-class subtemple.

The Imanishi residence in Nara City is believed by some to be a remnant of the Daijo-in, although there is no evidence that it was the guesthouse of a temple. It is in the residential style that became common from the end of the Muromachi period. In its inner-gate corridor and its façade it displays eaves of the type known as "Chinese gables." Despite a somewhat radical departure from the floor plan of the standard temple guesthouse, its front view still communicates the spirit of the Muromachi period, and it belongs to the same category as the Kojo-in Guesthouse in Shiga Prefecture, built in 1601, and the East Precinct Prince Shotoku's Hall of the Horyu-ji. Because it is a private residence, it is not open to the public.

Most of the other guesthouses remaining in Nara were built in the Edo period—for example, those of the Amida-ji, the Kombu-in, the Sutoku-ji, the Horyu-ji Saion-in, and the Hokke-ji. The Hozan-ji Guesthouse dates from the Meiji era. Abbots' residences dating from the Edo period are found at the Amida-ji, the Kofuku-ji, the Sutoku-ji, and the

Chogaku-ji. Reception halls survive at the Jiko-in (along with a teahouse) and at the Taima-dera Middle Precinct.

Beginning with the Nara period, bathhouses had been built for hygienic and medicinal purposes. There are no remains of older ones, but examples from Muromachi times can still be seen at the Ko-fuku-ji, the Todai-ji (Fig. 181), and the Horyu-ji.

Eight-legged gates of the Muromachi period include the Horyu-ji South Main Gate (Fig. 101), which, in keeping with an increasingly employed style, has a hipped-and-gabled roof, and the South Gate of the Horyu-ji East Precinct, which has a conventional gabled roof. The East Inner Gate and and the West Inner Gate of the Todai-ji Great Buddha Hall corridor, rebuilt in the Edo period, also follow the tradition of having gabled roofs. The Kimpusen-ji Gate of the Guardian Kings is an example of a double-roofed gate of the Muromachi period. Although, on the basis of the inscription on its wind chimes, it has been considered to date from 1456, it may be more feasible to rely on the inscriptions on the statues of the Guardian Kings and thereby to date it from the late fourteenth century. Both the three-bay Enjo-ji Gatehouse and the Oka-dera Guardian Kings' Gatehouse are in the turret style, and both date from Muromachi times. The South Inner Gate of the Todai-ji Great Buddha Hall is also in the turret style.

◁ 203 (opposite page, left). Gable of East Main
Gate, West Precinct, Horyu-ji, Ikaruga, Nara Pre-
fecture, employing a double rainbow beam with
frog-crotch struts. Eighth century.

◁ 204 (opposite page, right). Front view of East Main
Gate, West Precinct, Horyu-ji, Ikaruga, Nara Pre-
fecture. An eight-legged gate. Frontage, 9.37 m.
Eighth century.

205. Underside of roof of East Main Gate, West
Precinct, Horyu-ji, Ikaruga, Nara Prefecture. Three-
ridge construction. Eighth century.

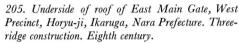

There are many examples of four-legged gates, including the Front Gate of the Horyu-ji Bath-house and the Yakushi-ji South Gate, both of the Muromachi period, and, from the Edo period, the Amida-ji Inner Gate, the Kombu-in Main Gate, and the Hokke-ji South Gate. Arched gates are of two kinds: a "Chinese front-arch gate" with eaves in the previously noted style called "Chinese gables" and a "Chinese side-arch gate" with "Chinese gables" used in the side gables. The latter type can be seen at the Horyu-ji North Wing of the East Precinct (Fig. 207) and the Horyu-ji Saion-in. The Saion-in also has the remains of an earthen-roofed gate (Fig. 206). Gates of this type are frequently seen in picture scrolls, but most of the actual ones have decayed, and even the one at the Saion-in now has a cypress-bark rather than an earthen roof.

Of works in stone that survive in Nara from this period, only a few are worth mentioning. The Ensho-ji Five Elements Stone Pagoda dates from late Muromachi. The Hokaku-ji Mausoleum is actually a square-roofed round stone pagoda—a rare example with abundant ornamentation.

The revival of architecture in the Momoyama period, after almost a century of devastating civil strife, began with the construction of Azuchi Castle on the eastern shore of Lake Biwa in Omi Province (the modern Shiga Prefecture). This imposing structure, now no longer extant, was the stronghold of Oda Nobunaga (1534–82), who more or less completely pacified the warring daimyo and set the country on the road to unification. In order to display his power, Nobunaga mobilized painters and sculptors to adorn his castle in extravagant style. The construction of the castle gave impetus to the rising trend of the Muromachi period toward a lavish use of realistic sculpture and thereby created what is now called the Momoyama style—a style characterized by excessive embellishment.

There are some difficulties involved in clarifying the exact origins of the Momoyama style as to time and place, but it is my opinion that the techniques of the style probably originated among the carpenters of Kii Province (the modern Wakayama Prefecture). In any event, it was from castle construction that this flourishing style spread to influence temple and shrine architecture.

Around the beginning of the seventeenth century there was a certain amount of shrine and temple construction in Nara. Toyotomi Hideyori (1593–1615), son of Hideyoshi, appointed Katagiri Katsumoto (1556–1615) as commissioner in charge of the repair of the Hokke-ji Main Hall, and the sanctuaries of the Kasuga Shrine were repaired or reconstructed around the same time. This work, however, was purely restorative, and there was nothing in it characteristic of the Momoyama style.

206. Earthen-roofed Gate, Sai-on-in, West Precinct, Horyu-ji, Ikaruga, Nara Prefecture. Seventeenth to eighteenth century.

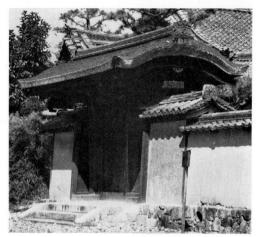

207. Chinese Gate, North Wing of East Precinct, Horyu-ji, Ikaruga, Nara Prefecture. Fifteenth century.

In fact, the only examples of Momoyama-style architecture in Nara are the Main Sanctuary of the Yakushi-ji Hachiman Shrine (Fig. 183), rebuilt in 1603, and the Denko-ji Main Hall. The former had another small shrine that has now been moved to the Yakushi-ji temple precinct and is considered to date from the Kamakura period. Although the Denko-ji is said to have been founded by Ganjin's disciple Shitaku, the present temple buildings were reconstructed by the Zen-sect nun Hoshuei. The Main Hall of the temple is a small structure of three by two bays, and its ridgepole has a tablet with an inscription from the year 1585, the date of completion. The statue of the Naked Jizo enshrined here is quite famous.

Generally speaking, the Momoyama style flourished during the Momoyama period only in those areas that were economically or technically connected with the central government. In other areas it did not begin to prevail until the early part of the Edo period. As to the restoration of temples and shrines, the Hoko-ji at Higashiyama in Kyoto was revived by Hideyoshi in the Momoyama period, but this was an exceptional case. Large-scale restorations did not begin until the mid-1620s, when the whole nation became politically more stabilized. The restoration of the Daitoku-ji, the Myoshin-ji,

and the Kiyomizu-dera (all in Kyoto) and of the Enryaku-ji in Shiga Prefecture took place during this period.

The greatest restoration project in Nara was that of the Todai-ji Great Buddha Hall (Fig. 104). The hall that had been built at the end of the twelfth century was destroyed by fire during the struggle between the warlords Matsunaga Masahide and Miyoshi Nagayori in 1567. Yamada Doan (?–1569) commissioned temporary repair work on the neck of the Great Buddha statue, but the hall itself was not rebuilt, and the statue remained exposed to the weather. Around the end of the seventeenth century the reconstruction of the hall was planned, and the work was completed in 1708. The width of the hall, however, was reduced to 170 shaku, so that its original grandeur was diminished. The Great Buddha style employed in this reconstruction clearly indicates that the tendency toward restoration remained quite strong in the Edo period. Other examples of relatively large-scale architectural restoration include the Hase-dera Main Hall (Fig. 191), rebuilt in 1650, and the Todai-ji Second Month Hall (Fig. 189), rebuilt in 1669. In addition, there are halls dating from the beginning of the Edo period, but by that time Nara was no longer a center of Buddhism.

Foldout 3: Detail of Temple Architecture
KEY TO THE PLAN

Frog-Crotch Board Struts
1. Golden Hall, Horyu-ji, late 7th c.
2. Dempodo, Horyu-ji, early 8th c.
3. Tegai Gate, Todai-ji, mid-8th c.
4. East Main Gate, Horyu-ji, 8th c.
5. Phoenix Hall, Byodo-in, 1053
6. South Gate, Jurin-in, mid-13th c.
7. Gekka Gate, Tofuku-ji, 13th c.
8. Main Sanctuary, Takakamo Shrine Nara, 1543
9. Denko-ji, 1585
10. Three Buddhas Hall, Rinno-ji, Tochigi, 1647
11. Koka Gate, Daiyu-in, Tochigi, 1653

Altar-Panel Decorations
12. Tamamushi Shrine, Horyu-ji, early 7th c.
13. Golden Hall, Toshodai-ji, late 8th c.
14. Taishi-do, Kakurin-ji, 1112.
15. Reliquary, Horyu-ji, 1219
16. Fudo Hall, Kongobu-ji, 13th c.
17. Sumeru Altar, Hodo-ji, Nara, c. 1400
18. Gonden, Kora Shrine, Shiga, 1634

Beam-End Covers
19. "Boar's eye," Keiga Gate, To-ji, early 13th c.
20. "Boar's eye," Initiation Hall, Muro-ji, mid-13th c.
21. "Three flowers," Main Hall, Kimpusen-ji, 1455
22. "Turnip," Inner Gate, Chion-in, 1617
23. "Port of plum blossoms," Anointment Hall, To-ji, 1634

Intermediate Supports
24. Block-on- strut, Five-storied Pagoda, Daigo-ji, 952
25. "Straw-raincoat· post," Kitamuro-in, Horyu-ji, 1494

Ornamented Bracket Arms
26. South Gate, Futai-ji, Nara, 1317
27. Tahoto, Jodo-ji, Hiroshima, 1329
28. Main Hall, Zuike-in, Nara, 1443

Genuine Frog-Crotch Struts
29. Yakushi Hall, Daigo-ji, 1121
30. Golden Hall, Chuson-ji, 1124
31. Main Hall, Saimyo-ji, Shiga, early 13th c.
32. Fudo Hall, Kongobu-ji, 13th c.
33. Main Hall, Taisan-ji, Ehime, 1305
34. Main Sanctuary, Aburahi Shrine, Shiga, 1493
35. Main Sanctuary, Hijiri Shrine, Osaka, 1604

36. Lecture Hall, Zuiryu-ji, Toyama, 1655
37. Konoma Kannon Hall, Nagano, early 19th c.
38. Great Lecture Hall, Enryaku-ji, 1642

Beam-End Nosings
(Zen-Sect Style)
39. Main Hall, Shojo-in, Wakayama, 1294
40. Five-storied Pagoda, Itsukushima Shrine, 1407
41. Three-storied Pagoda, Kojo-ji, Hiroshima, 1432
42. Main Hall, Zuike-in, Nara, 1443
43. Chinese Gate, Daitoku-ji, late 16th c.
44. Sutra Repository, Myojo-ji, Ishikawa, 1670
45. To-ji, mid-18th c.

Beam-End Nosings
(Great Buddha Style)
46. Pure Land Hall, Jodo-ji, Hyogo, 1192
47. Sutra Repository, Kairyuo-ji, c. 1288
48. Tahoto, Jodo-ji, Hiroshima, 1329
49. Haiden, Ono Hachiman Shrine, Hyogo, 13th c.
50. Main Sanctuary, Nakajima Shrine, Hyogo, late 17th c.

"Armpit Struts"
51. West Main Sanctuary, Naemura Shrine, Shiga, 1308
52. Jinushi Shrine, Shiga, 1502
53. Tsukubusuma Shrine, Shiga, 1602
54. Main Sanctuary, Otonashi Shrine, Kochi, 1663

Buddha Hall: Main Hall, Matsuno-o-dera
55. End tile
56. Demon-face tile
57. Sloping ridge
58. Child ridge
59. Demon-face tile
60. Hip ridge
61. Concave tile
62. Round tile
63. Ridgepole
64. Gable
65. Beam-end nosing
66. Mullioned window
67. Paneled door
68. Veranda post
69. Skirting veranda
70. King post
71. Principal rafter

72. Bargeboard
73. Skirting veranda
74. Railing
75. Head penetrating tie
76. Flying penetrating tie
77. Paneled door
78. End tile
79. Demon-face tile
80. Beam-end cover
81. Sloping ridge
82. Hip ridge
83. Child ridge
84. Worshipers' shelter
85. Beam-end nosing
86. Armpit strut
87. Bargeboard
88. Worshipers'-shelter pillar
89. Rear sanctuary
90. Altar
91. Inner sanctuary
92. Outer sanctuary
93. Side sanctuary
94. Side sanctuary
95. Flying rafter
96. Base rafter
97. Side pillar
98. Rainbow tie beam
99. Attic
100. Shrine
101. Altar
102. Three-block bracketing
103. Inner sanctuary
104. Greater rainbow beam
105. Outer sanctuary
106. Armpit strut
107. Worshipers'-shelter pillar

Side Structure
108. Lobster-shaped beam
109. Beam-end nosing
110. Mullioned window
111. Podium
112. Tortoise belly
113. Straw-raincoat post
114. Head penetrating tie
115. Flying penetrating tie
116. Dado penetrating tie
117. Floor penetrating tie
118. Bracket
119. Socket piece
120. Ledged-panel door
121. Architrave
122. Beam-end nosing
123. Transom
124. Cusped window
125. Plinth
126. Rounded pillar head
127. Ledged-panel door

Restored Compounds of Principal Temples

1 : 2500

Kawara-dera (mid-7th c.)

NORTH WING
WEST WING
MINOR CELLS
LECTURE HALL
MIDDLE GOLDEN HALL
BELFRY
SUTRA REPOSITORY
EAST WING
CORRIDOR
CORRIDOR
PAGODA
WEST GOLDEN HALL
INNER GATE
SOUTH MAIN GATE

Shitenno-ji (early 7th c.)

MINOR CELLS
REFECTORY
MINOR CELLS
MONKS' QUARTERS
MONKS' QUARTERS
BELFRY
SUTRA REPOSITORY
LECTURE HALL
GOLDEN HALL
PAGODA
CORRIDOR
CORRIDOR
INNER GATE
SOUTH GATE

Asuka-dera (late 6th c.)

LECTURE HALL
BELFRY
SUTRA REPOSITORY
CORRIDOR
CORRIDOR
CORRIDOR
WEST GOLDEN HALL
MIDDLE GOLDEN HALL
PAGODA
INNER GATE
EAST GOLDEN HALL
SOUTH GATE

Horyu-ji (mid-7th c.)

LECTURE HALL
SUTRA REPOSITORY
BELFRY
WEST WING
CORRIDOR
PAGODA
CORRIDOR
GOLDEN HALL
EAST WING
INNER GATE
SOUTH GATE

Yakushi-ji (late 7th c.)

MONKS' QUARTERS
CROSS HALL
MONKS' QUARTERS
REFECTORY
MONKS' QUARTERS
MONKS' QUARTERS
LECTURE HALL
CORRIDOR
GOLDEN HALL
CORRIDOR
PAGODA
PAGODA
INNER GATE
SOUTH MAIN GATE

Minami Shiga Hai-ji (mid-7th c.)

REFECTORY
LECTURE HALL
MONKS' QUARTERS
WEST GOLDEN HALL
MONKS' QUARTERS
GOLDEN HALL
CORRIDOR
PAGODA
CORRIDOR
INNER GATE

Kanzeon-ji (mid-7th c.)

LECTURE HALL
CORRIDOR
CORRIDOR
GOLDEN HALL
PAGODA
INNER GATE
SOUTH GATE

Koga-ji (mid-8th c.)

MINOR CELLS

REFECTORY

MONKS' QUARTERS

BELFRY

SUTRA REPOSITORY

LECTURE HALL

PAGODA

CORRIDOR

CORRIDOR

CORRIDOR

GOLDEN HALL

INNER GATE

INNER GATE

Niibari Hai-ji (8th c.)

MONKS' QUARTERS

BELFRY

REFECTORY

NORTH GATE

LECTURE HALL

CORRIDOR

CORRIDOR

PAGODA

GOLDEN HALL

PAGODA

INNER GATE

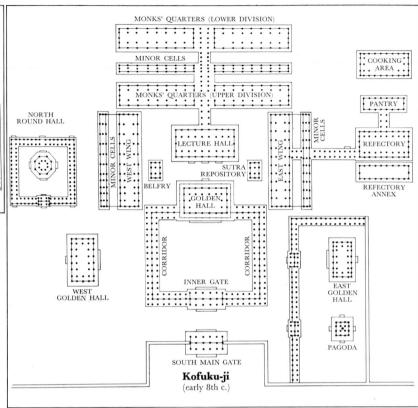

Kofuku-ji
(early 8th c.)

MONKS' QUARTERS (LOWER DIVISION)

MINOR CELLS

COOKING AREA

MONKS' QUARTERS (UPPER DIVISION)

PANTRY

NORTH ROUND HALL

MINOR CELLS

WEST WING

LECTURE HALL

EAST WING

MINOR CELLS

REFECTORY

BELFRY

SUTRA REPOSITORY

GOLDEN HALL

REFECTORY ANNEX

WEST GOLDEN HALL

CORRIDOR

CORRIDOR

INNER GATE

EAST GOLDEN HALL

SOUTH MAIN GATE

PAGODA

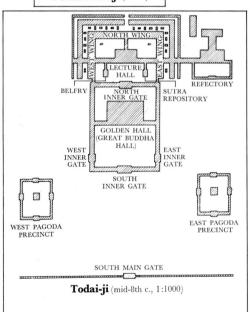

Todai-ji (mid-8th c., 1:1000)

NORTH WING

WEST WING

EAST WING

LECTURE HALL

BELFRY

REFECTORY

SUTRA REPOSITORY

NORTH INNER GATE

GOLDEN HALL (GREAT BUDDHA HALL)

WEST INNER GATE

EAST INNER GATE

SOUTH INNER GATE

WEST PAGODA PRECINCT

EAST PAGODA PRECINCT

SOUTH MAIN GATE

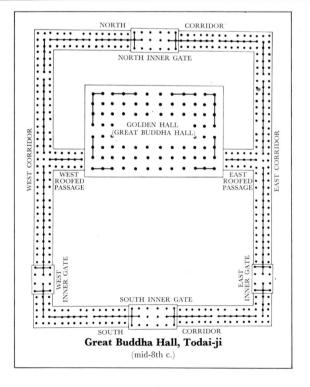

Great Buddha Hall, Todai-ji
(mid-8th c.)

NORTH CORRIDOR

NORTH INNER GATE

WEST CORRIDOR

EAST CORRIDOR

GOLDEN HALL (GREAT BUDDHA HALL)

WEST ROOFED PASSAGE

EAST ROOFED PASSAGE

WEST INNER GATE

EAST INNER GATE

SOUTH INNER GATE

SOUTH CORRIDOR

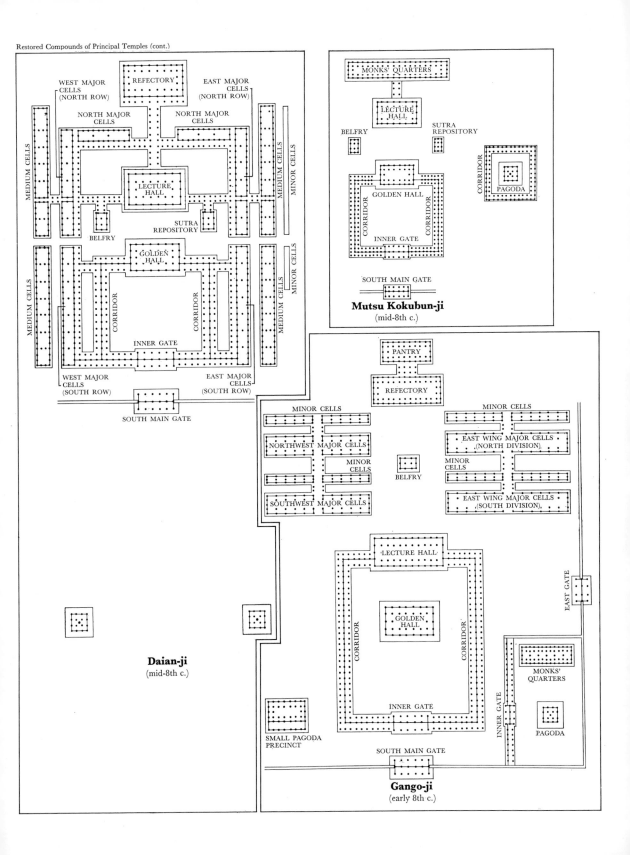

Restored Compounds of Principal Temples (cont.)

Mutsu Kokubun-ji
(mid-8th c.)

Daian-ji
(mid-8th c.)

Gango-ji
(early 8th c.)

TITLES IN THE SERIES

Although the individual books in the series are designed as self-contained units, so that readers may choose subjects according to their personal interests, the series itself constitutes a full survey of Japanese art and will be of increasing reference value as it progresses. The following titles are listed in the same order, roughly chronological, as those of the original Japanese editions. Those marked with an asterisk (*) have already been published or will appear shortly. It is planned to publish the remaining titles at about the rate of eight a year, so that the English-language series will be complete in 1975.

The "weathermark" identifies this book as having been planned, designed, and produced at the Tokyo offices of John Weatherhill, Inc., 7-6-13 Roppongi, Minato-ku, Tokyo 106. Book design and typography by Meredith Weatherby and Ronald V. Bell. Layout of photographs by Ronald V. Bell. Composition by General Printing Co., Yokohama. Color and gravure plates engraved and printed by Nissha Printing Co., Kyoto, and Mitsumura Printing Co., Tokyo. Monochrome letterpress platemaking and printing and text printing by Toyo Printing Co., Tokyo. Bound at the Makoto Binderies, Tokyo. Text is set in 10-pt. Monotype Baskerville with hand-set Optima for display.